IMAGES
of America

CLEVELAND'S
MILLIONAIRES' ROW

IMAGES
of America

CLEVELAND'S MILLIONAIRES' ROW

Alan F. Dutka

ARCADIA
PUBLISHING

Published by Arcadia Publishing
Charleston, South Carolina

Library of Congress Control Number: 2019941207

For all general information, please contact Arcadia Publishing:
Telephone 843-853-2070
Fax 843-853-0044
E-mail sales@arcadiapublishing.com
For customer service and orders:
Toll-Free 1-888-313-2665

Visit us on the Internet at www.arcadiapublishing.com

CONTENTS

ACKNOWLEDGMENTS

Members of six different departments of the Cleveland Public Library contributed to this book: Photographs (Brian Meggitt, Adam Jaenke, Nicholas Durda), History (Olivia Hoge, Terry Metter, Danilo Milich, Lisa Sanchez, Aimee Lepelley), Special Collections (Stacie Brisker, Michael Jacobs), Map Collection (Thomas Edwards), Fine Arts (Pamela J. Eyerdam), and Archives (Ann Marie Wieland).

At Cleveland State University, William C. Barrow and Lynn M. Duchez Bycko in Special Collections and William Becker in Archives made contributions in obtaining images and providing insights.

David Horan shared his knowledge and archives. Diane D. Ghorbanzadeh contributed several images. Priscilla Dutka provided her amazing proofreading skills and special insights into virtually anything I write.

Euclid Avenue underwent two significant address changes since the 1880s. Some millionaires resided in more than one home on the avenue (and often in additional homes outside of Millionaires' Row), while others constructed homes for relatives without ever living in the house. These and other reasons have contributed to a significant amount of incorrect information regarding the addresses, owners, and images of the various mansions. Craig Bobby, one of the absolute most knowledgeable persons regarding Euclid Avenue's history, graciously and painstakingly studied my original drafts and offered both suggestions and corrections to make this book as historically accurate as possible.

Thanks to everyone at Arcadia Publishing who helped bring this book to life: Jeff Ruetsche, Stacia Bannerman, Chrissy Smith, Jessica Mickey, Mike Litchfield, Haley Johnson, and Mike Nieken.

INTRODUCTION

In the mid- to late 19th century, Euclid Avenue's fame extended across America and beyond the Atlantic Ocean into Europe. Philosopher and historian John Fiske praised the street during a talk at the Royal Society of Great Britain. A leading international travel guide depicted the avenue as a pleasurable destination for European tourists. Bayard Taylor, an author, poet, and world traveler, called Euclid Avenue "the most beautiful street in the world." Sophisticated international visitors considered Euclid Avenue comparable to or exceeding the beauty of Avenue des Champs-Elysées in Paris, Unter den Linden in Berlin and Nevsky Prospekt in St. Petersburg.

Samuel L. Clemens (Mark Twain) described Euclid Avenue as "one of the finest streets in America." The much-admired author and humorist even socialized with avenue residents. When Clemens visited the Holy Land (a trip inspiring his celebrated book *The Innocents Abroad*), his entourage included Euclid Avenue banker Solon Severance, his wife Emily, and Eliza Otis Crooker, another member of Millionaires' Row.

Those not fortunate enough to reside on the famous street playfully labeled Euclid Avenue's north-side millionaires "nabobs;" occupants of the less-desirable south side were mere "bobs." Northern inhabitants gained a reputation for owning estates encompassing sweeping lawns, artistic wrought-iron fences, and views of Lake Erie; their southern counterparts lived in mere houses surrounded by smaller yards that offered glimpses of the regal mansions they could not afford. These beliefs gave rise to an anonymous poem depicting the street's north and south neighbors:

> They called one side the nabob side,
> The bob was cross the way.
> Between the two a channel wide
> In dismal darkness lay.
> The lady nabob raised her gown
> And minced with nose in air.
> The lady bob look meekly down
> And felt the icy state.
> Someday they'll turn from earthly jobs
> In endless joy to dwell.
> But when the nabobs see the bobs
> Will they all leave for—
> Berea?

Yet the south-side mansions of William Chisholm Jr., Alonzo P. Winslow, and others rivaled their northern counterparts in opulence and elegance. A few millionaires, for economic reasons, purposely chose to reside in less ornate homes among the purportedly inferior bobs, the best examples being two immensely wealthy cofounders of the Standard Oil Company. John D. Rockefeller preferred

the street's south side because it offered a better value for his hard-earned and carefully invested money. Stephen Harkness witnessed his $75,000 investment in Standard Oil soar in value into hundreds of millions; observing first-hand Rockefeller's remarkable business intellect, Harkness followed Rockefeller's path to the street's south side.

Northside millionaires were often cast as Cleveland's nobility, while southsiders exemplified the successful working class. But unlike European nobility, many first-generation millionaires on the north side, lacking in formal education, began their careers in poor-paying and low-status positions. Amasa Stone started his carpenter apprenticeship earning $40 in his first year, $50 in his second, and $60 in his third. At the age of 20, he collected $1.25 per day working for a railroad. Twenty years later, Stone presided as either president or on the board of directors of several railroads. Journalists referred to his Euclid Avenue home as resembling a castle. Stillman Witt launched his career in transportation receiving $10 per month paddling a ferryboat across the Hudson River. He later gained his millionaire status building railroads. At its peak, the "Millionaires' Row" defining Cleveland's late-19th-century wealth and influence encompassed mansions situated between East Eighteenth Street and East Fortieth Street. Within these blocks, the wealthy sought prestige, power, and tranquility. Residents engaged in quaint afternoon teas, formal dinners, extravagant evening parties, summer lawn concerts, and holiday open houses. Their homes served as settings for debutante balls, wedding receptions, birthday and anniversary celebrations, and somber funerals.

In 1874, Jeptha Wade contributed $1,500 to St. Paul's Church (which still stands diagonally across from Wade's prior mansion site) on the condition that the church stop tolling its bells, a practice he found annoying. For 16 years, until Wade's 1890 death, his gift completely silenced the church chimes. Yet Wade's spirited parties in his own home, sometimes involving 600 guests, included entertainment provided by orchestras and military bands. A newspaper reporter invited to one gathering noted, "The great house received the crowd with as much ease and little inconvenience as though it was an everyday affair."

The western segment of Euclid Avenue, rapidly expanding into an important commercial thoroughfare, threatened the continued survival of the wealthy residential community to the east. In 1896, concerned city officials devised a plan to sustain the affluent neighborhood by integrating the street into Cleveland's park system. Further commercial expansion between East Fourteenth and East 105th Streets would be banned, thus preserving the magnificent setting for Euclid Avenue's mansions. The city soon rescinded the proposal, since business interests had already prevented its implementation and citizens rallied against the proposal.

Not wishing to irritate the city's privileged families with noisy traffic or easy public access to their grand neighborhood, Cleveland banned streetcars on Euclid Avenue between East Twenty-Second and East Fortieth Streets; the vehicles detoured south to Prospect Avenue during this stretch of the prominent thoroughfare.

Despite Euclid Avenue's grandeur, the dawning of the 20th century altered many citizens' seemingly archaic Victorian views. In 1908, union workers decided to modify a long-standing Labor Day parade route to pass through the entire portion of the forbidden streetcar route. Members of the building, metal, and printing trades joined longshoremen marching across land formerly considered almost sacred. "We want to show the mayor the strength of labor in the city," explained one of the parade organizers.

Just two weeks later, Cleveland's city hall joined in the anti-millionaire movement. Rev. Dr. Harris R. Cooley, Cleveland's director of charities and corrections, equated Millionaires' Row with the downtown Haymarket District, Cleveland's poorest neighborhood, claiming "slums are located in the parts of the city inhabited by the very rich and very poor." He defined slums as "the abnormal environments surrounding the people who are not employed, whether it be because of great riches or because of inability to find work," and excoriated Euclid Avenue's wealthy residents for "idleness and the spending of unearned fortunes." He concluded his remarks by observing, "We never have any trouble with the middleclass, the people who render some service to society and are well paid for the service." Cooley never expounded upon the trouble, if any, created by the millionaires.

Seven years later, Millionaires' Row suffered its most acute setback to date. At 5:00 a.m. on September 20, 1915, the rumbling from the Cleveland Railway Company's yellow streetcars began replacing the hoofbeats of horses pulling the carriages of millionaires. Two months to the day of the Ohio Supreme Court's ruling that wealthy residents could not prevent the construction of a streetcar route through their neighborhood, four lanes of streetcar tracks finally concluded a lengthy legal battle. The streetcars carried 122,490 people on Euclid Avenue between the previously prohibited ground bordering East Twenty-Second and East Fortieth Streets.

Two days before the new streetcar route opened, the *Plain Dealer* expressed its unqualified approval: "Hundreds of thousands of car riders are now detoured night and morning to avoid the forbidden district. The hundreds of thousands are put to daily inconvenience and loss of time in order to save a few dozen families from the possible discomfort of having streetcars run by their homes." The actual time saved amounted to less than two minutes each way.

Stanley L. McMichael, secretary of the Cleveland Real Estate Board, correctly predicted the new streetcar route would encourage both conversions of vacated mansions into apartments and construction of new commercial property. He described Euclid Avenue as "doomed for residents" and urged the City Planning Commission to develop a system of cross streets before business interests consumed all the available land. As one example of McMichael's foresight, in 1924 the pristine Temple Court apartments, located on Euclid Avenue at East Thirty-Sixth Street, advertised, "Live in Millionaires' Row for only $35 per month."

No zoning laws or building codes existed to thwart new construction; as a result, wealthy Sylvester Everett could not prevent the remodeling of his neighbor's home into the Hotel Del Prado directly east of his own castle-like mansion.

The local government's approach to real estate tax valuations compounded the millionaires' predicament. In determining property values and assessing charges, no distinction existed between residential and commercial usage. In 1890, the $39,000 valuation on Everett's residence triggered a $1,100 real estate tax liability. By 1920, the property valuation had soared to $604,000, largely due to the surrounding commercial property that Everett loathed. As a result, the family's liability climbed to $14,000. Two years later, the mansion began a new life as an apartment house. By the mid-1920s, the burdensome tax increases even caused businesses to vacate the street.

Beginning in the late 1930s and extending through the 1950s, popular culture placed little value on the beauty of late-19th-century architecture. In 1938, during the demolition of the stunning Everett mansion, a *Plain Dealer* article described the home as "a stone structure of Gothic design that was considered attractive in the days of Millionaires' Row."

Euclid Avenue's deterioration also fostered its share of ironic turns of events. The street's affluent residents understandably detested the growing smog and pollution pervading the avenue, yet these millionaires generated much of this affluence as owners of nearby factories. Euclid Avenue's prosperous inhabitants also fretted about the expanding slum emerging south of their mansions, yet these industrial leaders actively recruited unskilled, low-paid workers for factory work who naturally settled close to their place of employment.

As commerce relentlessly devoured Euclid Avenue's accessible space, remaining millionaires willingly sold their homes, moving to other desirable parts of Cleveland (Wade Park and Edgewater), enclaves bordering the city (Bratenahl), nearby suburbs (Shaker Heights, Lakewood, West Park, Rocky River, and Cleveland Heights), and partially developed farmland (Gates Mills, Willoughby, and Wickliffe).

The last great Millionaires' Row wedding reception took place in 1940. Mrs. Samuel A. Raymond (Emma, the grandmother of the bride) hosted the reception for Emma Garretson Raymond and Frederick Rollin White Jr. in her Euclid Avenue home. In 1950, John Carlin, the final wealthy connection to Euclid Avenue's past glory, moved to Fairmount Boulevard in Cleveland Heights. Before departing the once-magnificent street, Carlin hosted a farewell party and dance attended by 100 dignitaries. At the gathering, Cleveland mayor Thomas A. Burke made a few obligatory comments about the greatness of Millionaires' Row and then concluded by remarking, "But the city marches on."

One

MANSIONS TO MERCHANTS

PUBLIC SQUARE THROUGH EAST THIRTEENTH STREET

Euclid Avenue did not enjoy an auspicious beginning. Flooded by rainwater, rutted by wagon wheels, mired in mud or dust and frequented by wolves and panthers, the street originally functioned as an uninviting trail through a nearly impenetrable forest. The northeast quadrant of the intersection of Euclid Avenue and East Ninth Street gained early notoriety, especially after a heavy rain, as a place to sail toy boats and float rafts; adults and children used the term "frog pond" to describe the land. The soggy Euclid Avenue land was not very expensive. In 1816, an opportunist willing to gamble $5,000 could have purchased all of the lands on both sides of the 17-block expanse from Public Square through what would become the Playhouse Square entertainment district.

In the 1820s, the slice of Euclid Avenue between Public Square and East Ninth Street routinely served as a 1,650-foot horse race track known as the Cleveland Course. On May 6, 1826, Portage Polly defeated Black Billy in one of Euclid Avenue's most publicized and heavily wagered racing events. By 1837, this portion of the street, no longer a race track, supported 11 residences, 6 businesses (a paint shop, cobbler, blacksmith, wagon maker, carpenter, and joiner), and 35 empty lots. In the 1830s, Samuel Cowles and Truman Handy constructed the street's first impressive mansions.

By the mid-1870s, street-level shops catered to affluent customers while upper floors of newly constructed buildings enticed first-class office tenants. In 1893, the brief era of residential homes between Public Square and East Ninth Street ended as the Henry Chisholm mansion surrendered to wreckers. *Town Topics* (a high-society Cleveland periodical) lamented that Euclid Avenue's status as "the handsomest street in the world" would never have ended "if it were not for some very discreditable buildings erected along it, during recent years, for business purposes."

This section of Euclid Avenue remained an important business district throughout most of the 20th century. In the first two decades of the current century, a trend never dreamed of, even in the 1990s, gathered powerful momentum. The street is reinventing itself as a residential community. Apartment dwellers, living in former high-rise office buildings or newly constructed residences, walk their dogs down Euclid Avenue and bicycle to work. Visitors to the city wander down the avenue to nearby East Fourth Street to investigate dining selections from numerous excellent restaurants. And suburbanites, who had not ventured downtown in years, are discovering an exciting atmosphere not present since the 1950s.

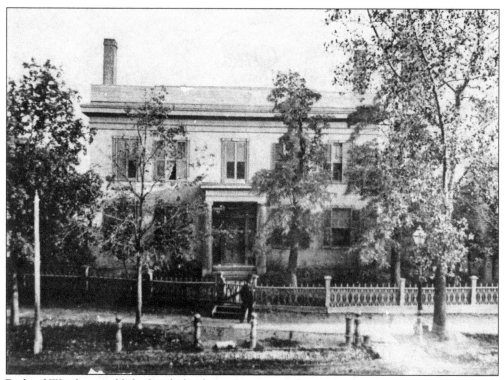

Richard Winslow established a wholesale grocery store and commission merchant business trading in salt, flour, linseed oil, pork, beans, butter, and fish. Expanding his horizons and personal wealth, he subsequently built, owned, and operated a fleet of merchant ships. In 1832, Winslow constructed one of Euclid Avenue's first homes at 2 Euclid Avenue. Just east of Public Square, his residence did not quite rival the pretentious mansions soon to populate the street. In 1854, Winslow retired at the age of 85; three years later, he died in his Euclid Avenue home. (Photograph Collection, Cleveland Public Library.)

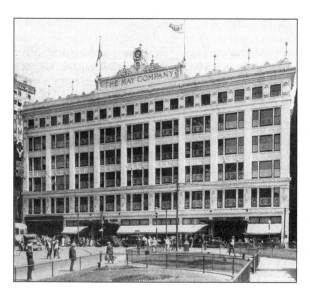

The Central Rink, an ice-skating facility, replaced the Winslow home. Following its almost immediate failure, Beckwith, Sterling & Company constructed a store to display and sell carpets. In 1914, the growing May Company department store erected the still-existing terra-cotta building depicted in this 1929 photograph. In 1931, the company added two additional floors to create an eight-story, 17-acre shopping experience. The May Company continued to operate in this location into 1992. The building now houses apartments. (Special Collections, Michael Schwartz Library, Cleveland State University.)

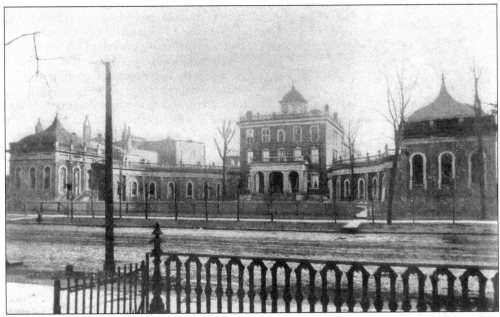

In 1833, pioneer attorney and businessman Samuel Cowles built Euclid Avenue's first imposing residence, a 5,000-square-foot brick Colonial structure (above center) situated in a grove of elm trees at 622 Euclid Avenue. Cowles enjoyed his residence for only four years prior to his death. In 1850, the Ursuline Sisters converted the home into a centerpiece for a new convent and boarding school by adding structures on the east and west sides of the old residence. The sisters remained on Euclid Avenue until relocating to East Fifty-Fifth Street in 1893. (Special Collections, Michael Schwartz Library, Cleveland State University.)

In 1907, the William Taylor Company constructed a five-floor department store on the earlier convent site. Seven years later, the flourishing store added four additional floors. Pictured here, a salesperson in the glove department is ready to assist customers in 1934. The department store closed in 1961; offices and street-level retail utilized the building for the next three decades. The structure is now an apartment building. (Photograph Collection, Cleveland Public Library.)

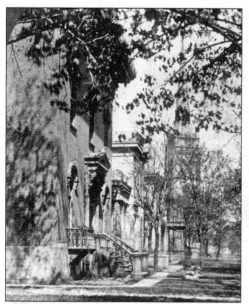

Henry Chisholm and four partners founded the Cleveland Rolling Mill Company, an eventual important segment of US Steel. Chisholm's Tuscan villa mansion at 619 Euclid Avenue is the first home to the left in this 1865 photograph of Euclid Avenue's north side looking east from about East Sixth Street toward East Ninth Street. Purchasing the six-year-old home in 1863, Chisholm resided there until his death in 1881. Construction of the Garfield Building (1894) and New England Building (1895) eliminated any trace of the Chisholm residence. These buildings currently house offices, apartments, and a Holiday Inn Express Hotel. (Photograph Collection, Cleveland Public Library.)

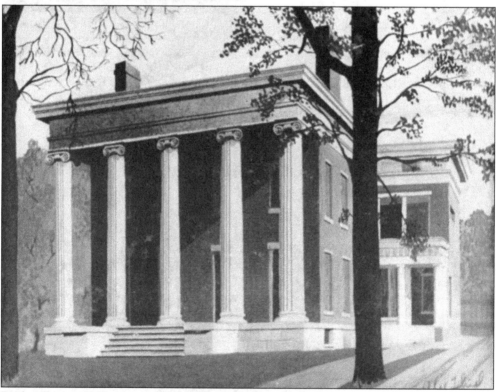

Banker Truman P. Handy visited Cleveland in 1832 on his honeymoon and decided to remain in the city. Five years later, he constructed this brick home at 800 Euclid Avenue. Handy sold the residence after only four years. His growing wealth allowed him to construct a more extravagant Euclid Avenue residence farther to the east. The Union Club used the first Handy home as its headquarters from 1872 to 1905 and then moved to its current location on Euclid Avenue and East Twelfth Street. (Photograph Collection, Cleveland Public Library.)

Constructed in 1907, the Hippodrome Theater occupied the former Handy site for 73 years. Originally built to accommodate live performances including large spectacles, in the 1930s, the Hippodrome became the largest American theater devoted exclusively to motion pictures. The exterior of the Hippodrome is shown in late 1952, during the run of *Pony Soldier* starring Tyrone Power. The William Taylor Department Store is directly to the right. In 1980, a nondescript parking garage, with adjoining surface parking on both Euclid Avenue and Prospect Avenue, replaced the former celebrated playhouse and movie theater. (Special Collections, Michael Schwartz Library, Cleveland State University.)

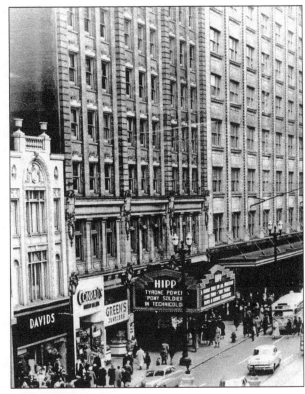

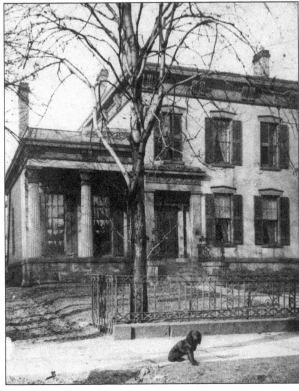

Henry L. Gaylord acquired his wealth as the founder of a wholesale drug company. In 1855, he constructed this attractive Italianate home at 833 Euclid Avenue, which would exist for a mere three decades before being replaced by a theater. (Photograph Collection, Cleveland Public Library.)

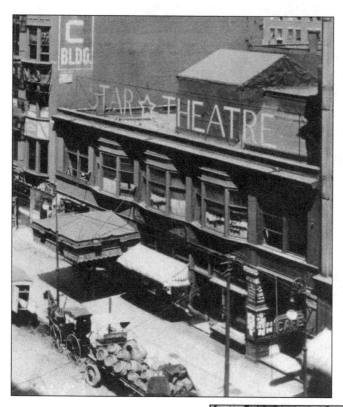

Built in 1887, the Columbia Theater changed its name to the Star Theatre within two years. Vaudeville, melodrama and comic opera dominated the offerings until the introduction of burlesque in the late 1890s. The Star was renamed the Cameo in 1925 and demolished in 1938; only the east and west walls remained. Utilizing these old walls, the predominately second-run Embassy Theater replaced the Cameo. The Embassy persisted for nearly four decades, closing in 1977 to allow construction of the National City (now PNC) Bank Building. (Photograph Collection, Cleveland Public Library.)

In 1870, the north side of Euclid Avenue, looking west from East Ninth Street, still consisted mostly of refined residential homes. Within 30 years, commercial enterprises would replace every one of these residences. Euclid Avenue's north side today is highlighted by the towering PNC bank building. (Special Collections, Michael Schwartz Library, Cleveland State University.)

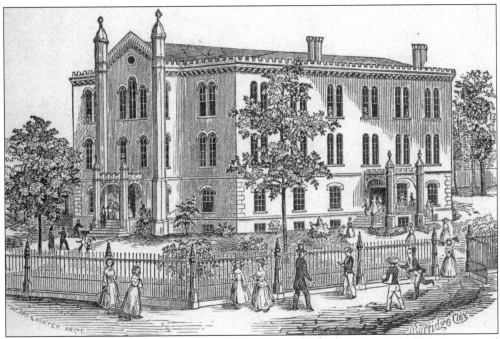

Graduates of Central High School, located just west of the intersection of Euclid Avenue and East Ninth Street, included future Millionaires' Row residents John D. Rockefeller, Charles F. Brush, and Samuel Mather. Even after its 1856 opening, many taxpayers disliked supporting the city's first public high school, believing that educational expenses beyond the elementary level should be privately funded. Following the school's relocation to East Fifty-Fifth Street in 1878, the Cleveland Public Library used this site until 1901. (Special Collections, Michael Schwartz Library, Cleveland State University.)

Constructed in 1902, the Schofield Building (left), utilizing a small 40-foot frontage on Euclid Avenue, extends 173 feet south on East Ninth Street. In 1903, the Citizens Savings and Trust Company constructed the next-door Citizens Building (right). Today, the Schofield (Kempton Hotel) and Citizens (City Club) Buildings still occupy the same places on Euclid Avenue. (Alan Dutka.)

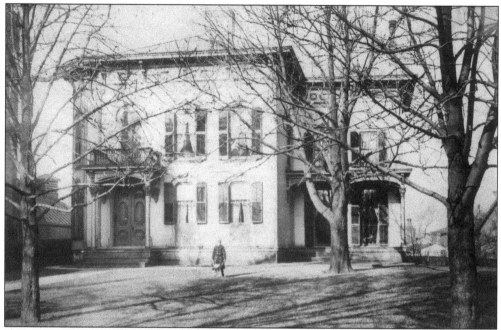

Born in Vermont, Samuel Blake Prentiss settled in Cleveland in 1840. He established a law practice and built this home at 1107 Euclid Avenue in 1844. Prentiss later served as a Common Pleas judge for 15 years prior to his death in 1884 at the age of 87. Early in the 20th century, real estate investor John Hartness Brown constructed a building that encompassed the former Prentiss site. The building is now undergoing a substantial renovation. (Photograph Collection, Cleveland Public Library.)

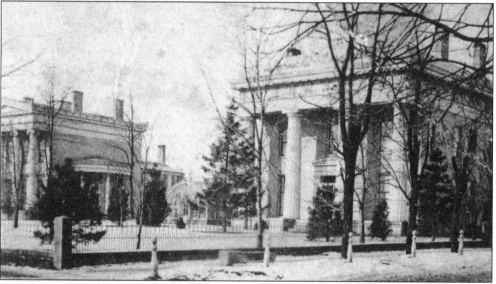

In 1842, Anson Smith, a woolen merchant and produce shipper, built his 1167 Euclid Avenue residence (right). Nine years later, Stillman Witt, a designer of canals, bridges, and railroads, constructed the residence to the left. These Greek Revival homes occupied land at the time considered to be a significant distance from Cleveland's business district. (Photograph Collection, Cleveland Public Library.)

In 1875, Stillman Witt died at sea while traveling to Europe. Nine years later, the Stillman Hotel rose on the site of his demolished home. Set back about 100 feet from the street, the redbrick, eight-story hotel provided lodging for distinguished guests, including presidents Benjamin Harrison and William McKinley, Civil War general W.T. Sherman, and industrialists Andrew Carnegie and Cornelius Vanderbilt. Meanwhile, Col. William H. Harris purchased and extensively remodeled the Anson Smith home (right). (Photograph Collection, Cleveland Public Library.)

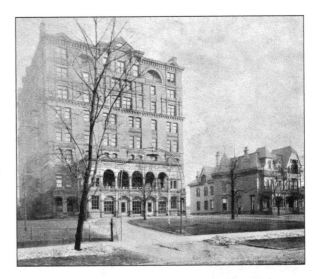

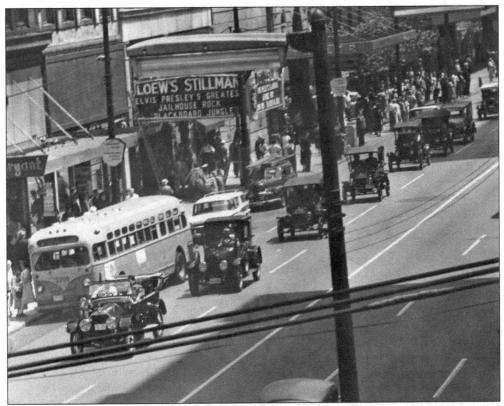

The Stillman Hotel closed in 1901; fifteen years later, the 1,800-seat Stillman Theater began its 47-year tenure on the site. On June 4, 1959, a parade honoring the 50th anniversary of Ford Motor Company's victory in a New York–to–Seattle endurance run passed in front of the theater. The Stillman closed in 1963 for construction of a Statler Hotel parking garage. The former hotel is now an apartment building. (Photograph Collection, Cleveland Public Library.)

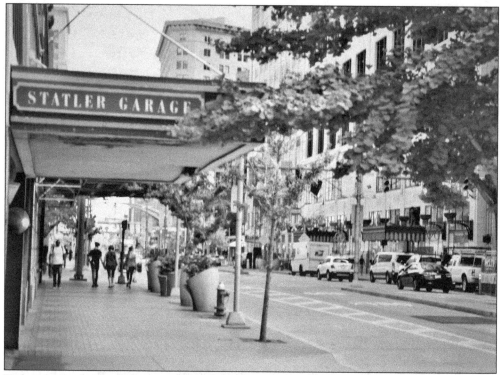

Today, the Statler Arms Apartments are located in part on the combined Witt and Smith/Harris sites. The sign (once the marquee of the Stillman Theater) directs customers to the parking garage. (Alan Dutka.)

In 1889, a Washington's Birthday parade passes 1118 Euclid Avenue (the tall structure with the cupola), the imposing mansion of attorney and coal industry executive David W. Cross, who died two years later at the age of 76. (Photograph Collection, Cleveland Public Library.)

In 1910, the Cleveland Athletic Club convinced a builder already constructing a five-story office building on the former Cross property to add nine additional floors to accommodate the club's relocation from the New England Building. Amenities included a main lobby, 80 sleeping rooms, a gymnasium, a swimming pool, bowling alleys, and an area for gun practice. The windows vary in size by floor, reflecting the organization's diverse activities. The club closed in 2007; the building now houses apartments. The Statler Hotel construction site is in the foreground of this 1911 photograph. (Photograph Collection, Cleveland Public Library.)

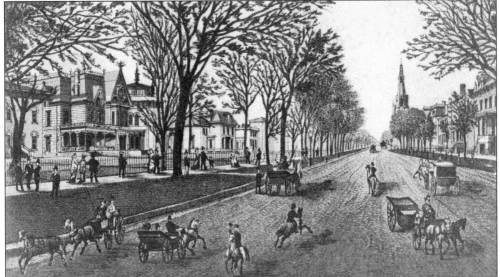

In the 1870s, fine homes anchored the thriving residential section between East Twelfth and East Fourteenth Streets. To the north (left), the mansions of John Hay, Amasa Stone, and Samuel L. Mather exemplified the city's prosperity. The site of the Euclid Avenue Presbyterian Church (right background) is now the Hanna Building at East Fourteenth Street. (Photograph Collection, Cleveland Public Library.)

By the mid-1920s, department stores and office buildings had replaced the once-flourishing residential area. Today, most of these nearly century-old structures still remain part of the Euclid Avenue landscape. (Alan Dutka.)

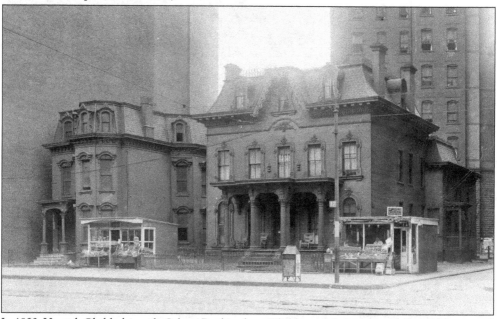

In 1833, Herrick Childs, his wife, Selena Buckingham Childs, and their three small children paused to rest in Cleveland before continuing their anticipated trip from Massachusetts to Chicago. The family settled in a Cleveland home (right) when the exhausted Selena Childs refused to continue the arduous journey. Grocer William P. Southworth constructed his residence next door (left) in 1860. At the extreme left is the west wall of the Halle Department Store; the Wyandot Hotel (facing Huron Road) is in the background. The houses occupied 1200 to 1281 Euclid Avenue. (Photograph Collection, Cleveland Public Library.)

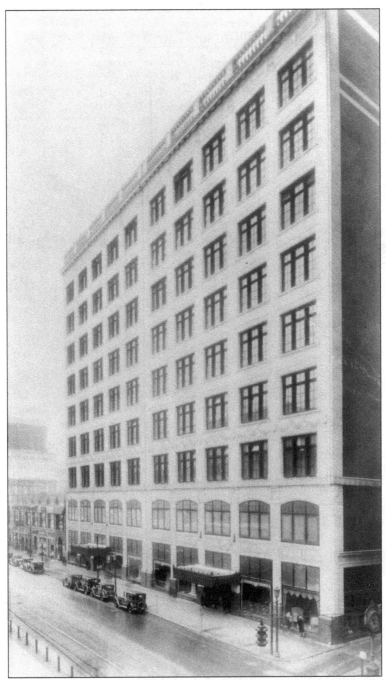

In 1914, the Halle Department Store owners demolished the Childs and Southworth homes to expand their original 1910 store. On the rooftop, employees enjoyed a glass-enclosed and heated area containing a restaurant, kitchen, library, sun parlors, men's smoking room, relaxing rooms, and even a hospital. In 1929, the prominent Halle and Chisholm families united when Walter M. Halle married Helen Chisholm, the great-granddaughter of Cleveland pioneer Henry Chisholm. The building, now comprising offices and apartments, remains a Euclid Avenue landmark. (Photograph Collection, Cleveland Public Library.)

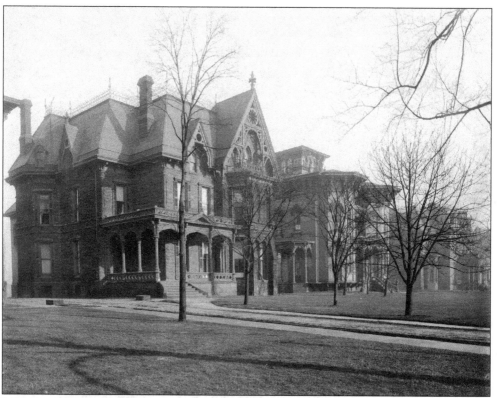

John Hay served as private secretary to Abraham Lincoln, ambassador to Great Britain, and secretary of state under both William McKinley and Theodore Roosevelt. Lincoln supposedly remarked, "Sometimes when I am out, he thinks he's president." In 1875, Hay and his wife, Clara, accepted a mansion (left) at 1235 Euclid Avenue as a wedding present from Clara's father, Amasa Stone (who lived next door to the right). On October 16, 1879, Hay hosted a dinner party for two special guests: then US president Rutherford B. Hayes and his successor, James A. Garfield. (Photograph Collection, Cleveland Public Library.)

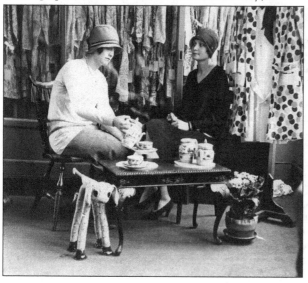

Sterling, Welch & Company, established in 1889, originally specialized in carpets, furniture, draperies, wallpaper and decorative art. The first of Cleveland's larger retailers to locate east of East Twelfth Street, the company built its new store in 1909 on the former John Hay mansion site. In the 1920s, two ladies (left) pause for tea as they shop at the Sterling store. This portion of the later Sterling-Lindner-Davis Department Store (home of the famous annual Christmas tree) was demolished in 1967 and is now a parking lot. (Photograph Collection, Cleveland Public Library.)

In 1858, railroad entrepreneur and bridge designer Amasa Stone erected a 6,500-square-foot Italianate villa at 1255 Euclid Avenue; the exterior required more than 700,000 bricks. A quarter-century later, unable to cope with personal tragedies and business downturns, Stone fired a bullet through his heart while bathing in his plush home. Stone's misfortunes included the accidental drowning of his son, the death of 151 people traveling across a bridge he designed that collapsed in a windstorm, and the failure of three of his businesses. Wreckers demolished the home in 1910. (Special Collections, Michael Schwartz Library, Cleveland State University.)

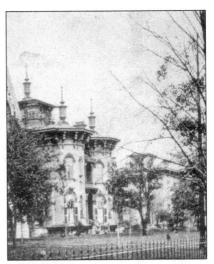

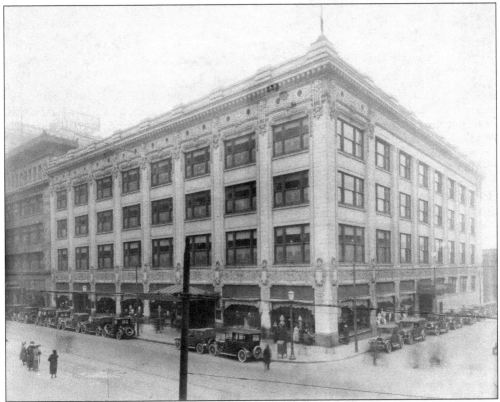

Mirroring his son-in-law's next-door home, the Stone mansion site later accommodated a department store. In 1910, the Higbee Company constructed this four-story building. A fifth floor was soon added. After 1931, when the department store moved to Public Square, the building remained vacant except for an occasional auto show or white elephant sale. Returning to its department store heritage, the structure housed one part of the Sterling-Lindner-Davis Company until its closing in 1968, and it is now an office building. To the left is the since-razed Sterling, Welch & Company portion of the eventual Sterling-Lindner-Davis company. (Photograph Collection, Cleveland Public Library.)

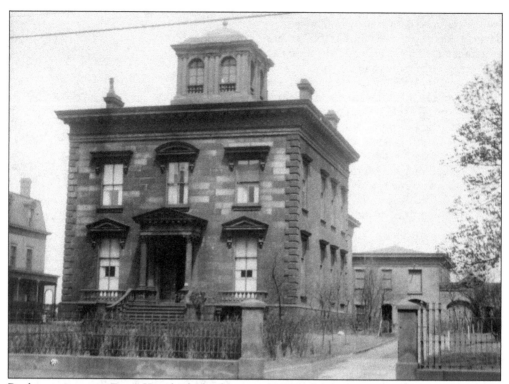

Real estate investor Zenas Kent built this home at 1369 Euclid Avenue in 1858; seven years later, he sold it to Samuel Livingston Mather (the father of industrialist Samuel Mather). An iron ore entrepreneur, the elder Mather lived in the home until his death in 1890. His son William continued to reside there until the Kinney & Levan Company purchased the site to construct a housewares store. Following the company's failure during the Great Depression, the Stouffer Company's headquarters became the building's primary tenant. (Special Collections, Michael Schwartz Library, Cleveland State University.)

Radio station WJW broadcast from the second floor of the Stouffer Building between 1943 and 1956. At this location, Alan Freed used the expression "rock and roll" to describe the music he promoted. Catering to a theater crowd from 1935 into 1972, a Stouffer's restaurant consumed much of the first floor and basement; the Last Moving Picture Company, an eatery and disco owned by the Stouffer family, operated in the same spot later in the 1970s. The remodeled building is now a showcase for public radio and television stations. (Alan Dutka.)

Two

ENTERTAINMENT DISPLACES MILLIONAIRES

EAST FOURTEENTH STREET THROUGH EAST SEVENTEENTH STREET

In 1801, carpenter Samuel Dodge agreed to build Samuel Huntington a barn in the back of a downtown blockhouse constructed as protection against Indian attacks. When Huntington (soon to be governor of Ohio) could not deliver the required $330 cash payment, Dodge reluctantly accepted 110 acres of land to settle the debt. The property fronted Euclid Avenue between East Twelfth and East Twenty-Second Streets and extended north to Lake Erie. In 1804, Dodge built a cabin on what is now the middle of East Seventeenth Street near its intersection with Euclid Avenue. Inheriting an apple orchard as part of his land transaction, Dodge put his new terrain to creative use. Running his oxcart over two troughs of apples, Dodge used a long pole to press the resulting pulp, in the process creating Cleveland's first cider mill. Visitors traveled long distances to marvel at Dodge's mill and purchase a bushel of apples or peaches for $1.25.

Samuel's son Henry later tried to convince Jeremiah Green, one of the world's first photographers, to accept 10 acres of the land as payment for 100 pictures Green had photographed for him. Green carefully inspected the property, his most vivid impression being noise emanating from croaking bullfrogs. The photographer requested the cash option, telling Dodge he didn't need a duck pond. The very next year, Cleveland constructed a sewer, completely draining the Euclid Avenue swamp in the process. A century later, the property's value had soared to $5 million. By 1922, the Playhouse Square theater district consumed most of the Euclid Avenue frontage.

In 1905, a syndicate of investors purchased the Euclid Avenue Presbyterian Church. The shuttered church sat idle and decaying until its demolition in 1913; the land remained vacant for another eight years. Built in 1921, the Hanna office building and theater (the latter located in an annex facing East Fourteenth Street) still attracts theatergoers, business tenants, and, beginning in 2013, apartment dwellers. To the north on Euclid Avenue, demolition of the residences of industrialist Washington S. Tyler and physician Dr. Charles B. Parker, along with the Hotel Fuller (the previous site of the Henry Dodge residence), permitted construction of four splendid playhouses: the Allen, Ohio, State, and Palace. These theaters still incorporate the major portion of the Playhouse Square Theater complex, one of Cleveland's superb treasures. Most of the buildings in this section of Euclid Avenue, the majority constructed in the 1920s, have been meticulously renovated.

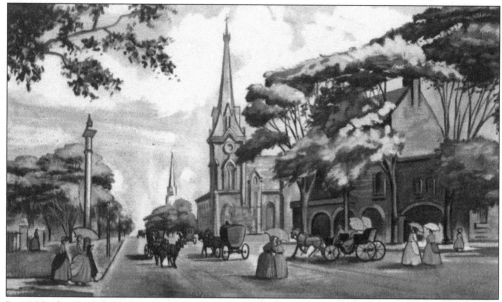

In 1876, the Euclid Avenue Presbyterian Church (center) and Euclid Avenue Baptist Church (center background) framed Millionaires' Row between East Fourteenth and East Eighteenth Streets. (Photograph Collection, Cleveland Public Library.)

By the 1920s, office buildings and theaters had replaced all residential homes on both sides of Euclid Avenue. This photograph was taken in late September, 1948. The major buildings continue to enrich this portion of Euclid Avenue to the present day. (Photograph Collection, Cleveland Public Library.)

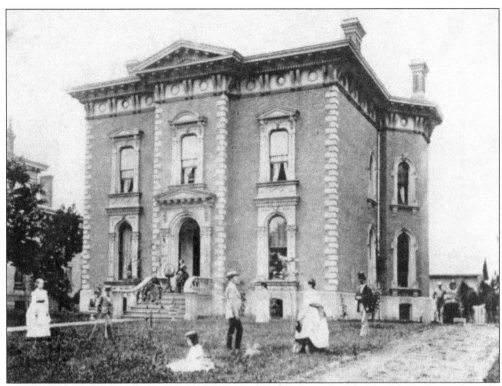

James F. Clark, a hardware store owner with financial interests in coal and railroad companies, built this home at 1415 Euclid Avenue about 1860. When Clark died in 1884, the residence passed to his widow and their adopted daughter, the wife of Washington S. Tyler. As founder of the Cleveland Wire Works, Tyler manufactured steel wire products, screening machines, and elevator cabs. His 10-acre, 24-building manufacturing facility, now known as Tyler Village, has been renovated into a massive mixed-usage facility in Cleveland's AsiaTown neighborhood. (Cleveland Public Library, Photograph Collection)

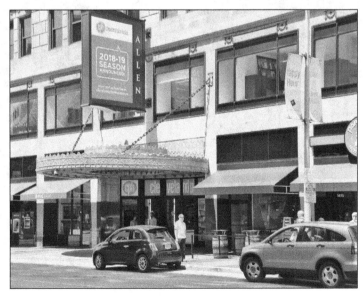

Robert J. Bulkley, a lawyer and politician, constructed the nine-story Bulkley Building on the former Tyler residential site. A 1921 booklet commemorating the building's unveiling referred to its location as "west of Cleveland's Automobile Row," a reference to the vast number of new- and used-car lots then pervading the street. The Allen Theater is the building's major street-level tenant. (Alan Dutka.)

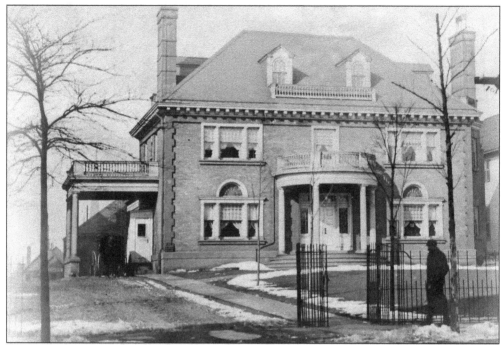

In 1892, prominent physician Charles B. Parker, valedictorian of Wooster University's 1877 medical college class, enlisted Charles Frederick Schweinfurth to design his home at 1521 Euclid Avenue. The noted architect eventually created at least 18 residences for wealthy Euclid Avenue clients. (Photograph Collection, Cleveland Public Library.)

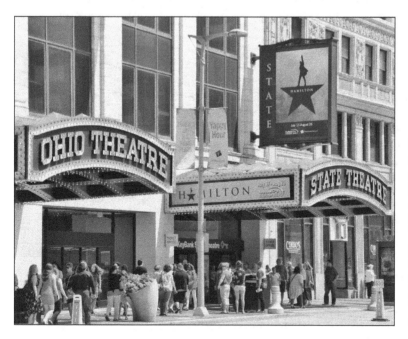

Since 1921, the former Parker residence site has been the home of the Ohio and State Theatres. The renovated playhouses are an important component of the Playhouse Square Theater District. (Alan Dutka.)

The Ohio Theatre's exquisite lobby, photographed in 1921, lay in complete ruins following a 1964 fire. In 2015, the Playhouse Square Foundation combined human craftsmanship with computer scanning and 3D printing technology to create a lobby remarkably similar to the original, even including recreations of three 10-by-30-foot murals. (Special Collections, Michael Schwartz Library, Cleveland State University.)

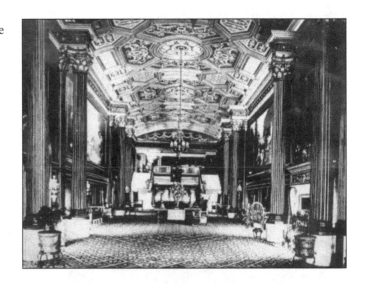

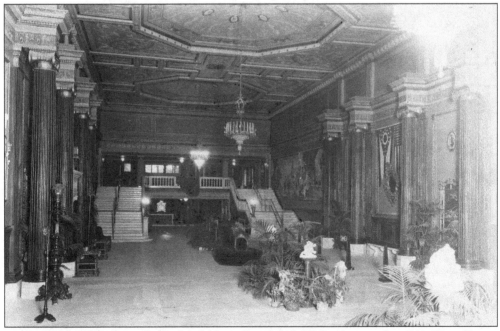

The State Theatre's dramatic 320-foot lobby is depicted above as it appeared in 1921. One of James Daugherty's four large American Modernist murals gracing the lobby is visible to the right. The exceptionally long lobby allowed the theater's marquee and entrance to face Euclid Avenue while the auditorium was constructed behind the next-door Palace Theater site. (Special Collections, Michael Schwartz Library, Cleveland State University.)

Born in 1810, Henry Dodge studied law, invested in Cleveland real estate, and earned political appointments arising from his membership in the Democratic Party. Dodge constructed his home on the northwest corner of Euclid Avenue and East Seventeenth Street at 1605 Euclid Avenue, directly west of his pioneer father's first log cabin. A Euclid Avenue resident for 60 years, Dodge died in 1889. An automobile dealership and, later, a hotel used the land until the construction of the B.F. Keith Building and Palace Theater. (Photograph Collection, Cleveland Public Library.)

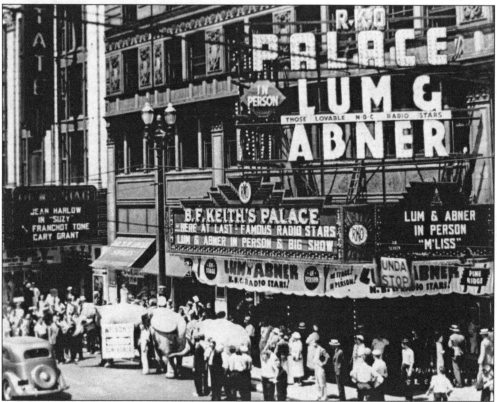

Debuting on November 6, 1922, the Palace Theater has remained one of the country's finest showplaces. The elaborate marquee (shown here in 1936) has disappeared, but the renovated interior is a national treasure. (The Lum and Abner Society.)

Three

WEALTHY LIVING, PARKED CARS, AND CLASSROOM BUILDINGS

EAST EIGHTEENTH STREET TO THE INNERBELT FREEWAY

Euclid Avenue from East Eighteenth Street to the Innerbelt Freeway is now a college campus. The north side is comprised entirely of Cleveland State University buildings; the school's presence also dominates the south side. More often than not, the cycle from mansions to classrooms entailed an intermediate period dominated by parking lots or used-car sales areas.

Beginning the cycle, Nathan Perry Jr. constructed one of Cleveland's earliest homes, surviving for 135 years as Euclid Avenue matured from a dirt road into the city's most important street. In the Millionaires' Row era, Perry's neighbors built some of Euclid Avenue's finest mansions. The homes of Samuel Mather, Henry Devereux, Charles Bingham, Rufus Winslow, Tom L. Johnson, and others stood as testimonials to Cleveland's wealth and importance.

Euclid Avenue's penchant for parked cars began not long after the invention of the automobile and creation of trade-in offers. New automobile showrooms and used-car lots often permeated large sections of the street between downtown and University Circle, although Euclid Avenue just east of downtown fashioned its own special automotive allure. From 1937 into the 1980s, Fenn College and its successor, Cleveland State University, generated an enormous demand for vehicle parking by functioning primarily as commuter schools. Stimulated by both the selling and parking of automobiles, Euclid Avenue's streetscape abounded with automobiles in a state of rest.

In the late 1960s, architectural planning for Cleveland State's expanding campus coincided with violent urban disturbances in Cleveland and other cities. The school's buildings intentionally turned their back to the street, fostering the impression of impregnable fortresses and shaping a rather uninviting campus. In a Plain Dealer article, architectural expert Steven Litt described the school's structural style during this period as "a cross between a prison and a factory." As memories of the urban disturbances faded, the school constructed more inviting glass structures while remodeling some of the earlier buildings to reflect a more welcoming environment.

A few of the exquisite mansions, serving as headquarters for cultural and civic institutions, continued their existence into the 1950s. But construction of the Innerbelt Freeway ended the last contiguous portion of Millionaires' Row. Today, the Samuel Mather mansion, owned by Cleveland State University, remains as the major remembrance of the former Millionaires' Row prominence between Public Square and the freeway.

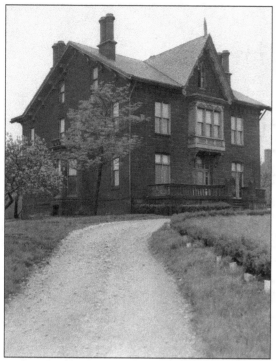

In 1847, Henry B. Payne, an attorney, politician and railroad executive, built this home at 2121 Euclid Avenue next to the childhood residence of his wife, Mary Perry Payne. Civil War general Philip Sheridan and presidential candidate Stephen A. Douglas enjoyed Payne's hospitality. Payne died in his residence in 1896; his widow and other family members continued to live in the home, later selling it to industrialist and philanthropist Dudley Blossom. The Red Cross used the home during World War I, followed by the American Legion until the home's razing in 1941. (Photograph Collection, Cleveland Public Library.)

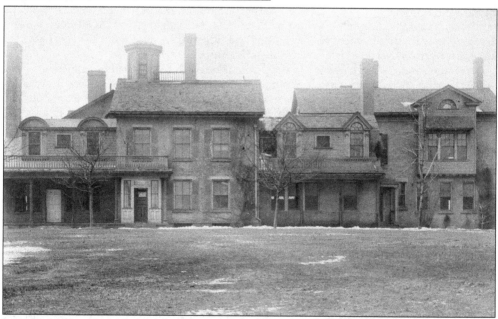

In 1824, Nathan Perry Jr. built his combined home and trading post on a 100-acre wooded lot at 2157 Euclid Avenue extending north to Lake Erie. The future East Twenty-First Street began as a horse path through his homestead. Perry accommodated his growing family by erecting additions to both sides of the home. This image also reflects another substantial renovation by Charles Bingham, a later owner. These modifications satisfied practical requirements but produced an odd architectural mishmash. (Special Collections, Michael Schwartz Library, Cleveland State University.)

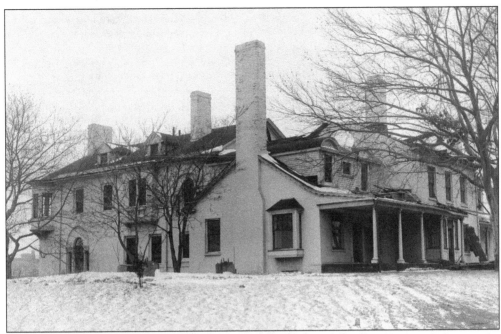

Charles W. Bingham and his wife (the daughter of Henry and Mary Perry Payne) inherited the Perry home. In 1901, the Bingham family relocated to the home from a previous Euclid Avenue address a few blocks to the east. The easternmost portion of the house is not visible in this image. During World War I, the house functioned as a British War Relief facility where "sewing squads" produced clothing and blankets. Through the years, the Red Cross, Visiting Nurses Association, Lake Erie School of Speech Reading, Community Fund, and Girl Scouts all utilized the home. (Photograph Collection, Cleveland Public Library.)

Known as the Perry House, the century-old residence developed into a popular venue for clubs and organizations staging meetings, concerts, teas, dinners, and card parties. Surrounded by trees and engulfed in parking lots, the home remained until its razing in 1959. (Special Collections, Michael Schwartz Library, Cleveland State University.)

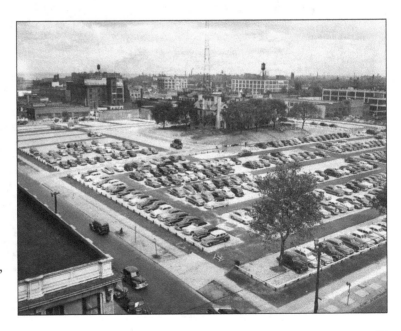

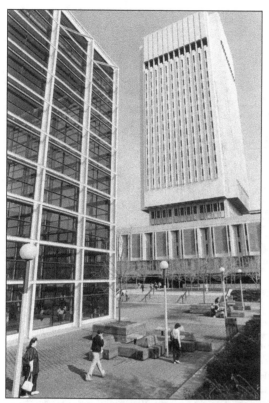

In 1974, Cleveland State University constructed University Center on the combined sites of the Payne and Perry homes. The glass building (left) contained a student union, dining facilities, faculty offices, and conference rooms. Heralded as the new gateway to the university, the structure proved to be an enormous consumer of energy and an uninspired student union design. In 2008, the school demolished the building. (Special Collections, Michael Schwartz Library, Cleveland State University.)

In 2010, Cleveland State introduced a new student center on the site of the former University Center. Designed especially for student activities, the four-floor facility houses the school's bookstore, student lounges, meeting areas, and dining establishments. (Alan Dutka.)

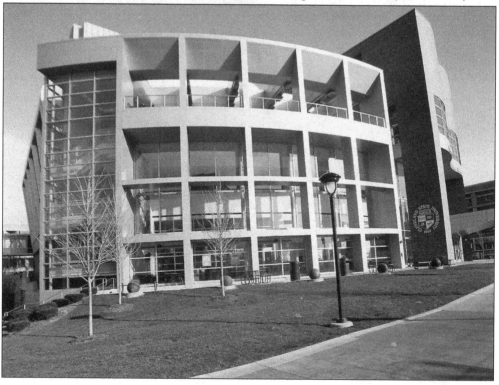

George W. Howe's résumé included bank executive, Cleveland police commissioner, and part owner of the Cleveland Spiders (the forerunner of the Cleveland Indians baseball franchise). Howe built this yellow-brick home at 2248 Euclid Avenue in 1894 and died in 1901; his widow remained in the mansion until 1910. The Howe residence then began a 70-year-existence as an art gallery. (Photograph Collection, Cleveland Public Library.)

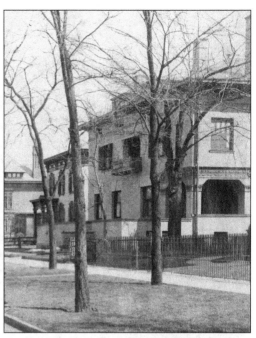

From 1910 into 1935, the George Gage Gallery of Fine Arts, specializing in American Impressionists, assisted wealthy Clevelanders in securing art treasures. Following the Gage Gallery's move to Shaker Square, the Vixseboxse Art Gallery relocated from Euclid Avenue's east-end neighborhood to the Howe home, remaining into 1979, when the company moved to Cleveland Heights. In 1962, portions of an episode of the television program *Route 66* were filmed in the gallery. In 1982, Cleveland State University purchased the former Howe residence, which now houses several university organizations. (Alan Dutka.)

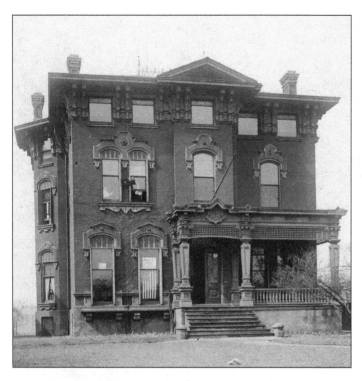

About 1870, Henry Chisholm built a mansion at 2317 Euclid Avenue for his daughter and son-in-law, Alanson T. Osborn, one of the founders of the Sherwin Williams Company. In 1916, a war relief center for French and British troops and citizens operated in the home. Volunteers gathered and shipped clothing, household goods, and raw materials (tin, lead, and platinum) critical to the war effort. In the 1930s, a used-car lot replaced the Osborn home prior to construction of offices for the Arthur McKee Company. (Photograph Collection, Cleveland Public Library.)

The Osborn homesite is now an attractive pedestrian space framed in all four directions by portions of Cleveland State University's urban campus. (Alan Dutka.)

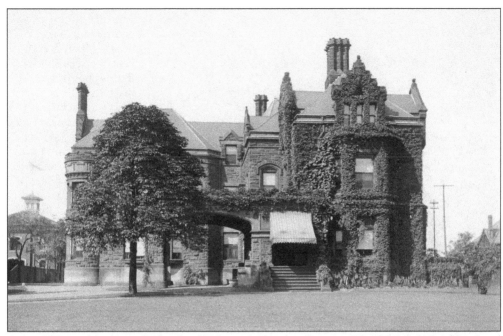

George W. Stockley owned Cleveland Telegraph Supply, a business Charles Brush purchased and incorporated into his Brush Electric Company. Built in 1885 on property once part of Nathan Perry's land, the Stockley mansion at 2343 Euclid Avenue changed owners in 10 years. Tom L. Johnson, an entrepreneur in the transit and steel industries, acquired and lavishly remodeled the residence by adding amenities including an indoor ice-skating rink doubling as a forum for political gatherings when the capitalist reinvented himself as a liberal politician serving in the US House of Representatives and as Cleveland's mayor. (Photograph Collection, Cleveland Public Library.)

Tom L. Johnson sold the mansion in 1911; new owners operated the residence as an apartment house for a brief period. In 1926, Ohio Motors demolished the home to construct a showroom and office building with Johnson's former front lawn forming the nucleus of a used-car lot and gasoline station. The perpetually vacant National Town and Country Club building (later Fenn Tower) is to the right. (Special Collections, Michael Schwartz Library, Cleveland State University.)

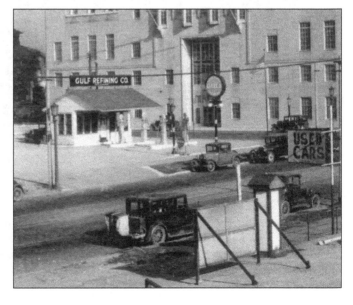

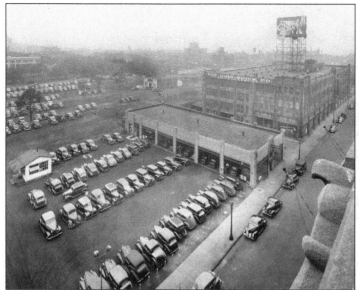

The used-car lot persisted for four decades. East Twenty-Fourth Street is visible in this photograph taken from Fenn Tower. The Ohio Motors Building, in the background, was later transformed into Fenn College's Stillwell Hall. The old Perry home is in the top left portion of the photograph. (Special Collections, Michael Schwartz Library, Cleveland State University.)

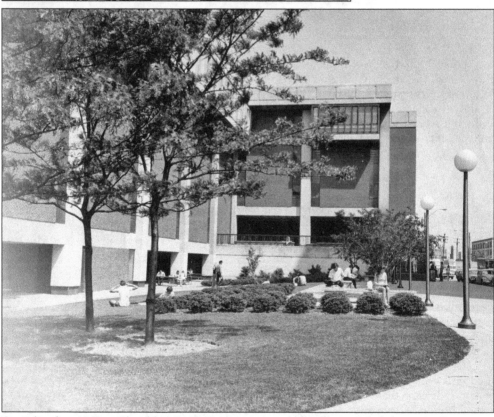

Completed in 1969, a Cleveland State University science building ended the site's 43-year-run as a used-car lot. The building originally provided nearly 1,000 laboratory stations for physics, biology, and chemistry students. During the past two generations, the building has undergone renovations reflecting changes in equipment, technology, and teaching techniques. (Special Collections, Michael Schwartz Library, Cleveland State University.)

Born in Pennsylvania in 1809, Levi Haldeman earned a doctor of medicine degree from Cincinnati Medical College. In 1860, he abandoned a lucrative medical career to develop oil properties. Relocating to Cleveland in 1864, he constructed this home at 2362 Euclid Avenue but sold the property in the late 1870s. A new two-story redbrick home replaced the Haldeman residence. (Photograph Collection, Cleveland Public Library.)

The brick home developed into a commercial property and eventually became part of the Cleveland State University campus. The site now houses a Cleveland State administrative building. (Alan Dutka.)

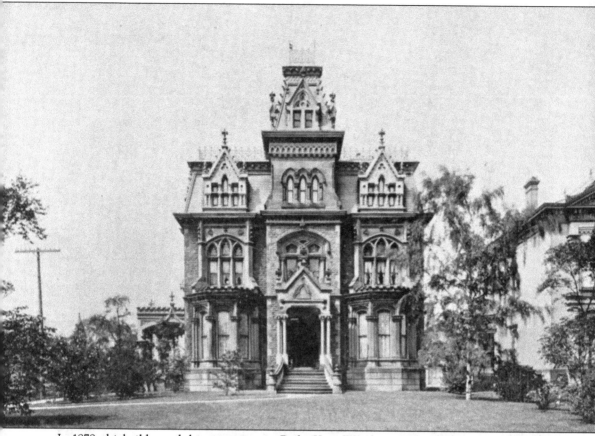

In 1878, shipbuilder and shipping magnate Rufus King Winslow constructed this 18-room high Victorian villa built of multi-colored stone at 2409 Euclid Avenue. The next owner, chemist Herman Frasch, invented a process to extract sulfur embedded underneath quicksand, a methodology generalized to remove all underground sulfur deposits. Standard Oil purchased Frasch's patents, allowing his retirement to Paris. During World War I, the Red Cross used the home to teach classes in first aid, surgical dressing, hygiene, nutrition, preserving food, and baking cherry pies. In 1925, the mansion was razed to construct an ill-fated executive club. (Photograph Collection, Cleveland Public Library.)

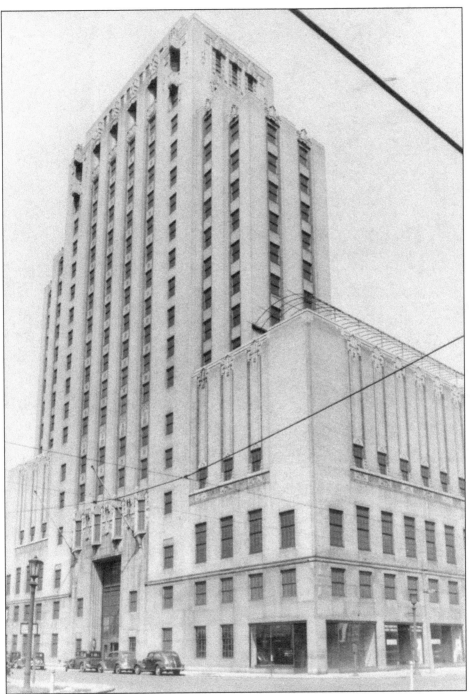

The National Town and Country Club constructed this 22-floor Art Deco homage to business success by targeting Cleveland's "new money" earned by doctors, dentists, lawyers, and merchants. A Depression-era disaster from its inception, the social organization staged one event (a luncheon) before drifting into receivership and obscurity. Fenn College converted the club into classrooms and offices. The failed club building is now a Cleveland State University dormitory. (Special Collections, Michael Schwartz Library, Cleveland State University.)

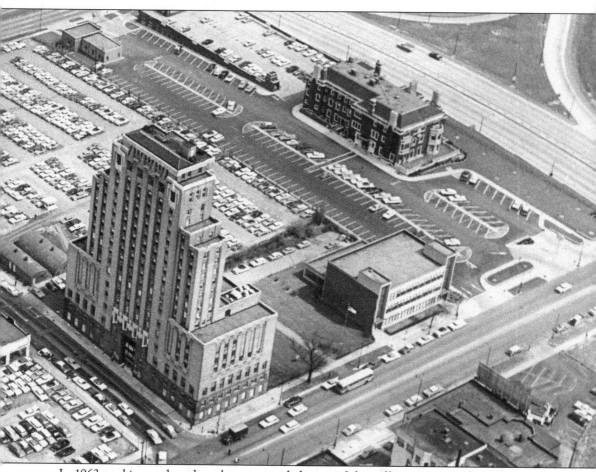

In 1963, parking and used-car lots surrounded most of the college campus. The Claud Foster Engineering Building is between Fenn Tower and the old Samuel Mather mansion. At the top right, a portion of the Innerbelt Freeway is visible. (Special Collections, Michael Schwartz Library, Cleveland State University.)

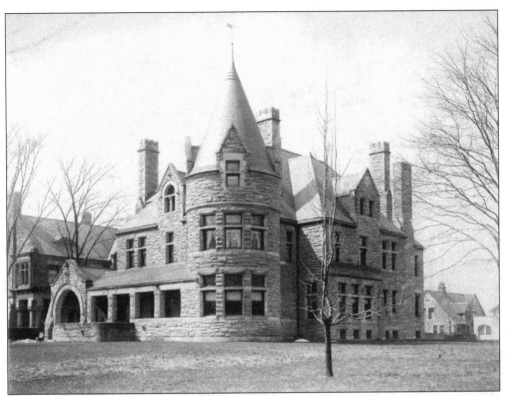

In 1890, railroad baron Julius French built this mansion at 2525 Euclid Avenue for his daughter and son-in-law, Harry Kelsey Devereux. As a child, Devereux posed as the drummer boy for Archibald Willard's famous painting *Spirit of '76*. The son of railroad executive John Henry Devereux, Harry continued in the vocation of his father and father-in-law. When Devereux moved in 1916, the Red Cross used the home as a World War I relief center. Various charitable organizations followed until the home's 1951 demolition. A parking lot replaced the Devereux property. (Special Collections, Cleveland Public Library.)

Cleveland State University's Julka Hall, hosting the College of Education and Human Services and the School of Nursing, sits on the previous front lawn of the Devereux residence. This photograph, taken from the front porch of the next-door Samuel Mather mansion, depicts the back of Julka Hall. (Alan Dutka.)

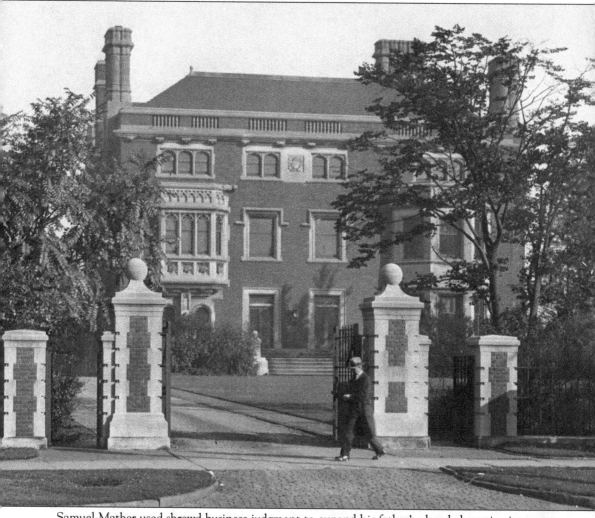

Samuel Mather used shrewd business judgment to expand his father's already-lucrative iron ore and coal mining businesses; this 43-room mansion at 2605 Euclid Avenue testifies to his success. Handmade to Mather's specifications, the outer bricks are duplicates of those used at Harvard University. Completed in 1910, Mather's residence incorporated formal gardens, squash courts, an eight-car garage, and a 65-by-27-foot ballroom capable of accommodating 300 guests. Cleveland State University purchased and meticulously restored the Mather mansion for use as offices and other university functions. (Special Collections, Michael Schwartz Library, Cleveland State University.)

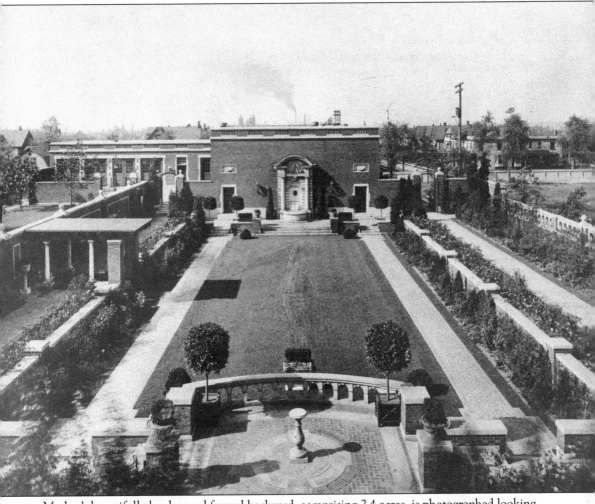

Mather's beautifully landscaped formal backyard, comprising 2.4 acres, is photographed looking south toward the rear of the mansion. The former beautiful area is now a Cleveland State University parking garage. (Photograph Collection, Cleveland Public Library.)

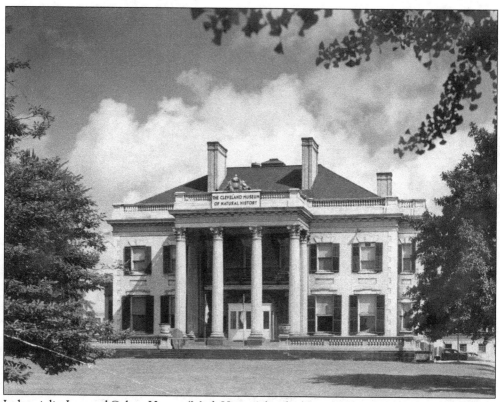

Industrialist Leonard Colton Hanna (Mark Hanna's brother) managed iron ore and coal businesses founded by James Ford Rhodes, Mark's father-in-law. In the early 1870s, not confining his talents to commerce, Hanna played second base for the Forest City Club, Cleveland's first professional baseball team. In 1903, Stanford White designed Hanna's 40-room Georgian mansion at 2717 Euclid Avenue. Following Hanna's death in 1919, the Cleveland Museum of Natural History converted the home into its headquarters. In 1957, the museum relocated to University Circle when construction of the Innerbelt Freeway forced the mansion's razing. (Special Collections, Michael Schwartz Library, Cleveland State University.)

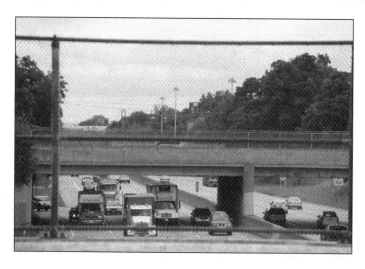

Viewed from Euclid Avenue, the Innerbelt Freeway has replaced Hanna's mansion along with the next-door Hickox home. Opened in 1959, the freeway provides critical and convenient downtown links to Interstates 90, 71, and 77. (Diane D. Ghorbanzadeh.)

48

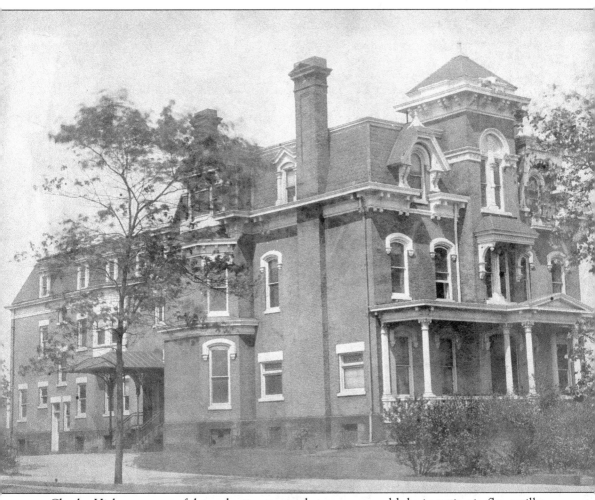

Charles Hickox, a successful merchant, generated even more wealth by investing in flour mills, railroads, banks, insurance companies, and iron manufacturers. His French-inspired mansion at 2727 Euclid Avenue, completed in 1855, included a lawn used for public concerts. Hickox died in 1890; his daughter and son-in-law (Elizabeth and Harvey Brown) then lived in the home, followed by Hickox's son Frank. The Cleveland Museum of Natural History purchased the mansion, converting it into offices and laboratories. In 1958, the Innerbelt Freeway claimed another Euclid Avenue mansion. (Special Collections, Michael Schwartz Library, Cleveland State University.)

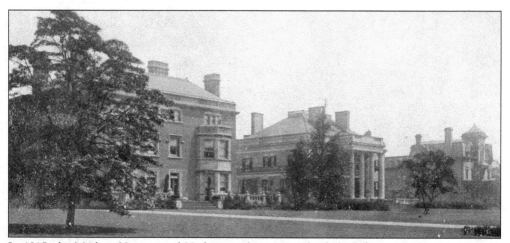

In 1915, the Mather, Hanna, and Hickox residences stood side by side as proud monuments to Cleveland's iron ore, coal, railroad, and banking heritages. (Photograph Collection, Cleveland Public Library.)

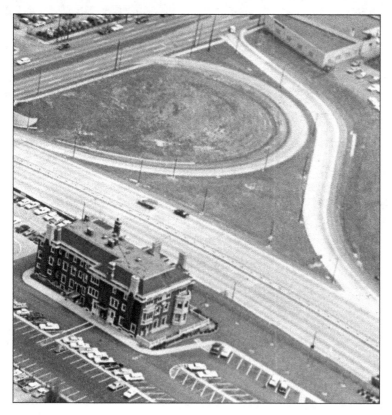

In 1963, the Mather mansion is surrounded on three sides by automobile parking. To the east, the Innerbelt Freeway has consumed the once-neighboring Hanna and Hickox sites. (Special Collections, Michael Schwartz Library, Cleveland State University.)

Four

THE AVENUE'S GRANDEST MANSIONS

THE INNERBELT FREEWAY TO EAST FIFTY-FIFTH STREET

This 28-block segment of Millionaires' Row included the home of John D. Rockefeller, although other residents constructed far more ostentatious homes. Samuel Andrews, once Rockefeller's business partner, built a massive and somewhat peculiar mansion, partly in the futile hope of luring the queen of England as a dinner guest.

Sylvester T. Everett constructed an enormous home visited by four US presidents. The three-floor mansion was filled by 35 principal rooms, 40 fireplaces, 15 bedrooms, and a dozen bathrooms. One room, completely soundproofed and intentionally designed without windows, served as an occasional refuge for Everett's wife, who harbored an unusually intense fear of thunderstorms.

Daniel Eells's palatial home also attracted presidents as guests. Mark Hanna convinced William McKinley to run for president during a meeting in the mansion's library. Charles Brush built a nearly 40,000-square-foot dwelling. Jeptha Wade and his son Randall resided in magnificent side-by-side mansions. Anson Stager's mansion, the only surviving vestige of the street's past glory in this section of Euclid Avenue, is now a children's museum.

Former mansions were converted into a business school, Bible college, and schools providing training for X-ray technicians, practical nursing, and social etiquette for upper-class women. A facility for alcoholic treatment operated in John Rockefeller's former home. At separate times, the Cleveland Institute of Music occupied two former mansions.

Yet even into the 1940s, an occasional event invoked memories of the street's past glories. Second-generation millionaire John Carlin's 1941 marriage created both a grand social event and a revered Cinderella tale. The couple first met in the downtown Guardian Building, where the millionaire practiced law while his future wife operated one of the building's elevators.

Euclid Avenue's decline fostered the spread of apartments, motels, and used-car lots. Construction of the Cleveland Arena inspired the addition of parking lots, bars, and clubs. Beginning in the 1950s, Euclid Avenue witnessed the addition of many new, architecturally uninspiring office buildings, hotels, and motels, the latter often invaded by prostitutes and gamblers.

The illicit behavior has now disappeared. In the past quarter-century, several new organizational headquarters buildings have brightened Euclid Avenue's landscape. The American Red Cross constructed an elegant redbrick structure; Applied Industrial Technologies built a sleek, suburban-styled edifice; the Northeast Ohio Regional Sewer District added a modernistic glass building. Certainly not duplicating the grandeur of Millionaires' Row, this portion of Euclid Avenue has nevertheless regained respectability.

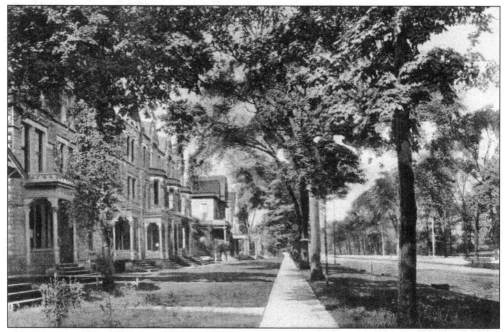

In the 19th century, the Brooks School for Young Ladies and Misses prepared upper-class women for their vital roles in Cleveland society at 2808 Euclid Avenue. In 1886, Anne Hathaway Brown purchased the school, renamed it Hathaway Brown, and relocated it to adjacent townhouses on the south side of Euclid Avenue. When the school moved in 1905, the townhouses embarked on a half-century existence as a hotel. (Alan Dutka.)

An office building constructed in 1958 (left) replaced the townhouses. Looking west, Euclid Avenue now bears no resemblance to its once-scenic, tree-lined procession of fine homes. (Alan Dutka.)

Born in 1843, William Chisholm assumed the presidency of the Cleveland Rolling Mill Company following his father Henry's death in 1881. William lived in this sandstone Romanesque mansion at 2827 Euclid Avenue, built in 1887, until 1905, when he died while purchasing a new coat in a Prospect Avenue tailor shop. Francis E. Drake bought the home following William's death and lived there into 1921. Drake, an executive with Cleveland's Walker Electric Company, also directed the operations of electrical power plants at the 1893 Chicago World's Fair and the Paris Exposition of 1900. (Photograph Collection, Cleveland Public Library.)

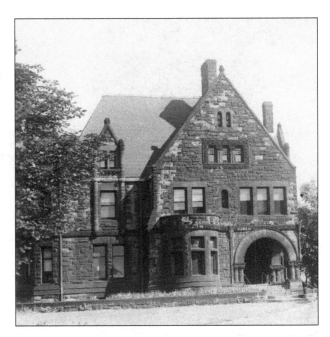

The Chisholm/Drake mansion served as the home of the Cleveland Institute of Music from 1922 into 1932; the building then became the Beaux Arts Building, catering to artists, musicians, and instructors. An apartment building in the 1940s (with a used-car lot in the front lawn), the old home concluded its existence in the 1950s as a dormitory for the Cleveland Bible College. In 1959, an office building replaced the Chisholm/Drake home. It was originally marketed to insurance companies; the current occupant is a financial services company. (Alan Dutka.)

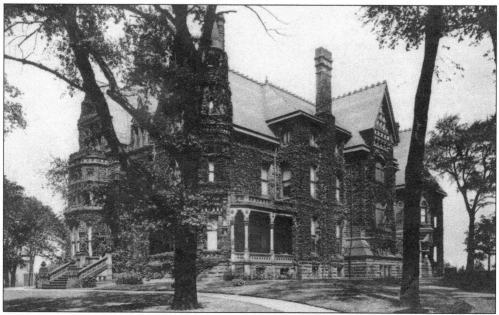

Samuel Andrews cofounded the Rockefeller and Andrews Company, a forerunner of Standard Oil. At Andrews's request, Rockefeller bought out the discontented executive's business interests for $1 million. In an attempt to outshine Rockefeller, Andrews constructed this English Gothic 33-room mansion featuring 13 bedrooms, a large ballroom, servant's quarters, and the first elevator in a Cleveland residential home at 3033 Euclid Avenue. The nearly 100 servants often interfered with each other while maneuvering through an utterly impractical floor plan. The dream palace soon acquired the nickname "Andrews' Folly." (Photograph Collection, Cleveland Public Library.)

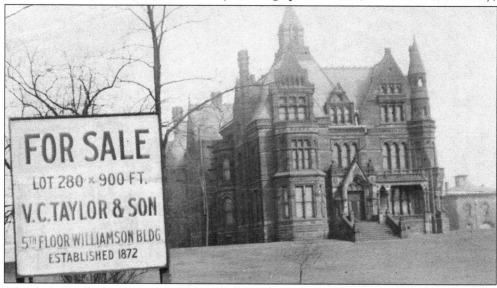

After living in the home for only three years, the Andrews family relocated to New York. The mansion remained mostly vacant, apart from infrequent visits by Andrews's son and more habitual stopovers by homeless people. In 1923, Andrews' Folly suffered its demise after attempts to sell the mansion failed. The demolition brought closure to Euclid Avenue's most unusual and impractical mansion. (Special Collections, Michael Schwartz Library, Cleveland State University.)

While it was mostly vacant for three decades, a gas station and the Hole in One golf course operated on the Andrews site for brief periods. To the right is the Charles A. Otis mansion. (William Barrow.)

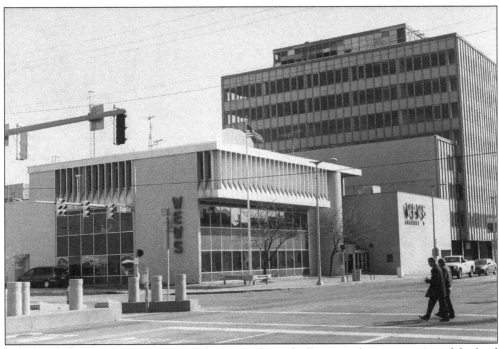

In late 1956, television station WEWS built a studio and office complex on a portion of the land where the Andrews home once stood. Several other buildings also sit on the mansion's former grounds. First broadcasting on December 17, 1947, WEWS is the oldest commercial television station in Ohio and 16th oldest in the United States. (Alan Dutka.)

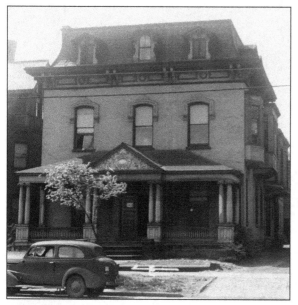

In 1866, George Hoyt, an artist, writer, and *Plain Dealer* vice president, built this yellow-brick home at 3112 Euclid Avenue. Banker Dudley Baldwin Wick later purchased and remodeled the home. Occupying the residence in 1914, the Radium Institute promised relief from rheumatism, gout, neuritis, cancer, and heart disease. In the 1950s, the Beywood Academy trained students for employment as doctors' assistants and X-ray technicians. In between, and throughout much of its 20th-century life, the residence existed as a furnished apartment house, its function in this 1943 photograph. The building was razed in 1956. (Photograph Collection, Cleveland Public Library.)

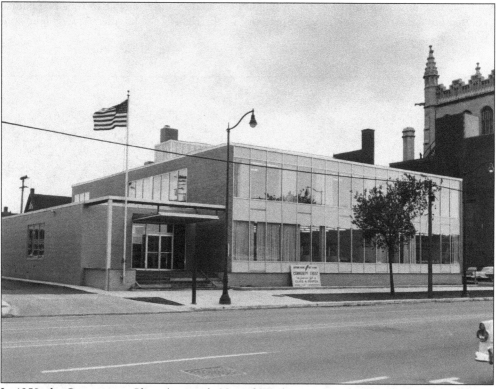

In 1958, the Community Chest (presently United Way) constructed its headquarters on the old Hoyt site. The charity proudly announced that its new nerve center contained super-modern filing cabinets capable of storing thousands of note cards containing past pledge data as far back as the initial pledge effort in 1919. The Positive Education Program, an organization providing individualized care to children and youth who experience emotional disturbances, currently utilizes this building. (Photograph Collection, Cleveland Public Library.)

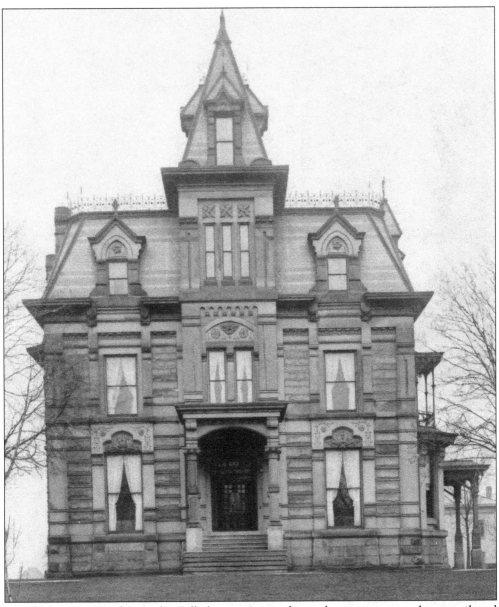

In 1876, banker Daniel Parmelee Eells (an investor in the steel, iron, cement, coke, gas, oil, and railroad industries) built this Victorian villa mansion at 3201 Euclid Avenue. Presidents Benjamin Harrison, James Garfield, and William McKinley all paid visits to Eells's home. In 1893, Warren Holmes Corning purchased the residence for $100,000 when Eells moved to an estate near the Rocky River. Corning earned his fortune as a merchant, operator of his father's distillery, and real estate investor. He died in 1899 after failing to recover from the amputation of his leg. (Photograph Collection, Cleveland Public Library.)

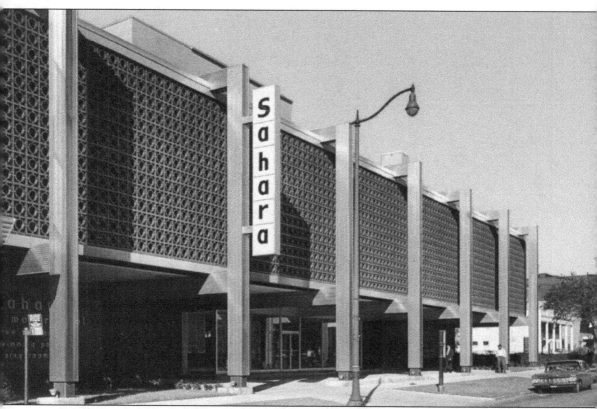

Industrialist Price McKinney, the Spencerian Business College, and Cleveland Bible College all later resided in the old Eells mansion. In 1960, the 150-room Sheraton Sahara Motel replaced the razed mansion. Within two years, Sheraton sold the hotel to the YWCA. Wrecking balls ended the building's existence in 1995. The site is now the western border of the Applied Industrial Technologies (former Bearings Incorporated) corporate headquarters, which encompasses the former sites of five Millionaires' Row homes. (Alan Dutka.)

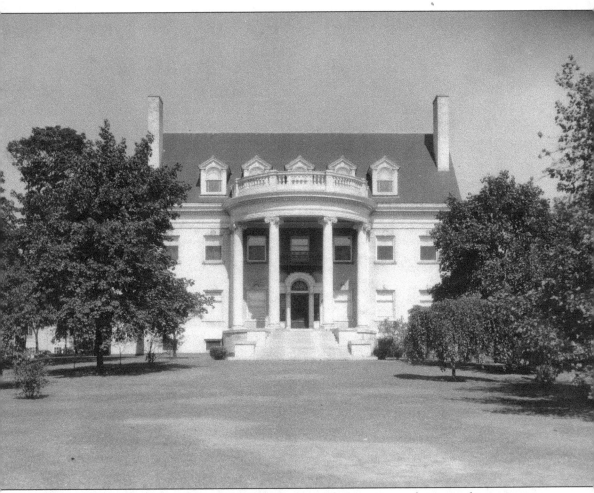

Irish immigrant Anthony Carlin earned his fortune manufacturing steel rivets and investing in Cleveland real estate. Built in 1911, the Colonial Revival mansion at 3233 Euclid Avenue included a bedroom marble chapel and a fish pond in the sunroom. In 1938, his son John inherited the home. John moved to the suburbs in 1950. The mansion endured for another 46 years as the International Ladies Garment Workers Union Headquarters and later as a psychiatric treatment facility. This is the second of five consecutive former mansion sites to become the Applied Industrial Technologies headquarters. (Photograph Collection, Cleveland Public Library.)

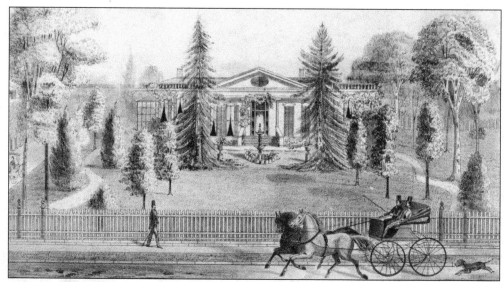

In 1832, dry goods merchant Peter Weddell built this 3333 Euclid Avenue residence. Fifteen years later, Peter died during a trip to the east to acquire furnishings for the then-under-construction Weddell House hotel in downtown Cleveland. His son, Horace P. Weddell, inherited the property but lost control of it following a business scandal in 1884. In 1887, George Willis Pack purchased the mansion. (Photograph Collection, Cleveland Public Library.)

George Pack substantially remodeled the former Weddell home (above) and also constructed a home slightly to the west for his daughter and son-in-law (Mary and Amos McNairy). Pack then commissioned architect Charles F. Schweinfurth to physically combine the houses. In the early 1900s, George's son Charles reigned as one of America's wealthiest men directing the family's lumber and salt businesses. Charles vacated the home after becoming president of the American Forestry Association. The McNairy family owned the residence into 1942, after which it served briefly as an apartment until being replaced by two new motels. (Photograph Collection, Cleveland Public Library.)

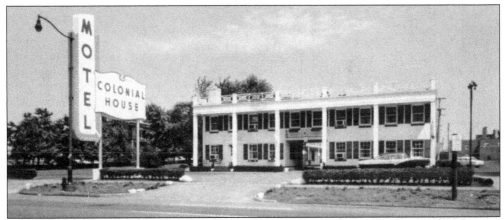

The two-floor, 60-room Colonial House Motel opened in 1950 on the western portion of the former Pack/McNairy residence. By the mid-1970s, widespread deterioration plagued the neighborhood. Police described the motel as "a rat's nest teeming with prostitutes." In 1975, as one example of the hotel's decline, a tenant stabbed and killed his bride of 24 days two years after being paroled for killing his Marine Corps drill instructor. (Alan Dutka.)

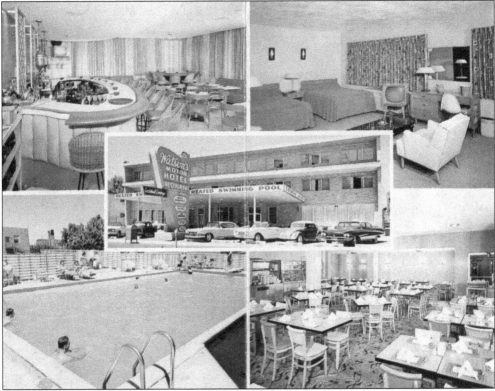

In 1952, financial problems delayed construction of the Watson Motel on the eastern part of the former Pack/McNairy residence. The owners built a parking lot in the interim period. In 1956, the new 24-room motel charged between $7.50 and $15 per day. Three years later, the construction of a third floor added 32 more suites. The motel continued in operation into 1990 using the names Travel Lodge and Guest Lodge. The two motel sites compose the middle part of the current Applied Industrial Technologies headquarters. (Alan Dutka.)

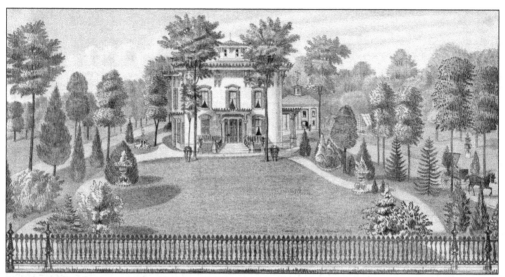

Joseph G. Hussey accumulated his wealth by owning a lake shipping business, a smelting furnace, and an early oil refinery purchased by John D. Rockefeller. In 1860, he built this mansion at 3411 Euclid Avenue. He died of cholera in 1886. (Special Collections, Michael Schwartz Library, Cleveland State University.)

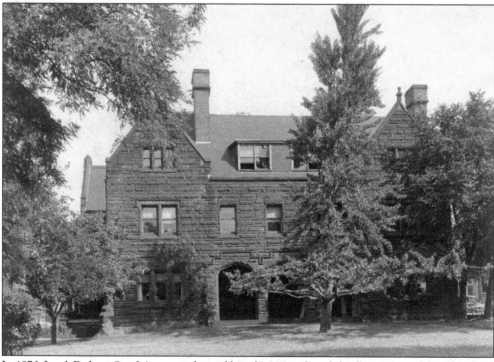

In 1876, Jacob Dolson Cox Jr.'s parents loaned him $2,000 to found the forerunner of the Cleveland Twist Drill Company. Twenty-two years later, Jacob replaced the Hussey home with a new mansion. Cox died in 1930; his family remained on Euclid Avenue for nine more years prior to moving to Bratenahl. From 1940 into 1961, the Cleveland Institute of Music was located in the Cox mansion. The Al Koran Shrine temporarily used the site from 1961 to 1968 after fire destroyed its East Thirty-Sixth Street location. (Photograph Collection, Cleveland Public Library.)

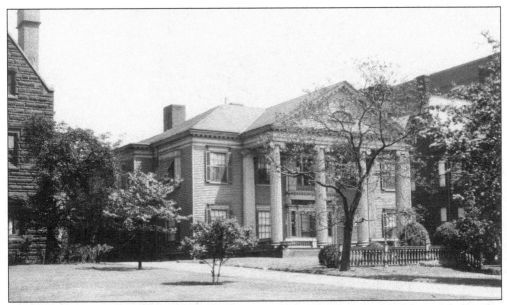

Andrew Squire, a founding partner of the Squire, Sanders & Dempsey law firm, resided in this 27-room Colonial mansion at 3443 Euclid Avenue from 1895 until his death in 1934. Four years later, when Squire's widow died, the Red Cross purchased the mansion. In 1946, a former butler in the home converted it into the Sweden Manor smorgasbord, but he died six months after its opening. The Knights of Columbus and Salvation Army later utilized the home. In 1968, an Al Koran mosque replaced the razed mansion and remained into 1995. (Photograph Collection, Cleveland Public Library.)

In 1997, Applied Industrial Technologies, a leading distributor of industrial products and parts, constructed its headquarters on a four-block, nine-acre stretch of Euclid Avenue. The complex encompassed the contiguous land once comprising the Eells, Carlin, Weddell/Pack, Cox, and Squire mansions. (Alan Dutka.)

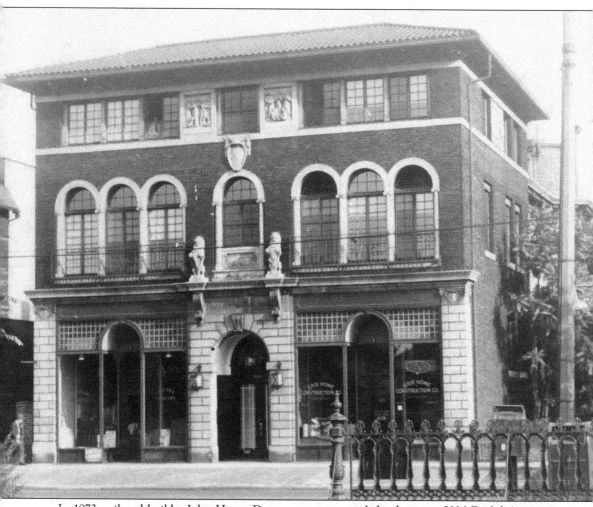

In 1873, railroad builder John Henry Devereux constructed this home at 3226 Euclid Avenue. Forty-eight years later, the remodeled residence enjoyed new life as the Fine Arts Building. Fifty-seven studios attracted painters, sculptors, photographers, architects, musicians, and instructors who offered training in music, voice, languages, drama, and dance. The addition of a false front changed the home's outward appearance, but the solid walnut doors, parquet floors, and stained-glass skylight remained to provide an elegant environment. By the 1950s, the building operated as an apartment house, and it still exists in a deteriorated state. (Photograph Collection, Cleveland Public Library.)

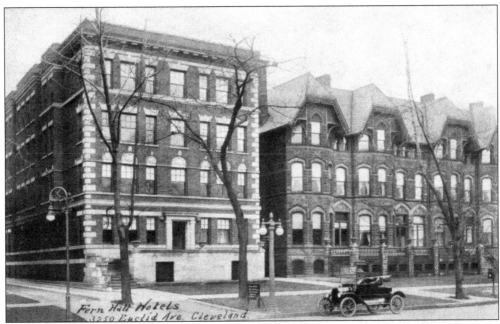

In 1870, Alfred C. Armstrong, owner of a wholesale drug business, constructed the home to the right at 3250 Euclid Avenue. It was substantially remodeled and operated as the Armstrong Apartments after the turn of the 20th century. New owners renamed the building Fern Hall in 1909 and added the structure to the left. Advertising promoted the hotel as "only a short walk from Public Square" and promised "a new high-class family hotel with service in keeping with the location." (Alan Dutka.)

In 1958, Fern Hall became the Colony Motor Hotel. The street-level Biscayne Lounge and basement Downstairs Room employed exotic dancers while collecting citations for harboring prostitutes and staging illegal gambling. A 1970 fire led to the demolition of the motel. In 1973, the Joseph Valenti Building debuted as a home for labor unions. (Alan Dutka.)

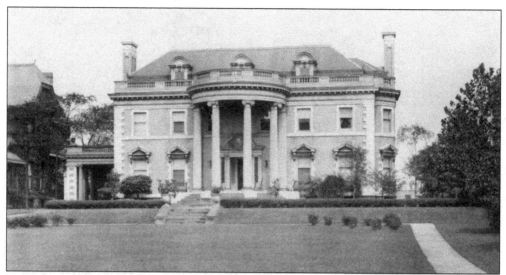

Henry C. Wick continued in his father's banking business, additionally gaining a reputation as an accomplished tennis player. In 1904, he built this classically styled home at 3515 Euclid Avenue. A mere 15 years after the home's construction, Wick moved his house a few hundred feet north to East Thirty-Sixth Street near Chester Avenue to accommodate construction of the Masonic Temple. (Photograph Collection, Cleveland Public Library.)

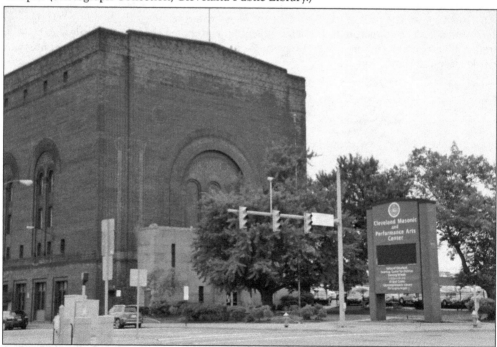

The Masonic Temple debuted in 1921 to serve its members' needs. In addition, Clevelanders have trekked to the temple's 2,250-seat auditorium for nearly a century to enjoy entertainment ranging from John Philip Sousa and Anna Pavlova to Pat Boone and Bill Haley and his Comets. In the 1950s, Bob Hope starred in a live television broadcast from the temple. Much later, Nike filmed one of LeBron James's first commercials in the temple. In 2017, the Masons sold the temple to a private developer, but their presence and the entertainment options continue. (Alan Dutka.)

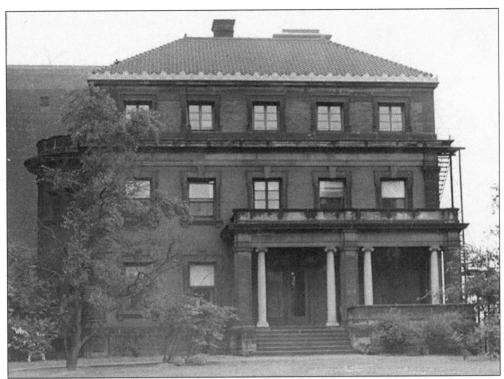

Seventeen-year-old James Jared Tracy Sr. used the Erie Canal and a stagecoach to reach Cleveland from Lansingburg, New York. In Cleveland, his endeavors included banker, capitalist, real estate investor, and civic leader. In 1855, he constructed a home on the later Sterling-Lindner-Davis department store site. In 1904, at the age of 85, Tracy built this home (3535 Euclid Avenue), which he enjoyed for only six years before he died after injuring his head in a fall. This photograph illustrates the home in 1950, near the end of its existence. (Special Collections, Michael Schwartz Library, Cleveland State University.)

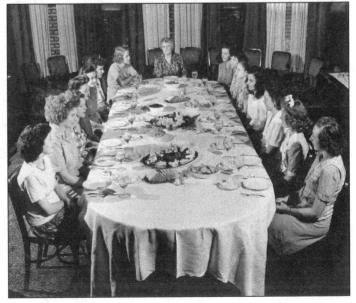

From 1914 into the early 1940s, the Tracy mansion housed the Cleveland Women's Club. In 1943, the home became Bliss Hall, a dormitory for Fenn College female students. This photograph depicts classmates preparing for dinner in 1951, the year of the building's demolition. A parking lot replaced the 47-year-old home. (Special Collections, Michael Schwartz Library, Cleveland State University.)

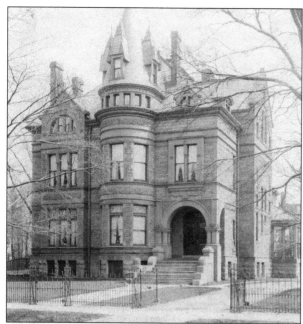

William Chisholm Jr., a member of the family that became leaders in Cleveland's iron and steel industry, constructed this home at 3618 Euclid Avenue about 1889. Dr. William Thomas Corlett, a distinguished dermatologist, later purchased the residence. In the 1920s, Corlett rented the home to the Elks' Club when he moved to East Boulevard. Orchestra leader Guy Lombardo made his first US appearance at the club. From the 1940s into the early 1960s, the old Chisholm home served as a rooming house. (Photograph Collection, Cleveland Public Library.)

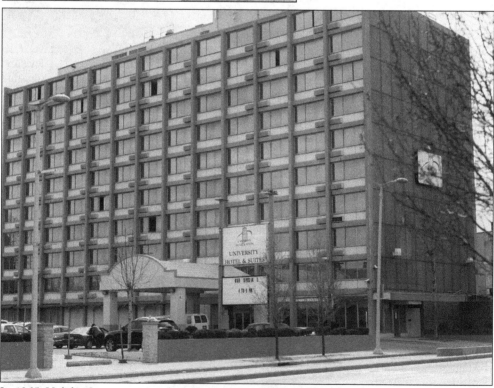

In 1965, Holiday Inn constructed a 10-story, 152-room hotel on the Chisholm/Corlett site. The decor of the hotel's Zappone's 1880s Restaurant incorporated chandeliers, stained-glass windows, and oak doors salvaged from the former home. The hotel later became part of the Sheraton chain, the Shangri-La Inn, a Travelodge hotel, a Best Hotel and Suites, and currently, a Days Inn. (Alan Dutka.)

Seventeen-year-old George Worthington worked as a hardware store clerk in Cooperstown, New York. In 1834, the then-21-year-old relocated to Cleveland, establishing a hardware business. Worthington expanded the company into a national wholesale operation while founding the Cleveland Iron and Nail Company and serving as president of First National Bank of Cleveland. In 1852, Worthington built this Greek Revival home at 3635 Euclid Avenue. He died in 1871, soon after his 58th birthday. In 1951, a parking lot replaced both the James Tracy and George Worthington homes. The lot is now used to park Red Cross vehicles. (Photograph Collection, Cleveland Public Library.)

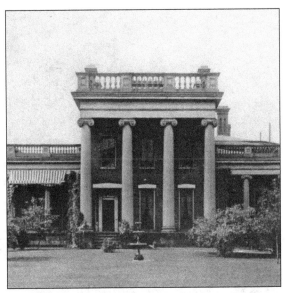

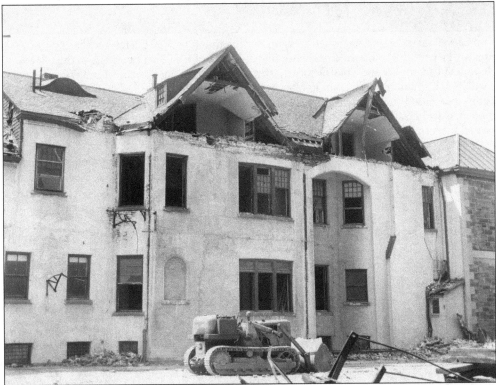

Alfred Atmore Pope resigned from his father's woolen business to invest in and manage Cleveland Malleable Iron, a company providing castings for railroads, wagons, buggies, and farm equipment. Pope constructed this home at 3648 Euclid Avenue in 1895. Upon retirement, he pursued life as a Connecticut gentleman farmer. William P. Leech, publisher of the *Cleveland Leader*, owned the home for several years. It was later reconfigured into a 1920s office building. Wreckers are demolishing the building in this 1963 photograph. A newer office building is now situated on the Pope site. (Photograph Collection, Cleveland Public Library.)

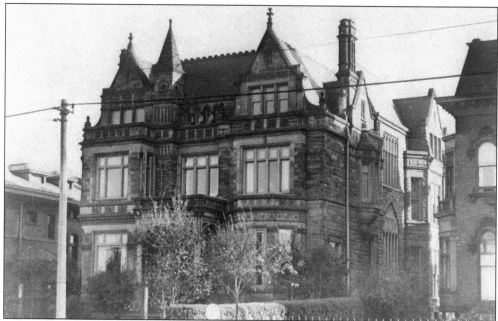

Two Cleveland industrialists owned this graystone mansion at 3730 Euclid Avenue, built in 1881. Stewart Henry Chisholm, the first owner, managed two of his father's businesses, the Cleveland Rolling Mill Company and a nail factory that evolved into the American Steel and Wire Company. In 1908, Chisholm moved about 30 blocks to the east, and Earl W. Oglebay, an iron and steel baron, purchased the 20-room home, relocating 19 blocks east of his previous Euclid Avenue residence. In 1939, the year of this photograph, the Banks & Baldwin Law Publishing Company owned the former Chisholm/Oglebay home. (Photograph Collection, Cleveland Public Library.)

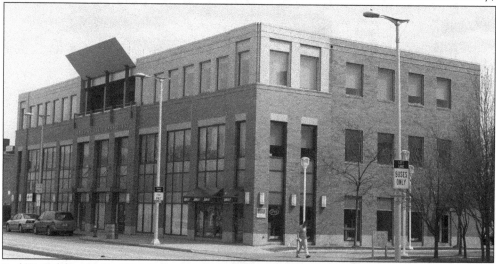

Earl W. Oglebay died in 1926. Later tenants included a health club, hospital, the Graystone Mansion Restaurant, Variety Club, American Legion, and a publishing company. In 1963, the mansion suffered fire damage, leading to its demolition the following year. A parking lot replaced both the demolished Pope and Chisholm/Oglebay mansions. Bearings Incorporated later integrated the site into part of its Euclid Avenue complex. In 1999, the Midtown Corporate Center, a three-story, 25,000-square-foot office building, was built on the then-vacant site. (Alan Dutka.)

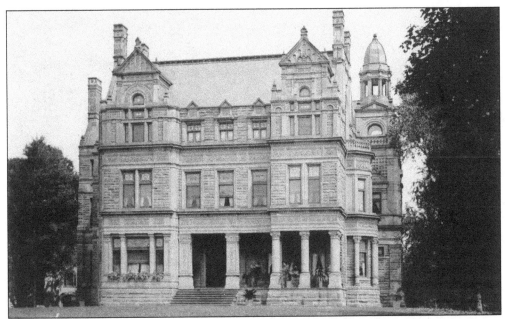

Born in 1849 on a farm about 10 miles east of Cleveland, Charles Francis Brush earned his fortune by inventing and marketing the first practical arc light. His nearly 40,000-square-foot mansion at 3725 Euclid Avenue, accented with Louis Tiffany–designed stained-glass windows, lighting fixtures, and skylights, attested to Brush's affluence. When he entertained guests, the millionaire added a personal touch by playing a massive pipe organ whose first-floor console pipes extended to the mansion's third-floor ballroom. (Photograph Collection, Cleveland Public Library.)

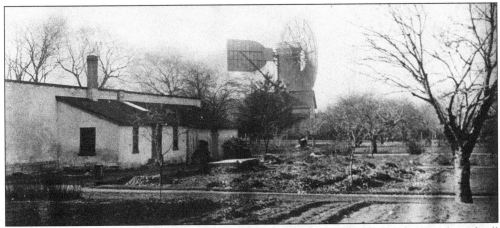

To his neighbors' amazement (and mostly chagrin), Brush designed and built a backyard windmill 56 feet in diameter. The remarkable contraption charged 10 tons of storage batteries, more than enough to generate electricity for the entire home. Rather than subjecting his residence to probable urban decay, Brush specified that the mansion must be torn down upon his death. The forced destruction paved the way for a parking lot followed by one of Cleveland's most memorable sports venues, the Cleveland Arena. (Special Collections, Michael Schwartz Library, Cleveland State University.)

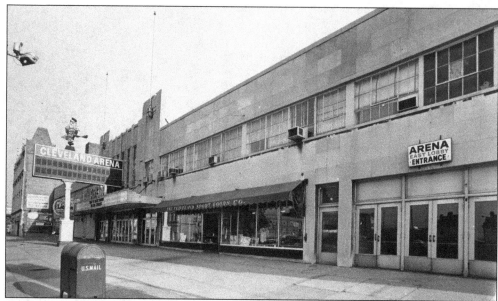

Debuting in 1937, the Cleveland Arena's attractions consisted of hockey, basketball, boxing, wrestling, ice shows, circuses, roller derbies, and six-day bicycle races. Fifteen-year-old Peggy Fleming won the first of her five US skating titles at the arena. Alan Freed's infamous Moondog Coronation Ball developed into a major disturbance. From Howdy Doody to Mick Jagger, concert performers also included Elvis Presley, Doris Day, Bob Hope, and Mae West. Gene Autry, the celebrity record holder for most number of separate bookings, appeared nine times from 1941 to 1957. (Special Collections, Michael Schwartz Library, Cleveland State University.)

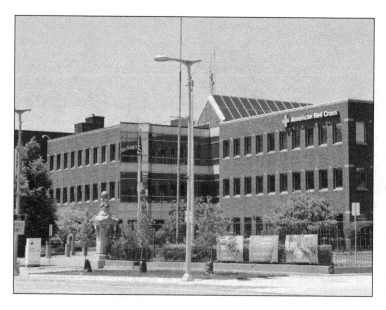

The Cleveland Arena closed in 1974. In 1990, the Cleveland chapter of the American Red Cross constructed its new headquarters encompassing much of the land where the Charles Brush mansion and the Cleveland Arena once stood. (Alan Dutka.)

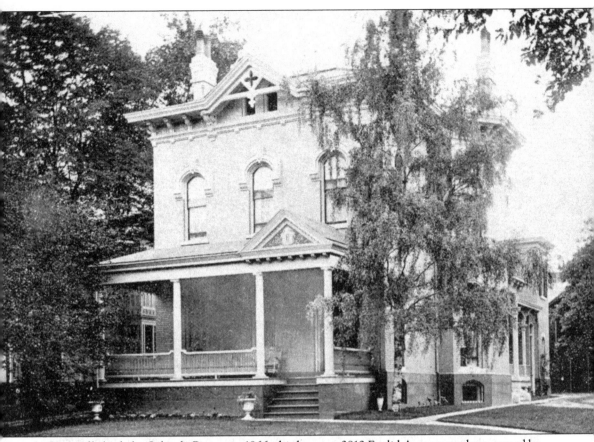

Originally built for Orlando Barnes in 1866, this home at 3812 Euclid Avenue was later owned by William G. Rose. A lawyer by profession, Rose served two terms as Cleveland's mayor (1877–1878 and 1891–1892) and died in his home in 1899. W.S. Kerruish, a prominent attorney, purchased the home in 1903. Following his death, a newly constructed building in 1921 functioned as a sales office and garage for the Craig Motor Company. The building became an office for the National Casket Company from 1930 into the 1970s. The mostly vacant building still exists. (Photograph Collection, Cleveland Public Library.)

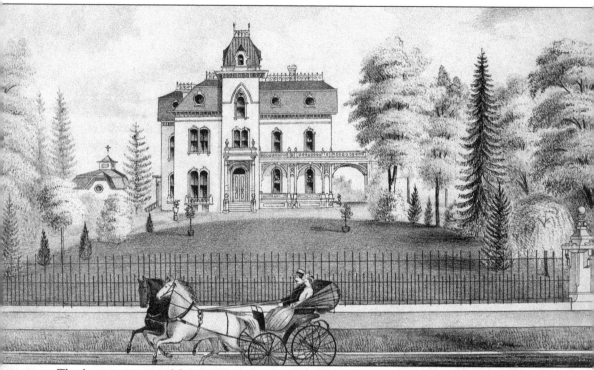

The first two owners of this 10,000-square-foot mansion at 3813 Euclid Avenue spent little time in their majestic edifice. Anson Stager had already amassed 20 years of experience in the fledgling telegraph business when he headed the government's Military Telegraph Department during the Civil War. Acquiring affluence as a cofounder of Western Union, Stager constructed the Second Empire–style home in 1866. Three years later, he relocated to Chicago, assuming the presidency of Western Electric. Thomas Sterling Beckwith, a leading dry goods merchant, purchased the mansion but died within two years. (Special Collections, Michael Schwartz Library, Cleveland State University.)

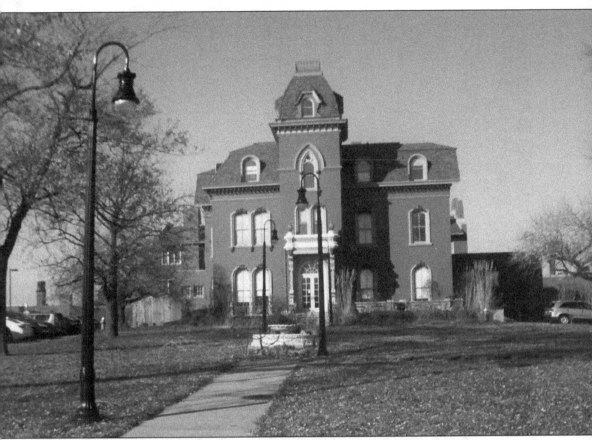

Beckwith's widow lived in the home until she died 25 years after her husband. Living directly to the west, Charles Brush purchased the home from the Beckwith estate to ensure the worthiness of his future neighbor. Spending 13 years in search of the ideal tenant, Brush sold the home in 1913 to the University Club, a social organization that remained for 90 years until it disbanded in 2002. The old mansion is now home to the Cleveland Children's Museum. (Alan Dutka.)

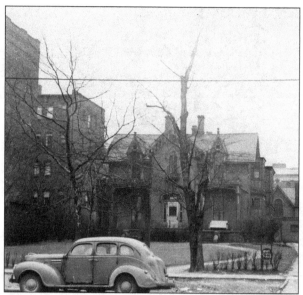

Samuel A. Raymond managed his father's wholesale dry goods business before joining Amasa Stone (his father-in-law) as a real estate investor. Raymond died in 1914; his widow remained in the home at 3826 Euclid Avenue until her death in 1943 at the age of 89. The residence was briefly converted into a rest home (pictured here in 1948 with the Belmont Hotel to the left). (Photograph Collection, Cleveland Public Library.)

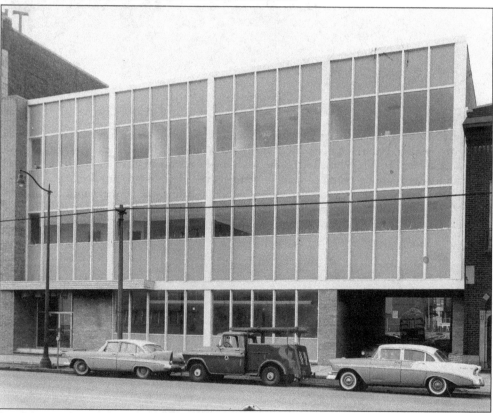

In 1957, wreckers razed the Raymond home to construct this office building initially used by a mortgage company. In the mid-1980s, the Northeast Ohio Regional Sewer District relocated its offices to the building, which was later demolished to allow expansion of the sewer district's headquarters, which now encompasses several blocks. (Special Collections, Michael Schwartz Library, Cleveland State University.)

From 1868 to 1884, John D. Rockefeller resided in one of Euclid Avenue's least pretentious houses, an existing home at 3920 Euclid Avenue previously owned by Francis C. Keith. Following Rockefeller's departure, the Neal Institute used the property to provide alcoholics a three-day treatment centered on the consumption of vegetable substances. The home's next tenant, a short-lived furniture store, soon gave way to an apartment. Following Rockefeller's death, the family sold the home, which was razed in 1938. (Photograph Collection, Cleveland Public Library.)

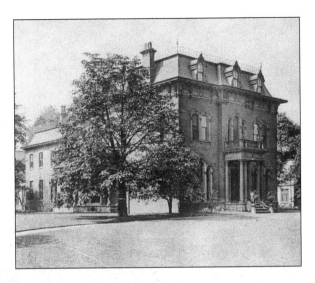

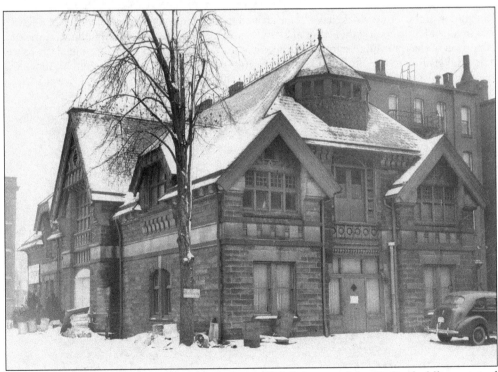

As an active competitor in trotting races down Euclid Avenue, John D. Rockefeller acquired a collection of excellent horses. While he did not participate in designing his family's home, Rockefeller built this elaborate stable in his backyard (facing Prospect Avenue) to house his animals, who resided in a building more ornate than his own residence. (Photograph Collection, Cleveland Public Library.)

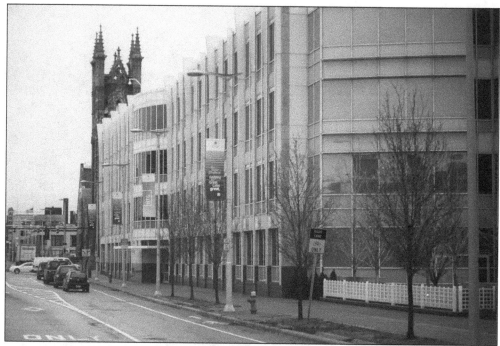

Demolition of the former Rockefeller home created space for a gas station and parking lot followed by a used-car lot. In the 1960s, National Cash Register constructed an office building on the site. A portion of the sprawling Bearings Incorporated industrial complex then consumed the space. The land leading to the St. Paul Catholic Shrine (previously an Episcopal church), including the Rockefeller and Raymond homes, now houses the Northeast Ohio Regional Sewer District headquarters, constructed in 2004. (Alan Dutka.)

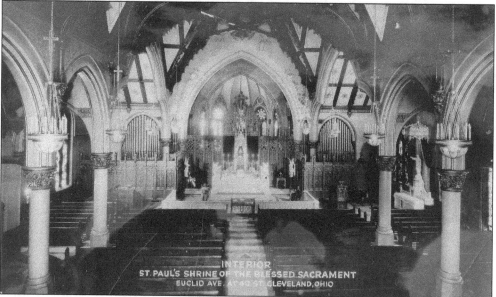

In 1876, the Victorian Gothic St. Paul Episcopal Church anchored one of Millionaires' Row's most beautiful segments. The Catholic diocese purchased the church in 1931 as a place of worship and home for Franciscan nuns. (Alan Dutka.)

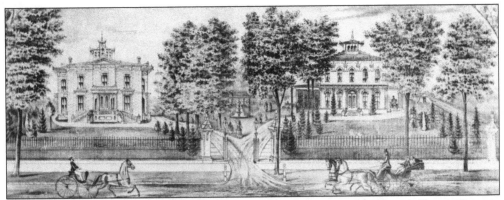

In 1866, Jeptha Homer Wade, president of Western Union, constructed side-by-side Tuscan Country villas for himself (right) and his son Randall Palmer Wade (left) at 3903 and 3917 Euclid Avenue, respectively. On August 16, 1870, Jeptha entertained Pres. Ulysses S. Grant. When Randall died a month short of his 41st birthday, his son Jeptha H. Wade II moved into the home. The elder Wade died in 1890, leaving a stipulation in his will that his house must be razed within a month of his death. The younger Wade died in 1926, and the family vacated that residence. (Photograph Collection, Cleveland Public Library.)

In 1955, the Campus Sweater and Sportswear Company, once the nation's largest manufacturer of men's casual clothing, constructed a large plant on the former Wade properties. In 1982, Cuyahoga County purchased the building for use as the county's department of children and family services. The Jane Edna Hunter Social Services Center is named in honor of the daughter of Southern sharecroppers who, in 1904, completed nursing training in Virginia. Relocating to Cleveland in 1911, she earned a law degree from the Cleveland-Marshall College of Law and gained admittance to the Ohio Bar. (Alan Dutka.)

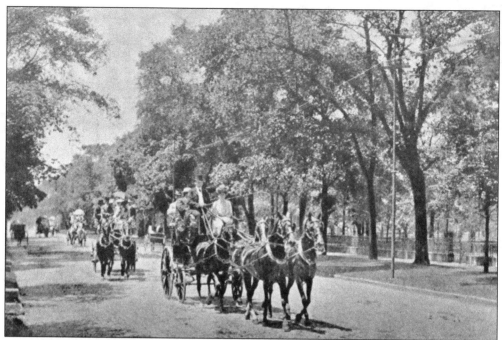

In the first decade of the 20th century, a group of Cleveland's wealthiest citizens formed the Four-in-Hand and Tandem Club. Members drove either four-horse teams with one driver or a two-seated carriage (tandem). In this illustration, the club's leisurely Millionaires' Row jaunt is approaching East Fortieth Street from the west. (Photograph Collection, Cleveland Public Library.)

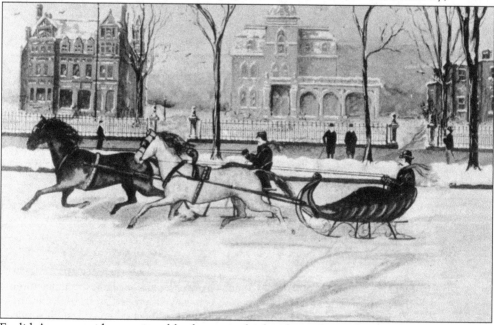

Euclid Avenue residents enjoyed both serene sleigh rides and competitive winter races down the magnificent street. This spirited ride is passing the stately mansions of Charles Brush, Thomas Beckwith, and Randall Wade. (Special Collections, Michael Schwartz Library, Cleveland State University.)

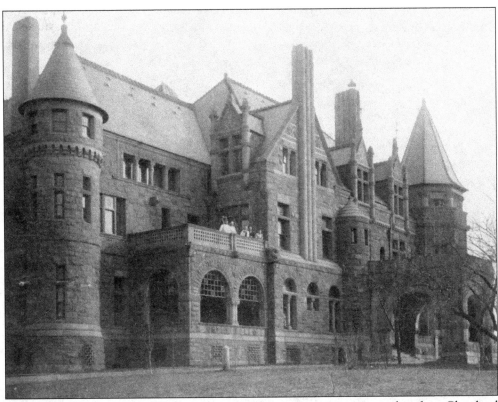

Fourteen-year-old Sylvester T. Everett launched his career as a messenger boy for a Cleveland bank. He subsequently founded the National Bank of Commerce. Everett also pursued interests in iron ore companies, street railways, railroads, and ranch properties. He partnered with Mark Hanna in business ventures and married the granddaughter of Jeptha Homer Wade. His 1883 Romanesque Revival mansion at 4111 Euclid Avenue the dignified street just east of the two Wade homes, one the childhood residence of his wife. This image, viewed from East Fortieth Street, depicts the west side of his home. (Photograph Collection, Cleveland Public Library.)

At least four presidents (Grant, Hayes, McKinley, and Taft) visited the Everett mansion; the list probably also included his presidential friends Harrison and Harding. Banker J.P. Morgan and industrialist Andrew Carnegie also called on Everett. Everett died in 1922. His family sold the mansion, which survived until 1938 as an apartment building with a small golf course embellishing the front lawn. Used-car and parking lots eventually replaced the apartment house. The site today is a parking lot. (Alan Dutka.)

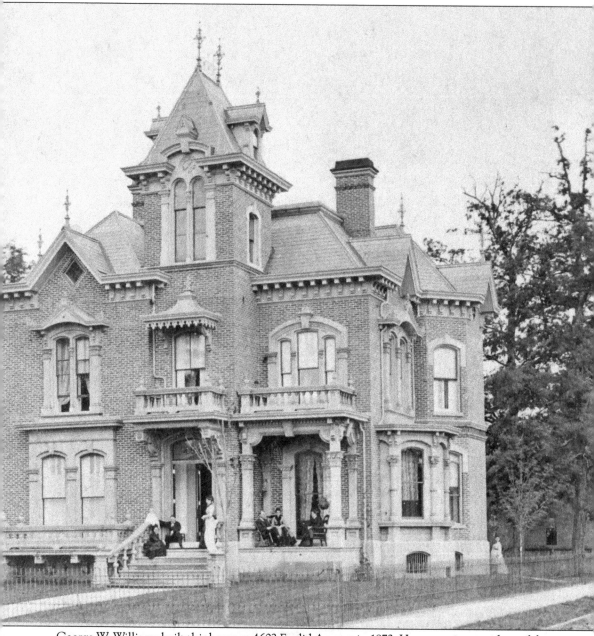

George W. Williams built this home at 4602 Euclid Avenue in 1873. He was a vice president of the E.M. McGillin & Company dry goods store, located on West Third Street. Williams died in 1919 at the age of 74. By the 1920s, the former Williams home and surrounding parcels had all been consumed by new- or used-car lots. In 2010, an office building replaced the mostly vacant two-block segment of Euclid Avenue that had included the Williams residence. (Special Collections, Michael Schwartz Library, Cleveland State University.)

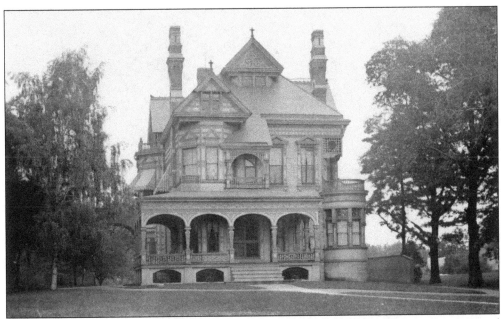

Judge Stevenson Burke resided in a Queen Anne–inspired home at 4811 Euclid Avenue constructed in 1882. An attorney working primarily in the railroad industry, Burke also held executive positions in manufacturing and railroad businesses. Opening in 1916, the privately owned Euclid-Forty-Sixth Street Market replaced the Burke residence and additional land to the west. Only three years later, an automobile showroom consumed much of the unsuccessful market. The remaining smaller market closed in 1934. Prior to the building's 1965 demolition, tenants included a restaurant, barbershop, dance studio, and the Carnegie Institute of Practical Nursing. (Photograph Collection, Cleveland Public Library.)

The Burke site is now the Regional Transit Authority (RTA) Paratransit Center (left) and Salvation Army Adult Rehabilitation Center (right). The RTA facility provides door-to-door travel service for disabled persons. The rehabilitation center offers spiritual, social, and emotional assistance to drug addicts and others unable to cope with problems. (Alan Dutka.)

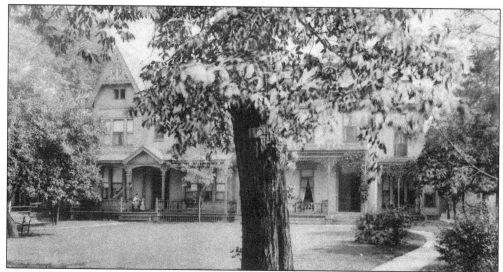

The Charles H. Gill (right) and Levi H. Malone (left) residences, at 5004 Euclid Avenue and 5012 Euclid Avenue respectively, resembled a duplex, intentionally constructed in 1875 so the two families would have easy access to each other. Malone founded the Malone Stone Company. Gill toiled as a piano player and magician in the Barnum Circus before achieving financial success in the lumber business. The pair of industrialists married two daughters of Cleveland shipbuilder Thomas Quayle. (Photograph Collection, Cleveland Public Library.)

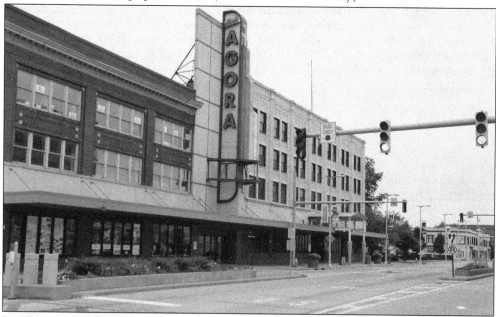

In 1913, construction of the Metropolitan Opera House necessitated razing both the Gill and Malone homes. The approximately 2,000-seat theater, debuting with a production of *Aïda*, quickly introduced silent movies and live entertainment ranging from Yiddish theater to boxing matches. The Metropolitan closed in 1948; radio station WHK used the facility as a studio and auditorium from 1950 into 1977. In 1984, the old playhouse briefly functioned as the New Hippodrome movie theater, followed by the still-existing rock-oriented Agora Theatre. (Photograph Collection, Cleveland Public Library.)

Five

ELEGANCE, DECAY, AND REBIRTH

BEYOND EAST FIFTY-FIFTH STREET

The neighborhood east of East Fifty-Fifth Street expanded slowly, hindered by the lack of reliable and inexpensive transportation. In 1818, a solitary frame house stood in a small clearing later to become East Fifty-Fifth Street. Near the future East Seventh-Ninth Street, a combined residence and tannery, along with Timothy Watkins's 17-acre farm, constituted the only buildings on Euclid Avenue between East Fifty-Fifth Street and the Doan's Corners neighborhood centered near East 105th Street.

In 1850, construction of a railroad crossing and later train depot at East Fifty-Fifth Street's intersection with Euclid Avenue sparked commercial growth while simultaneously discouraging residential development. Yet even though business dominated the immediate area bordering East Fifty-Fifth Street, a fashionable residential neighborhood rose 10 blocks to the east.

In 1866, Steven Harkness constructed a stylish home. A year earlier, Rollin White built the first of the White family's several Millionaires' Row mansions. Alvah Bradley joined the neighborhood in 1870. In the 1880s, Thomas H. White, David Norton, and Morris Bradley added beautiful residences. The next decade welcomed John Severance, Louis Severance, William B. White, Henry Windsor White, Dan Hanna, and Ambrose Swasey. Even as the residential neighborhood faded and land prices soared, James Corrigan constructed a fine home in 1907. Three years later, Francis Drury built one of the street's most extravagant mansions.

In the half-century between 1850 and 1900, the price of land near East Seventy-First Street increased from $80 to $30,000 per acre. Not three quarters of a century later, the *Plain Dealer* (August 9, 1964) described the intersection as "frequented by prostitutes, drug addicts, shoplifters, drunken rollers, blackmailers, con artists, and female impersonators." The demise of Millionaires' Row led to a proliferation of used-car lots, decaying apartment buildings, cheap hotels, sleazy bars, and pornographic movie theaters.

In the 1990s, the neighborhood's turnaround gathered momentum. The once ubiquitous used-car lots disappeared completely as the pre-owned automobile business followed its clients to the suburbs. In the past 20 years, the razing of decrepit buildings, renovation of attractive structures, and new construction have attracted high-tech research organizations and other businesses, along with health care facilities and residential housing. A diminishing number of still empty fields patiently await their conversion to a future calling.

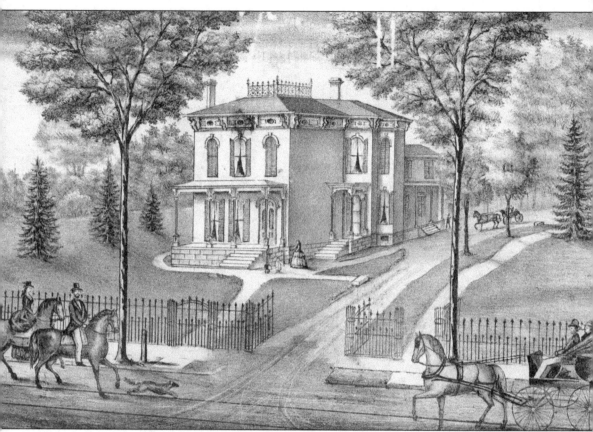

Alva Bradley purchased his first pair of boots with money he earned chopping wood. In 1835, at the age of 21, he left his parents' Lorain farm with all his possessions wrapped in a handkerchief. Securing employment as a deckhand on a schooner, Bradley eventually became a major shipbuilder. In 1870, he constructed this 6218 Euclid Avenue residence, where he died in 1885. During the 20th century, light industrial companies made use of the Bradley site. In 1995, Pierre's Ice Cream Company constructed a headquarters and distribution center on the land. (Photograph Collection, Cleveland Public Library.)

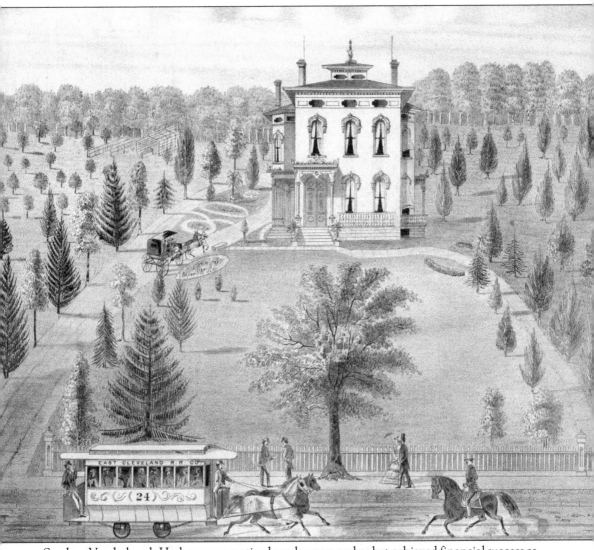

Stephen Vanderburgh Harkness apprenticed as a harness maker but achieved financial success as a distillery owner. His partnership with John D. Rockefeller in the oil-refining industry created almost unbelievable wealth. In 1866, he constructed this stately Italianate villa. When Harkness moved to New York, Dr. Perry L. Hobbs purchased the home at 6508 Euclid Avenue, living in it for 40 years until his death in 1912. In the 1920s, the razed home provided land for a large used-car lot. The site now consists of vacant land and a deserted 1950s-vintage building. (Photograph Collection, Cleveland Public Library.)

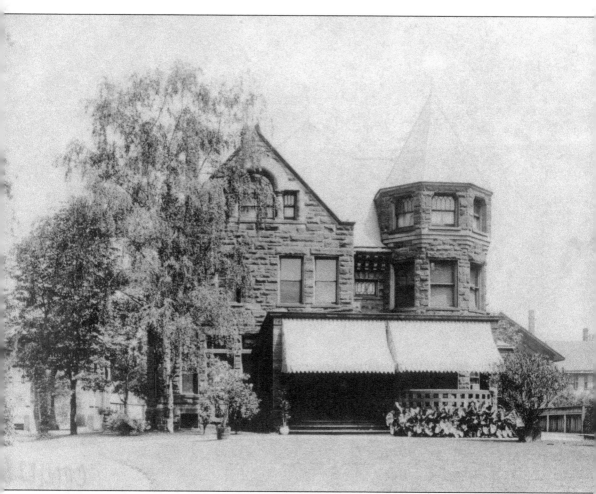

In 1891, Phineas M. Spencer, a vice president of Cleveland National Bank, constructed this home at 6513 Euclid Avenue, which was demolished within 20 years. After Spencer's death in 1907 at the age of 63, a commercial building replaced the home. (Photograph Collection, Cleveland Public Library.)

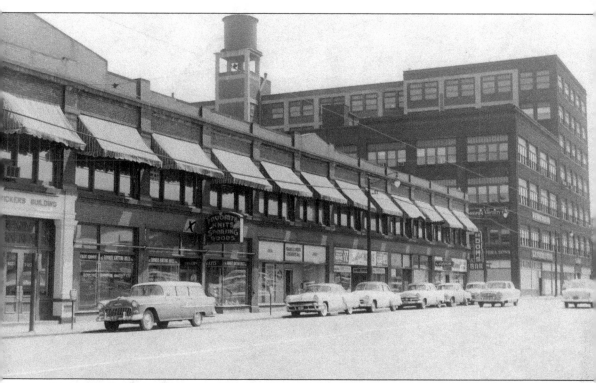

Replacing the Spencer home in 1911, the Vickers office building attracted diverse ground-floor tenants including a butter and eggs store, a furrier, an electric lamp store, a retail tire shop, and a printing company. In the 1920s, upper floors incorporated meeting places for the East End Psychology Club and the Cleveland chapter of the Theosophical Society. In 1922, the landmark Vixseboxse Art Gallery opened its first studio in the Vickers Building. By the 1950s, apartments constituted the building's major revenue. The site is now a vacant lot. (Photograph Collection, Cleveland Public Library.)

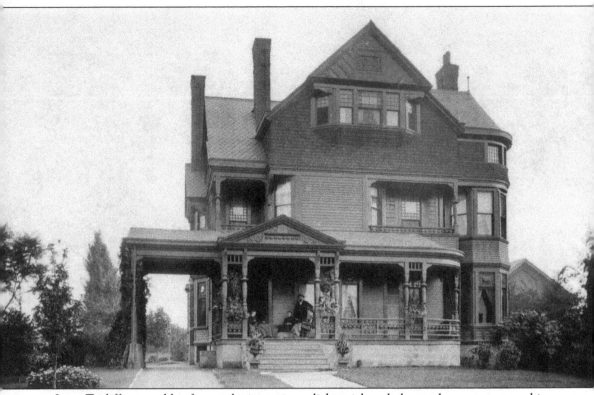

Isaac Topliff amassed his fortune by inventing a lightweight tubular steel component used in building carriage tops. He remained in his 6602 Euclid Avenue home, built in 1885, until his death in 1904. His widow continued living in the home until 1914, when she relocated to the Knickerbocker Hotel, also on Euclid Avenue about 20 blocks to the east. (Photograph Collection, Cleveland Public Library.)

An automobile showroom replaced the Topliff home. By the 1950s, the Big Store promoted itself as Cleveland's largest indoor used-car showroom. Beginning in 1958, General Motors owned the building for 10 years, followed by the United Electric Supply Company's 18-year stint. In 1988, Gallucci's Italian Food Market, displaced by the downtown Gateway project, relocated here. A large set of double doors, once used to drive automobiles into the showroom, is now a customer exit to a parking lot. A small balcony, utilized to finalize deals during the automobile showroom period, is now a storage area. (Alan Dutka.)

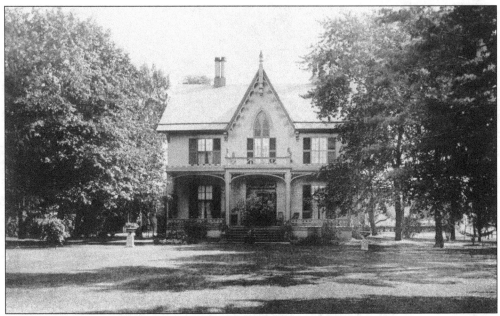

Pioneering dry goods merchant Alexander Sackett arrived in Cleveland from Sackets Harbor, New York, traveling about 400 miles on horseback. He constructed his 6700 Euclid Avenue home in 1852 and died in 1884. Starting in the late 1920s and continuing for more than 65 years, used-car lots prospered on the property. (Photograph Collection, Cleveland Public Library.)

In 2010, reflecting the encouraging trends in this portion of Euclid Avenue, the $21-million Midtown Tech Park opened as a 128,000-square-foot facility. Expanding east from the former Sackett property, the suburban-style brick-and-glass complex was created to attract start-up technological companies. (Alan Dutka.)

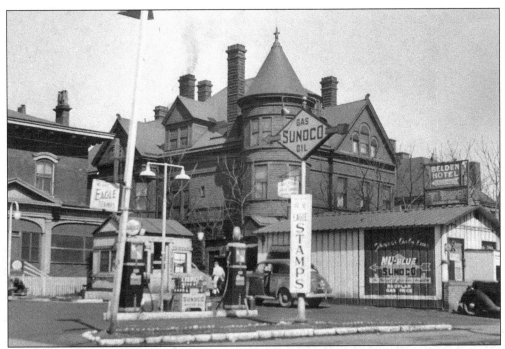

In 1931, used cars marred the front lawns of the Harry Wheelock King mansion at 7003 Euclid Avenue (right) and the George Shelley Russell home at 7011 Euclid Avenue (left). King, who managed his father's bridge construction company, sold his residence to an entrepreneur who converted the home into an illegal brewery during Prohibition. For more than half a century, banker George Shelley Russell resided in his home. By 1941, Sunoco had constructed a gas station in the spacious front yard. Dr. Homer W. Osborne, a cofounder of Huron Road Hospital, lived to the far right. (Special Collections, Michael Schwartz Library, Cleveland State University.)

The King and Russell residences, recast as apartments until their 1949 razing, paved the way for a more extensive automobile showroom and used-car lot. Existing as a 15-unit apartment from the 1920s into the early 1960s, the Osborne residence evaded the wrecking ball until 1963, when the land joined its eastern neighbors to form an even bigger used-car operation. In 1978, Cuyahoga County constructed a transportation center for the board of mental retardation on the land where the King, Russell, and Osborne families once resided. (Alan Dutka.)

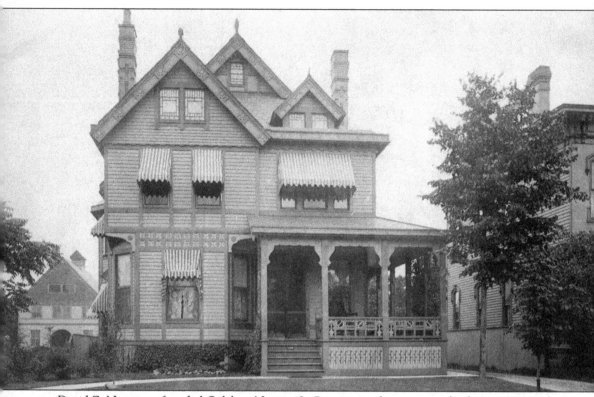

David Z. Norton cofounded Oglebay, Norton & Company, a business involved in mining and shipping iron ore. He lived in this home at 7023 Euclid Avenue from 1884 until his 1897 move three blocks to the east. The home functioned as a private residence, music school, doctors' offices, furniture store, funeral parlor, and apartment building until its demolition in the 1940s. The Norton site served as a used-car lot for Central Chevrolet in the 1950s and 1960s, prior to construction of a still-existing but vacant office building. (Photograph Collection, Cleveland Public Library.)

In 1825, attorney Thomas Bolton arrived in Cleveland, a town of less than 2,500 people at the time. Bolton built this home at 7030 Euclid Avenue in 1850. His farmland extended from Euclid Avenue south as far as Woodland Avenue. Bolton died unexpectedly in 1871, but his wife remained in the home until her death in 1914. By then, the neighbors' grazing cattle and swaying corn had been replaced by business blocks. Charles, the Boltons' son, moved the home, piece by piece, to Mentor. He died in 1930 while still enjoying the Mentor residence. (Photograph Collection, Cleveland Public Library.)

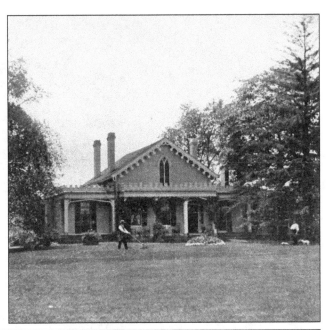

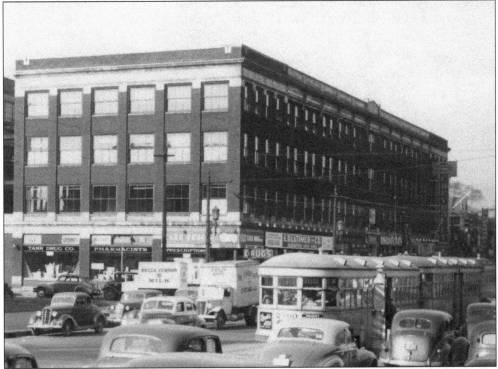

In 1916, the Bolton site housed a new building (pictured here about 1940) originally functioning as a new-car showroom. In the mid-1970s, female mud wrestlers entertained audiences at the Cabaret Theater and Disco within the building. By the early 1990s, the building stood vacant and dilapidated. In 1992, the remodeled and renamed Victory Building housed a warehouse. It is now known as the Victory Innovation Center after a substantial renovation was undertaken to attract tenants in research and medical fields. (Photograph Collection, Cleveland Public Library.)

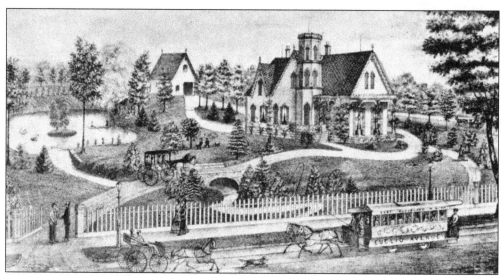

Capt. Alonzo P. Winslow earned his fortune by inventing novel products for the railroad industry. His best-known innovations were the Winslow Safety Stove, a heater engineered to automatically extinguish a potential fire created if it tipped over, and the Winslow Car Roof, constructed of corrugated metal sheets rather than wood. Winslow's 1860 Gothic country house at 7102 Euclid Avenue was razed in 1910. (Photograph Collection, Cleveland Public Library.)

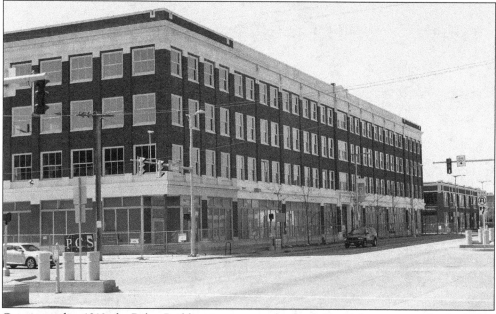

Constructed in 1910, the Baker Building incorporated a ground-level showroom to display Baker electric automobiles. The second floor contained bachelors' apartments; chauffeurs also slept in these quarters while their employers' automobiles received overnight battery charges. With the discontinuance of Baker automobiles, the showroom focused on, in succession, sales of Hupmobile, Pontiac, and Studebaker automobiles, followed by a factory to manufacture aircraft parts and a facility for printing companies. Tenants of the newly renovated building now range from high-tech companies to a renegade former Catholic church. A free battery charger is available for modern electric cars. (Alan Dutka.)

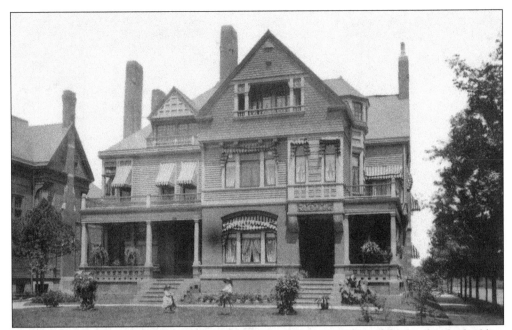

When his father Alvah died in 1885, Morris A. Bradley became president of the family's shipbuilding company. The following year, he constructed this English manor home at 7217 Euclid Avenue, residing there until a 1921 move to Shaker Heights. In 1928, banker James Potter purchased the house, now an apartment building, and lived in it with his family. Burdened by financial failures and a fraud investigation, Potter concocted pills, allegedly to prevent coughs, that he intentionally laced with poison. Consuming the pills with his family, Potter killed himself, his wife, and two teenage sons. (Photograph Collection, Cleveland Public Library.)

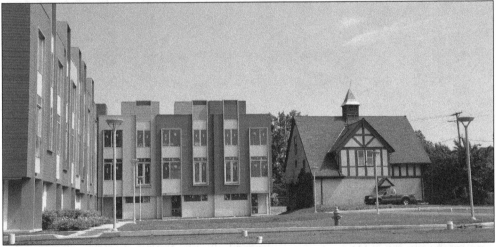

In 1929, federal agents raided Das Deutches Haus, a trendy restaurant situated in the old Bradley house. The agents thoroughly enjoyed dinner, even consuming second helpings, before arresting three waiters and seizing 11 barrels of beer. Following a fatal 1964 fire, the renovated mansion served as a nursing and elder-care facility into the 1970s. After demolition of the home, the site consisted of broken concrete, a diverse assortment of weeds, and families of urban squirrels. In 2018, construction of new townhouses encompassed the former Bradley site. To the right, the Bradley carriage house still remains. (Alan Dutka.)

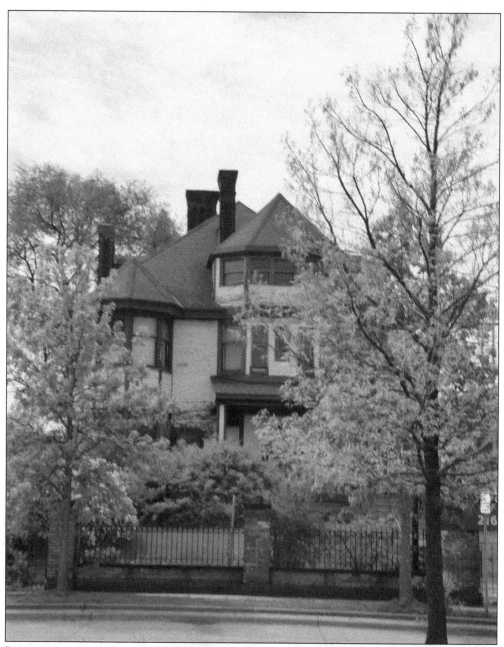

Prominent attorney Orlando Hall purchased this home at 7218 Euclid Avenue, constructed for Richard H. Allen in 1887, when Allen's commission business failed. Col. Jeremiah J. Sullivan, a banker, bought the property in 1897. Following Sullivan's death in 1922, the home became Miss Josephine's Shop, where French native Josephine Beaubernard sold expensive imports. In 1935, the Ohio Grand Lodge of the Sons of Italy purchased the home, adding a banquet facility in the back. From 1946 to 1960, the American Society of Heating and Ventilating Engineers transformed the structure into a research laboratory. In 1964, the home became the Coliseum Party Center, which hosted private parties and political events. The vacant building still stands on Euclid Avenue. (Alan Dutka.)

In 1897, after residing two blocks to the east, David Z. Norton constructed a Romanesque Revival home at 7301 Euclid Avenue to reflect his wealth as cofounder of Oglebay, Norton & Company, a business involved in mining and shipping iron ore. In 1928, Norton died 12 hours after the funeral of his wife of 51 years. Eleven years later, his heirs sold the home; the American Society for Metals converted the mansion into its national headquarters, remaining until the home's demolition in 1961. (Photograph Collection, Cleveland Public Library.)

A used-car lot replacing Norton's mansion quickly created a conflict with the Cleveland Independent Automobile Dealers Association by remaining in business past 6:00 p.m. A telephone caller threatened to bomb the lot because of the company's convenient-hours policy. As used cars vanished from Euclid Avenue, the site remained vacant for years. A Famous Gyro George restaurant now sells gyro, chicken, and fish sandwiches where Norton once lived in luxury. (Alan Dutka.)

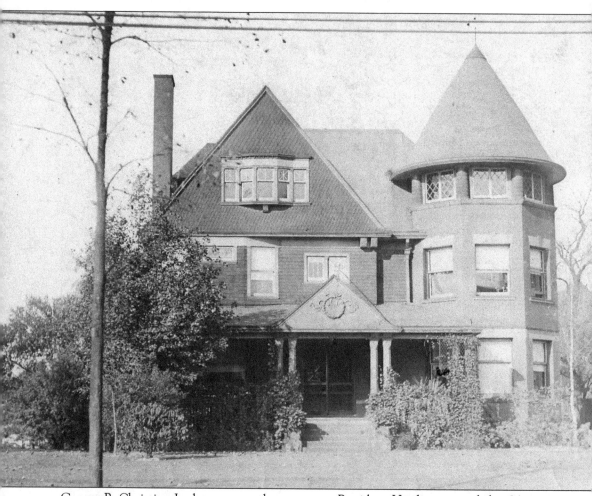

George B. Christian Jr., later personal secretary to President Harding, owned this 24-room stone mansion at 7341 Euclid Avenue, built in 1894. Henry P. McIntosh, president of Guardian Savings and Trust, purchased the residence in 1907. Beginning in 1929, the home functioned as an apartment. From 1947 into 1965, the Ace Motor Sales operated a used-car lot on the property while the home remained. Built in 1983, the Masjid Bilal Mosque encompassed the former Christian/McIntosh site and additional land to the east. (Special Collections, Michael Schwartz Library, Cleveland State University.)

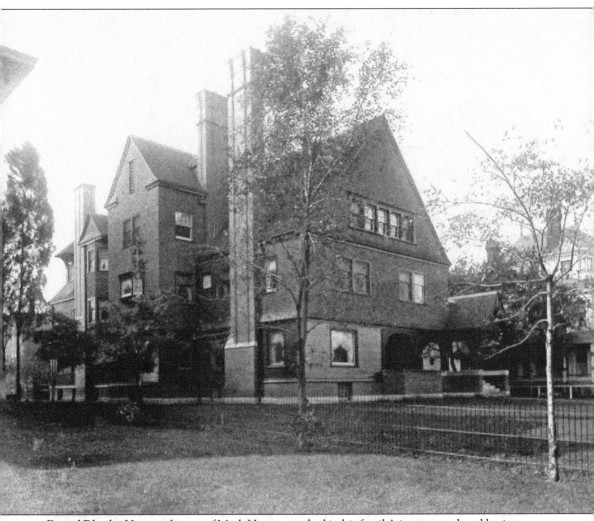

Daniel Rhodes Hanna, the son of Mark Hanna, worked in his family's iron ore and coal businesses. Hanna's residence at 7404 Euclid Avenue, constructed in 1895, eventually developed into the Art Colony Studio Building, a live-work facility for artists. After the Hanna home's demolition, a car wash, gas station, auto repair shop, used-car lot, and company selling new and used boats absorbed the site. Vacant for years, the land now comprises a grocery store and part of an office building. (Special Collections, Cleveland Public Library.)

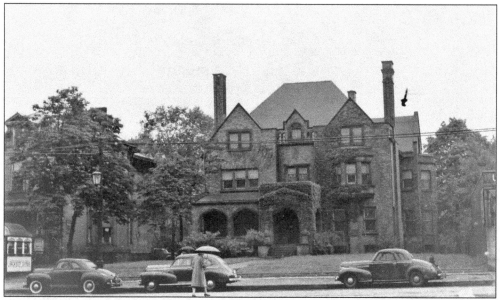

Luther Allen, a banker, railroad executive, and industrialist, built this home at 7609 Euclid Avenue in 1896. Beginning in the mid-1920s, the residence functioned successively as an apartment, alcoholism treatment center, nursing home, insurance office, savings and loan, and multipurpose office building. This 1942 photograph illustrates the residence operating as a nursing home. (Photograph Collection, Cleveland Public Library.)

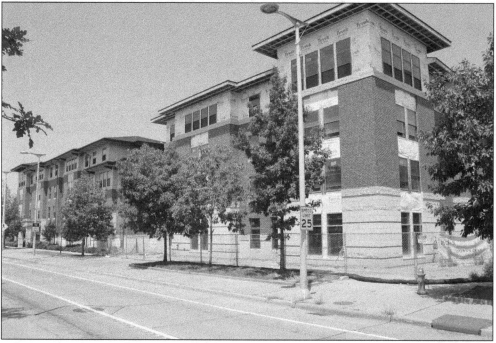

Following decades of failed renovation efforts, the Allen home was razed in 2018 for expansion (right) of Greenbridge Commons, a homeless shelter that first opened in 2011. The complex includes furnished apartments, a community room, vegetable gardens, and computers with Internet access. (Alan Dutka.)

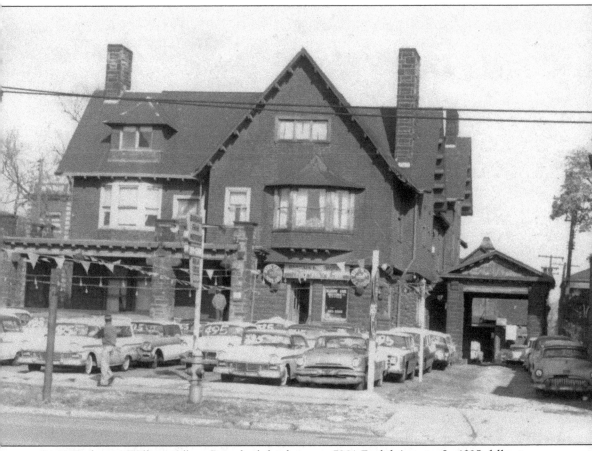

In 1903, dentist William Albert Price built his home at 7801 Euclid Avenue. In 1925, following Price's death, the residence turned into apartments for the general public and studios for music teachers. In the late 1940s, the apartments remained, while the front lawn housed the Midtown Auto Bargain Fair. The combined apartment and used-car lot continued into 1961, the year of this photograph. (Photograph Collection, Cleveland Public Library.)

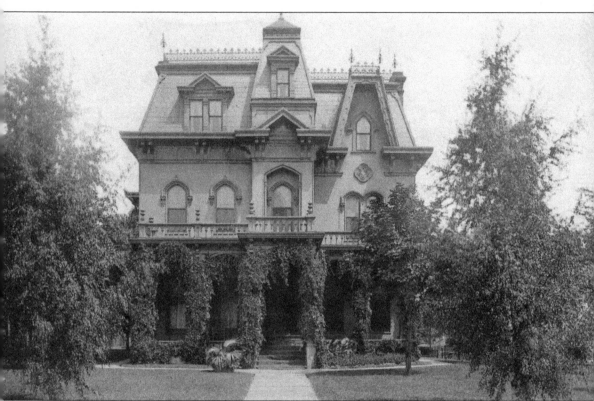

Joseph W. Britton, president of the Britton Iron and Steel Company, lived in this home at 7817 Euclid Avenue from its construction in 1875 until his death in 1901. A series of restaurants preceded the home's 1935 demolition. Tenants of the commercial building that replaced the residence consisted of a plumbing company, tailor shop, shoe repair facility, deli, and a string of beer parlors and lounges. In 1981, the Price and Britton sites reverted back to residential usage with the construction of the 181-unit Rainbow Place Apartments, a senior living community. (Photograph Collection, Cleveland Public Library.)

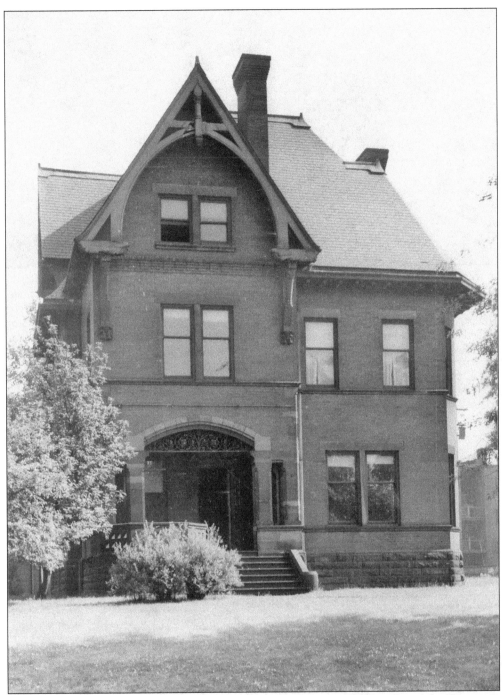

Ambrose Swasey, a scientist, engineer, inventor, astronomer, and cofounder of the Warner & Swasey Company, constructed this home at 7808 Euclid Avenue in 1891. Spending summers in his New Hampshire birthplace, Swasey continued to live in his Euclid Avenue residence until his death in 1937. Two years later, a used-car lot replaced the demolished home. The site is currently a parking lot for Calvary Presbyterian Church. (Photograph Collection, Cleveland Public Library.)

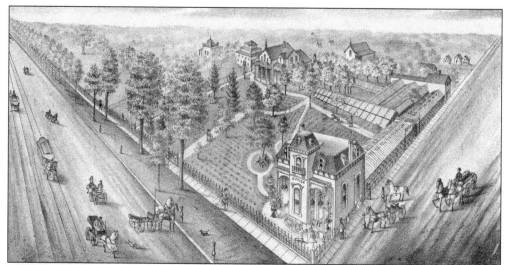

In this 1874 sketch, the home and office of Harris Hylas Jaynes, a prominent Cleveland florist, fills the southeast corner of Euclid Avenue and East Seventy-Ninth Street at 8000 Euclid Avenue. His home, built in 1845, is the small Gothic Revival structure in the center background. The office, constructed about 1870, is the prominent building on the corner. His property, extending to Cedar Avenue, contained greenhouses overflowing with camellias, tuberoses, carnations, and other fashionable flowers. (Photograph Collection, Cleveland Public Library.)

Jaynes died in 1883; ten years later, St. Agnes, a modest wooden church, became the first Catholic place of worship on Millionaires' Row. In 1916, splendor replaced modesty as a new St. Agnes Church prompted *New York Times* Pulitzer Prize–winning news correspondent Anne O'Hare McCormick to describe the Romanesque church as "the most perfect parish church in America." The church's 130-foot bell tower (left) still remains on the property, even though the church was demolished in 1975. The land remained vacant until a CVS drugstore began operation in 2010. (Alan Dutka.)

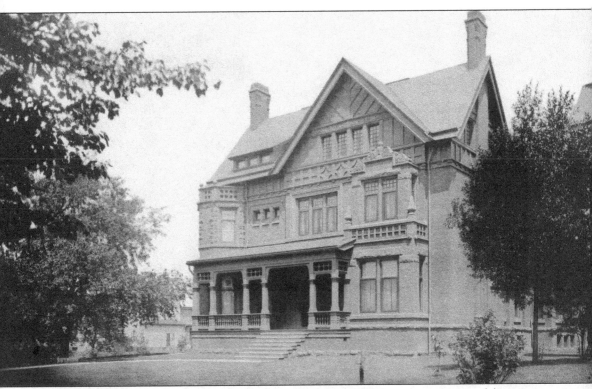

Edwin R. Perkins taught in the Cleveland public school system prior to pursuing successful careers in law, banking, and railroads. Perkins resided in this English manor house at 8011 Euclid Avenue from 1891 until his death in 1915. In 1924, razing of the home provided space for a new building consisting of restaurants, dry cleaners, and miscellaneous small shops. (Photograph Collection, Cleveland Public Library.)

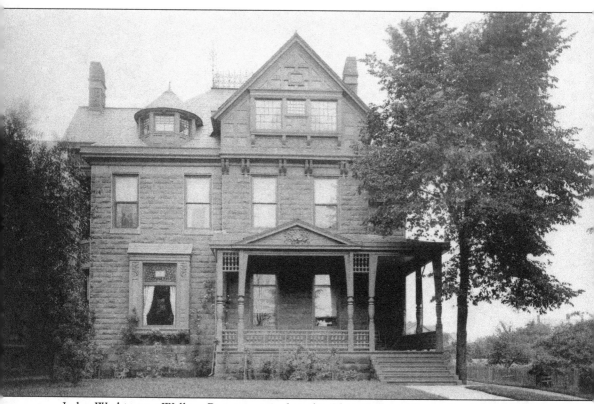

Judge Washington Wallace Boynton served in the Ohio House of Representatives and on the Ohio Supreme Court. After resigning from the state's highest court, Boynton built this residence at 8021 Euclid Avenue in 1884. In 1906, he retired from his lucrative law practice and relocated to Elyria. Dr. Benjamin L. Millikin, dean of the Western Reserve Medical School, purchased the home. After use as an apartment, the demolished home site served as a grocery store, hat cleaner, shoe repair shop, drugstore, television shop, record shop, and appliance store. (Photograph Collection, Cleveland Public Library.)

By the 1980s, the sites of the Perkins and Boynton homes, boarded up and condemned, had plummeted into complete disrepair. (Photograph Collection, Cleveland Public Library.)

The former Perkins and Boynton sites are now part of the 100,000-square-foot Church Square shopping center. On September 8, 1993, the urban strip mall began operations with visits from Pres. Bill Clinton, Vice Pres. Al Gore, and the secretaries of transportation, education, and housing and urban development. President Clinton called the mall "a model for the nation." (Alan Dutka.)

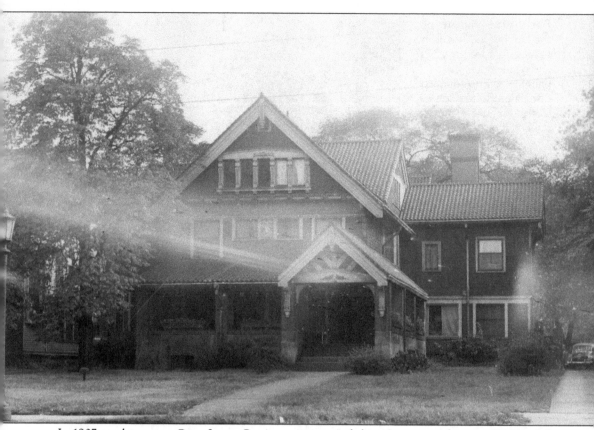

In 1907, steel magnate Capt. James Corrigan constructed this 19-room residence at 8114 Euclid Avenue. The next year, he died in the home. Edwin L. Gleason and his wife, who traced her ancestors eight generations back to Miles Standish, resided in the home from 1924 into 1931. The residence then became the Walter Carson Funeral Home, followed by a chiropractor's office, sanitarium, convalescent home, and hospital, all headed by Dr. Julia C. Bateman. From 1948 into 1964, an Eastern Star women's rest home used the substantially remodeled Corrigan home. In 1964, demolition of the Corrigan residence permitted construction of two currently abandoned fast-food restaurants. (Photograph Collection, Cleveland Public Library.)

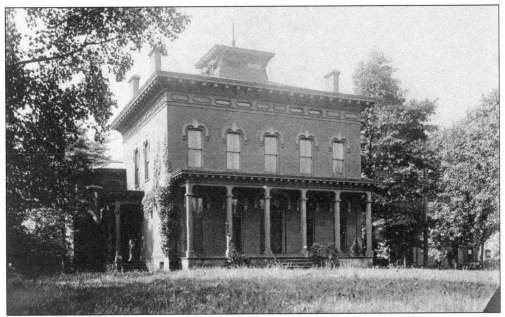

Dr. Leroy Chadwick, a wealthy and respected doctor, resided in this home at 8204 Euclid Avenue, constructed during the Civil War. His life turned to chaos when the widower married the infamous Cassie Chadwick, one of the world's most famous and proficient con artists. Cassie secured enormous bank loans pretending she would inherit $400 million from Andrew Carnegie, her as-yet-unrevealed father. Previously, Cassie had claimed to be a niece of Pres. Ulysses S. Grant, a daughter of a British general, the widow of an earl, and the heir to an Irish castle. (Photograph Collection, Cleveland Public Library.)

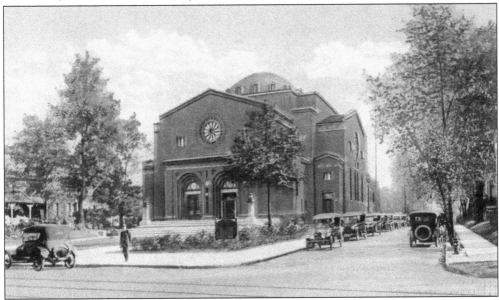

In 1912, the Euclid Avenue Temple replaced the Chadwick residence. The temple functioned as an important part of the neighborhood's Jewish life into the 1950s. In 1956, the Liberty Hill Baptist Church purchased the Neoclassical place of worship when the Jewish congregation moved to Beachwood. (Alan Dutka.)

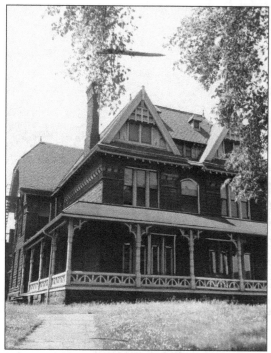

Thomas Howard White, founder of the White Sewing Machine Company, assisted one of his sons in establishing the White Motor Company, despite his personal view that horseless carriages constituted a mere passing fancy. In 1883, the elder White constructed this English manor house at 8220 Euclid Avenue. (Special Collections, Michael Schwartz Library, Cleveland State University.)

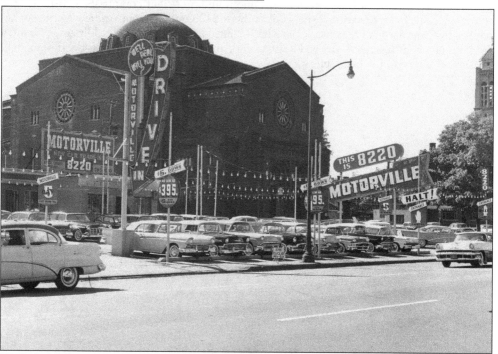

With the razing of the White home in 1951, another ever-present used-car lot took its place. In 1953, a current-year Mercury Monterey, driven only 1,300 miles, sold for $2,995. A 1951 Cadillac, with 9,000 miles on the odometer, commanded $3,095, while a 1952 Hudson carried a $2,295 sticker price. The Liberty Hill Baptist Church is in the background. (Photograph Collection, Cleveland Public Library.)

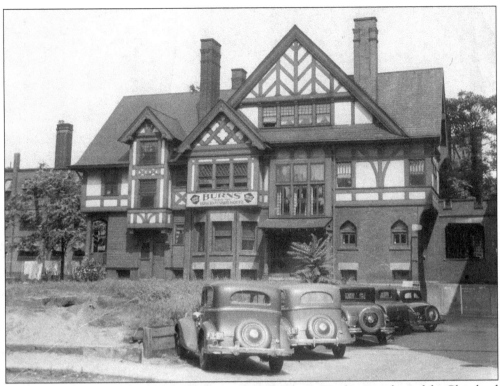

Originally constructed for Arthur W. Brown in 1897, John J. Stanley, president of the Cleveland Railroad Company, purchased the home at 8411 Euclid Avenue while he guided the electric streetcar business during the celebrated political streetcar wars between Mayor Tom L. Johnson and industrialist Mark Hanna. The Stanley home operated as the Venice Apartments from the 1920s into the early 1990s. This 1934 photograph illustrates a side of the home where a restaurant is operating. (Special Collections, Michael Schwartz Library, Cleveland State University.)

In 2003, a portion of the 80-home Woodhaven residential development, an expansion of the successful 92-unit Beacon Place project, replaced the Stanley mansion site. Woodhaven extends between East Eighty-Fourth and East Eighty-Seventh Streets, additionally bounded by Euclid and Chester Avenues. Initial townhouse prices ranged from $215,000 to $239,000. (Alan Dutka.)

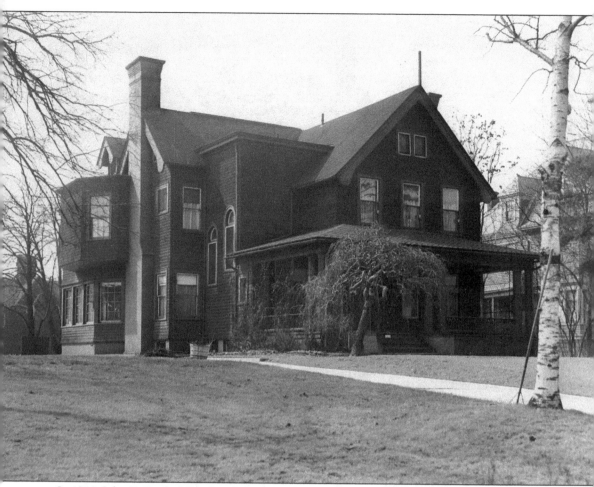

In 1900, John D. Rockefeller absorbed an oil company founded by John Teagle and two partners. The decision to join Rockefeller propelled Teagle into millionaire status and laid the groundwork for his son Walter's meteoric rise to the presidency of Standard Oil (Ohio) and then Standard Oil (New Jersey). John Teagle built his home at 8418 Euclid Avenue about 1877. The family raised rabbits and chickens on the property. Teagle's wife (later widow) resided in the home for 61 years before selling the property in 1938. The former Teagle site has served as a parking lot for Sears, Fisher Foods, the Cleveland Playhouse, and Cleveland Clinic. (Photograph Collection, Cleveland Public Library.)

William J. Morgan worked in a Cleveland copper smelting company prior to founding a lithographing and engraving business that earned an international reputation. In the 1870s, the company printed the world's first color theatrical poster (promoting John T. Raymond in *Millions in It*). In 1900, another artistic poster won a gold medal at the famous Paris exhibition. Morgan constructed this home at 8615 Euclid Avenue in 1889. Following his death in 1904, Francis Drury purchased the property and razed the home. (Photograph Collection, Cleveland Public Library.)

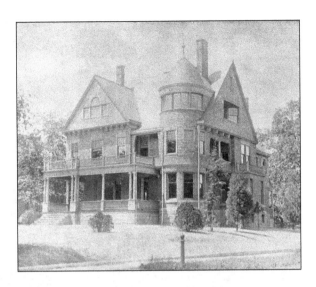

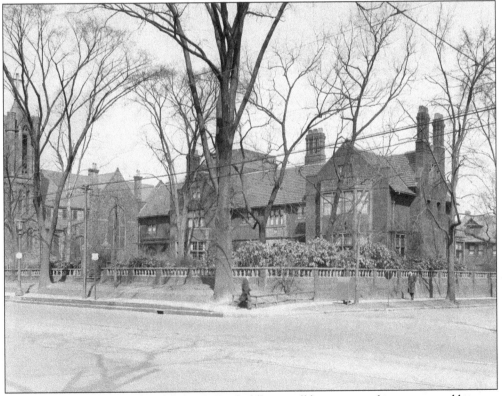

Francis E. Drury partnered with John D. Rockefeller to sell kerosene cooking stoves and heaters. The business arrangement increased Standard Oil's sale of kerosene while allowing Drury to accumulate a fortune manufacturing the stoves. Constructed between 1910 and 1912, Drury's 25,000-square-foot English Renaissance Tudor home demonstrated the monetary benefits of cultivating Rockefeller as a business colleague. The former Church of the Epiphany (later the Euclid Avenue Church of God) to the left has been razed. (Special Collections, Michael Schwartz Library, Cleveland State University.)

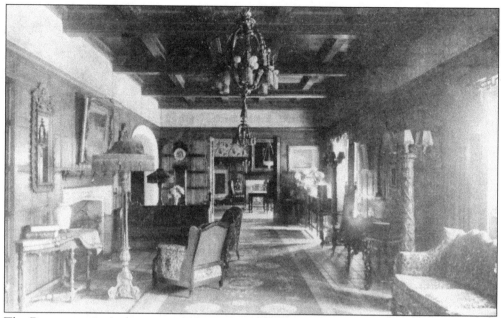

The Drury mansion's elegant interior consisted of carved woodwork, ornate ceilings, elegant furnishings, and fine art. Drury resided in the home for 12 years before relocating to Gates Mills. His new suburban residence bore an intended likeliness to the Euclid Avenue mansion. In 1926, Ralph Thrall King, the acting president of the Cleveland Museum of Art, purchased the Euclid Avenue home; he died the same year. King's family remained in the home until 1937. The Drury Club, the next tenant, converted the home into a very exclusive facility for wealthy and carefully chosen Clevelanders. (Photograph Collection, Cleveland Public Library.)

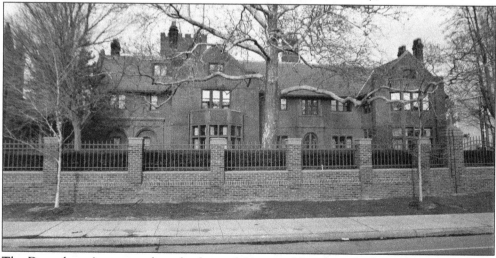

The Drury home's tenants abruptly changed from wealthy to needy. Beginning in 1946 and continuing into 1972, the Florence Crittenton House provided a maternity hospital, nursery, and place of refuge for unwed mothers. Next, the mansion offered treatment, testing, and counseling for parolees who had broken their parole and would otherwise have been sent back to jail. In 1988, the Cleveland Clinic Foundation purchased and restored the edifice. The renamed Foundation House hosts receptions, graduation ceremonies for medical students, and Cleveland Clinic board meetings. (Alan Dutka.)

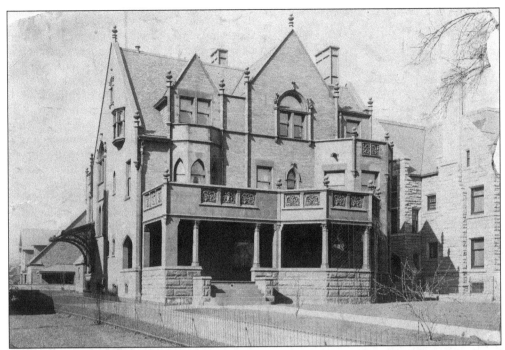

In 1896, Samuel T. Wellman, a designer and builder of industrial furnaces, constructed this home at 8803 Euclid Avenue. In 1919, at the age of 72, he died of heart disease while traveling to a fishing trip. The Greater Cleveland Dental Society then used the 25-room brick-and-brownstone home as a research facility. It was remodeled as a medical and surgical clinic in the 1930s; a rooming house followed in the 1940s. In the 1960s, the site contained a portion of Ingleside Hospital. A gas station and used-car lot were later tenants of the site. (Photograph Collection, Cleveland Public Library.)

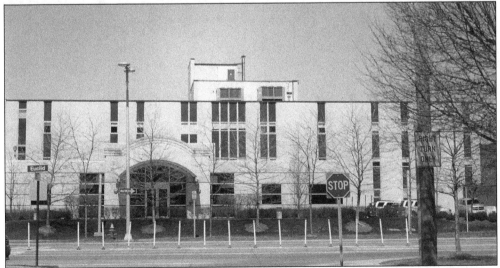

In 1984, Cleveland Clinic launched the Mellen Center on the former Wellman site. This two-block facility is devoted to research and treatment of multiple sclerosis. The center accommodates about 20,000 visits annually. (Alan Dutka.)

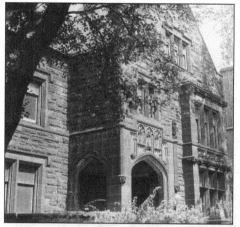

In 1838, Mary Long, the daughter of Cleveland's first doctor, wed merchant Solomon Lewis Severance. He died five years later, at the age of 26, leaving Mary and their sons, Solon and Louis. Louis's later marriage produced John L. Severance (who provided financial support for Severance Hall) and Elisabeth Severance. Elisabeth wed Dr. Dudley P. Allen; they built this gray sandstone mansion at 8811 Euclid Avenue in 1900. Dudley died in 1915. Two years later, Elisabeth married industrialist Francis F. Prentiss. The couple initially established their residence in the home but soon moved to Mayfield Road. (Photograph Collection, Cleveland Public Library.)

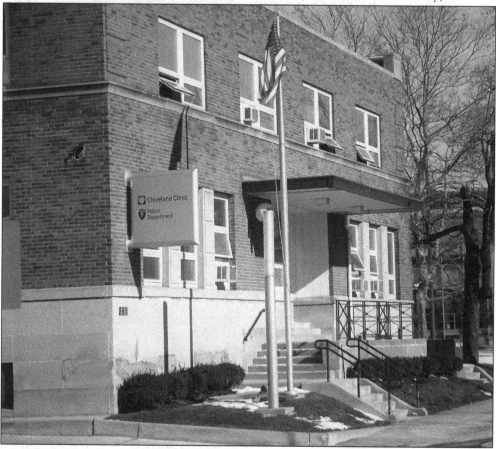

In 1919, Elisabeth Severance leased the property to the Huron Road Hospital, and in 1936, she donated the home to the proposed Cleveland Health Museum, which debuted in 1940. Five years later, the museum moved one block east into the former Lyman Treadway mansion. In the late 1940s, Ingleside Hospital expanded from its next-door location into the former Severance home, but the hospital razed the mansion in 1968. After serving as a parking lot, the front portion of the site is now the Cleveland Clinic Police Department headquarters (shown here), while the back is part of the Mellen Center complex. (Alan Dutka.)

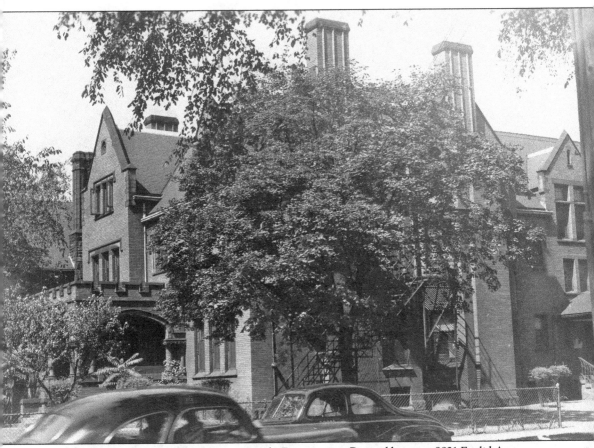

In 1906, banker Solon Severance constructed a Romanesque Revival home at 8821 Euclid Avenue, directly east of the Dudley/Prentiss residence. He died in 1915. The Huron Road Hospital expanded its operation into the home in 1925, remaining for 10 years. Beginning in 1937, the Ingleside Hospital used the mansion. The hospital's renovation included converting the family ballroom into an occupational therapy center and the top-floor servants' quarters into a medical records area. In 1972, the hospital closed during a bitter and prolonged labor dispute. The Severance site is now a parking lot and green space situated on the eastern edge of Cleveland Clinic's Mellen Center. (Photograph Collection, Cleveland Public Library.)

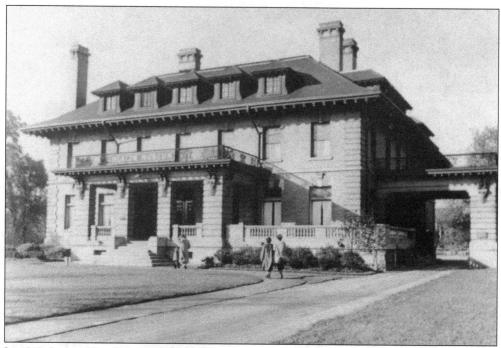

In 1919, Lyman Treadway, a hardware manufacturer and vice chairman of the Federal Reserve Bank of Cleveland, died in his home at 8917 Euclid Avenue at the age of 57. In 1923, his widow moved to Fairmount Boulevard in Cleveland Heights. Business tycoon Cyrus Eaton owned the Euclid Avenue home for eight years, although he spent most of his time at his country estate in Northfield. In 1932, the Cleveland Association of the Hard of Hearing resided in the home, followed by the Cleveland Health Museum in 1945. (Photograph Collection, Cleveland Public Library.)

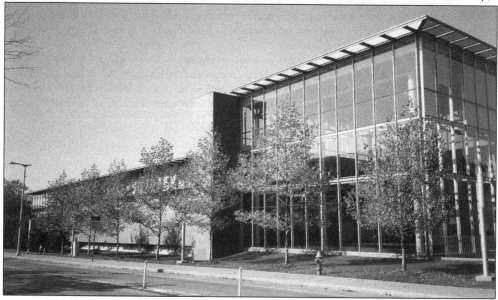

In 2003, the Cleveland Health Museum demolished the Treadway mansion to construct a new building. After only three years, a $17-million debt forced the museum's closure in 2006. Cleveland Clinic later purchased the building. (Alan Dutka.)

As the 20th century began, Henry Windsor White (an investor in his half-brother's sewing machine company) erected a 16,000-square-foot Victorian Gothic residence at 8937 Euclid Avenue. Apartments followed after White's death in 1923. In 1934, the residence began a 43-year run as a funeral home, after which the International Center for Artificial Organs and Transplantation used the mansion as its headquarters. In the 1990s, the Cleveland Health Museum owned the mansion, leasing it to various organizations for office space. After an extensive renovation, the health museum converted the residence into administrative offices. (Special Collections, Michael Schwartz Library, Cleveland State University.)

A grandson of Henry White, exhibiting a strong interest in weapons, added a shooting range to the basement of the home's adjoining stable. Growing in sophistication, the basement eventually developed into a ballistics laboratory. Now located in Maryland, the H.P. White laboratory is the largest independent ballistics testing facility in North America. After the health museum failed, Cleveland Clinic purchased the mansion, converting it into a center for alumni affairs. (Alan Dutka.)

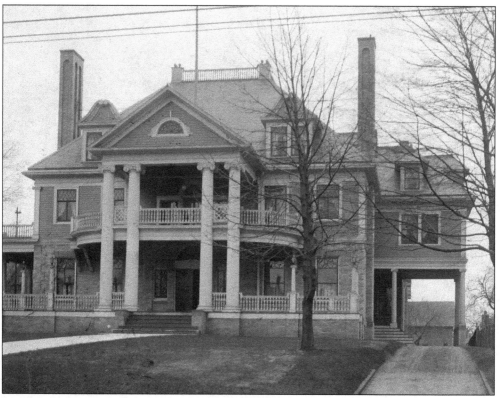

In 1896, the new Colonial Club at 9104 Euclid Avenue catered to Cleveland's wealthy east-end society. A large ballroom offered a perfect setting for social dances and debutante balls. Pianists and harpists provided background music for card parties, club meetings, and Bible study classes. Members also enjoyed a bowling alley, billiard and Ping-Pong tables, and shuffleboard accommodations. In 1918, the Colonial Club disbanded, allowing the Knights of Columbus Gilmour Council to purchase the facility. Demolished in 1926, a mere 20 years after the building's construction, a restaurant and gas station later used the site. (Photograph Collection, Cleveland Public Library.)

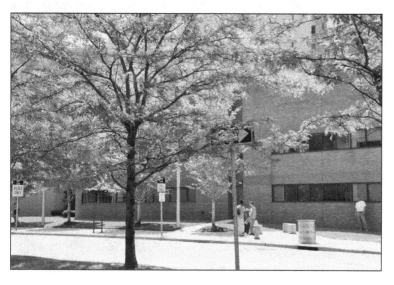

Constructed in 1996, Cleveland Clinic's F. Joseph Callahan Center for Radiation and Robotics is the current occupant of the former Colonial Club site. (Alan Dutka.)

Constructed in 1893 for real estate investor Joshua Gregg, this home at 9409 Euclid Avenue was later owned by music teacher and orchestra leader William Heinrich and then functioned as an apartment building, funeral home, nursing home, and used-car lot headquarters. In 1953, the lot suspended operations due to charges of unethical practices in selling cars. (Photograph Collection, Cleveland Public Library.)

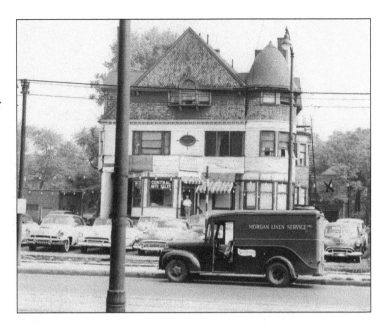

In 1954, the 50-unit University Center Motel replaced the Heinrich home site. In the postcard above, Toby, the motel's St. Bernard, relaxes on the lawn. Among his many duties, Toby greeted customers and accompanied the motel owner on daily trips to the bank. The motel closed in 1987. The site is now being redeveloped as a medical education center by Cleveland Clinic and Case Western Reserve University. (Alan Dutka.)

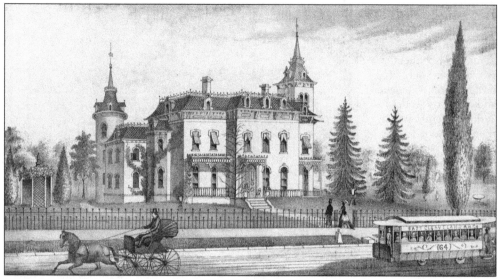

Marveling at the wealth Cleveland industrialists had accumulated, Dr. Worthy S. Streator decided commerce far outweighed opportunities in the medical profession. Following lucrative careers in railroads and coal mining, Streator embarked on a political career culminating in his election to the Ohio Senate. Streator constructed this 10,000-square-foot home at 9803 Euclid Avenue in 1862. The house was razed in 1906, following his death. For the next 110 years, the site contained a nondescript commercial building, a used-car lot, and vacant land. (Photograph Collection, Cleveland Public Library.)

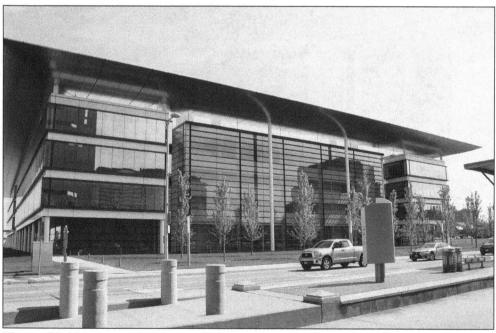

The new health education building now on the Heinrich home site also replaced the old Streator home site. (Alan Dutka.)

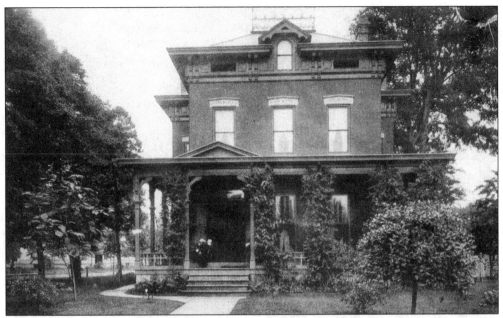

Born in Scotland to a seafaring family, Capt. Thomas Wilson founded a company in 1872 that constructed a large fleet of Great Lakes cargo ships. He married the daughter of the first person to ship coal out of Cleveland. In 1900, Wilson unexpectedly died of pneumonia as he vacationed in Palestine. His home was at 10034 Euclid Avenue. (Photograph Collection, Cleveland Public Library.)

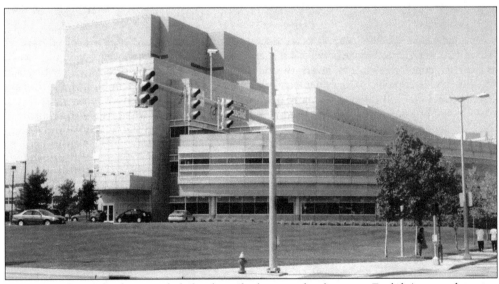

Captain Wilson's death coincided closely with the growth of a major Euclid Avenue shopping and entertainment district centered at East 105th Street. Although apparel outlets dominated the Wilson site for 70 years, an F.W. Woolworth store existed there in the 1930s. The Wilson site is now a portion of the five-block Cleveland Clinic Cole Eye Institute. (Diane D. Ghorbanzadeh.)

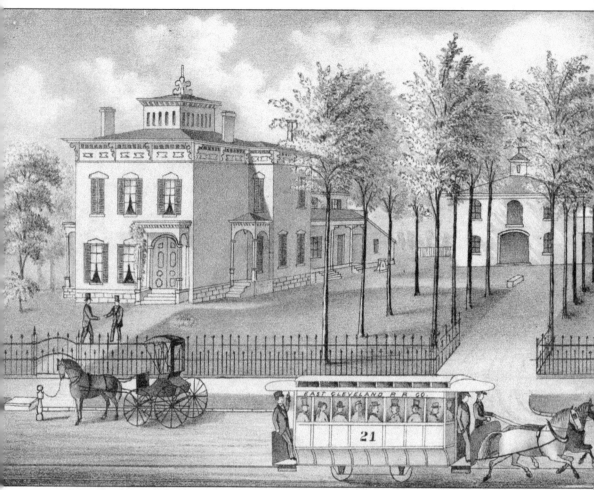

Albon Crocker Gardner once acted as an agent selling Wright's Indian Vegetable Pills, touted as a certain cure for headaches, fevers, rheumatism, gout, asthma, sore throats, yellow tinges of the skin, and liver problems. Gardner later participated in the development of the Chagrin Falls & Cleveland Plank Railroad Company. Turning to politics, he served for many years in the Ohio House of Representatives. He lived at 10204 Euclid Avenue, which is also now a part of the Cleveland Eye Clinic Cole Eye Institute. (Photograph Collection, Cleveland Public Library.)

MILLIONAIRES' ROW
LEGACY

Four restored Millionaires' Row mansions remain on Euclid Avenue's north side: the former homes of Samuel Mather (2605 Euclid Avenue), Thomas Beckwith (3813 Euclid Avenue), Francis Drury (8615 Euclid Avenue), and Henry Windsor White (8937 Euclid Avenue). On the south side, Cleveland State University has restored the William Howe home (2258 Euclid Avenue). Still existing, in an almost unrecognizable condition, is the residence of John Devereux (3226 Euclid Avenue). The Orlando Hall residence (7218 Euclid Avenue) is in need of extensive renovation.

Fortunately, Cleveland's early millionaires fashioned a legacy not confined to their lavish homes. Their commitment to music, arts, education, and charity resulted in both financial and leadership support vital to the creation of Cleveland's Museum of Art, Museum of Natural History, Institute of Art, and Western Reserve Historical Society. The two predecessor colleges to Case Western Reserve University owe a great debt to Euclid Avenue residents. The Case School of Applied Sciences traces its founders to Euclid Avenue residents, while others funded and encouraged Western Reserve University's relocation from Hudson, Ohio.

Euclid Avenue's elite also assisted in the founding of the Cleveland Orchestra and the construction of Severance Hall and the downtown Arcade between Euclid and Superior Avenues. Near University Circle, two of Cleveland's most beautiful parks bear the names of Millionaires' Row residents Rockefeller and Wade. The YMCA, YWCA, Hiram House, and numerous churches, hospitals, orphan homes, and other social organizations trace their origins to contributions from Euclid Avenue millionaires.

A large portion of these financial commitments occurred prior to any tax or wealth-planning advantages. John D. Rockefeller, as an example, kept a meticulous account of his spending as a struggling entrepreneur. These records indicate a very strong dedication to the church he attended, even though the support undoubtedly required sacrifices at this point in his life.

The radically changed Euclid Avenue is still a major downtown traffic artery and the western gateway to University Circle. While the once-magnificent homes have faded into history, the legacy of Euclid Avenue's millionaires remains to enhance the lives of future generations.

Discover Thousands of Local History Books Featuring Millions of Vintage Images

Arcadia Publishing, the leading local history publisher in the United States, is committed to making history accessible and meaningful through publishing books that celebrate and preserve the heritage of America's people and places.

Find more books like this at
www.arcadiapublishing.com

Search for your hometown history, your old stomping grounds, and even your favorite sports team.

Consistent with our mission to preserve history on a local level, this book was printed in South Carolina on American-made paper and manufactured entirely in the United States. Products carrying the accredited Forest Stewardship Council (FSC) label are printed on 100 percent FSC-certified paper.

MADE IN THE USA

CPSIA information can be obtained
at www.ICGtesting.com
Printed in the USA
LVHW061143190723
752798LV00009B/712

9 781540 240842

IMAGES
of America

CLINTON

Pictured here is an 1881 map of Clinton. Clearly represented are buildings that were present in the town at that time, 144 of which are now listed in the National Register of Historic Places. (Courtesy of Clinton Historical Society.)

IMAGES
of America

CLINTON

Peggy Adler

ARCADIA
PUBLISHING

Published by Arcadia Publishing
Charleston, South Carolina

Library of Congress Control Number: 2018967831

For all general information, please contact Arcadia Publishing:
Telephone 843-853-2070
Fax 843-853-0044
E-mail sales@arcadiapublishing.com
For customer service and orders:
Toll-Free 1-888-313-2665

Visit us on the Internet at www.arcadiapublishing.com

*Dedicated to my rescue pup Pepper for her enduring
patience while I worked on this book.*

CONTENTS

ACKNOWLEDGMENTS

I would like to thank the following people and organizations: Adam Coppola; Allison Friday; Ann Colson; Anna Filipkowska; Becky Elliot Keating for sharing her ancestor Jared Eliot's life story with me; Bo Potter, director of Clinton Parks and Recreation Department; Bob Bruch, sexton of the Indian River Cemetery; Bob Hale's postcard collection; Brian Boyd; Bryan Pelligrini; Carol Capirchio; Cathie and Enea Bacci; Charlotte Neely, Clinton Historical Society librarian and one of my proofreaders; Christopher and Heather Varone; Clinton Antique Center; the website of Clinton Beach Association; Clinton Historical Society (CHS); Clinton Police Department; Clinton Public Schools; Clinton Volunteer Fire Department; Deb Hawthorne; Dibby Jean Burnham for sharing the Pallenberg history and family photographs with me and being one of my proofreaders; Dan Meaney, Connecticut Water Company; David Perrelli, Old Beautiful Antiques & Art; Donald "Gus" Gustofson for his stories; Elaine Godowsky and the George Flynn Classical Concert Series, for the use of Vic Mays's logo; Eric Ambler and Rich Manley for their input and wealth of historical knowledge; Freeman Smith, owner of Snow's Block; First Church of Christ Congregational; Gail Leggett Webster for the loan of her postcard collection; Gary Skau; George and Tisha Marshall; Gloria Schoen McQueeney for the history of Pond's, Chesebrough-Pond's, and Unilever, and for being one of my proofreaders; Glenn Coutu; Harry Swaun for his input on the Clinton Parks and Recreation Department and for being one of my proofreaders; Henry Carter Hull Library; Jody Hudson for scanning whatever was necessary at the Clinton Historical Society; Joe Faughnan; Joe Flynn; Joe and Ginny Kabe; John O'Connell for William Stanton Andrews's will; Josie Elliot; Kathy Worrall-Nicely; Linnea Taylor Grande; Lois Ruggiero; Louise Lupone; Marcy Fuller for the loan of her family photographs and postcards; Mark Carlson; Mary-Kelly Busch; Miriam Green Antiques & Books; Nancy Vece Shuss for the loan of *Tercentenary Clinton, Connecticut: 1663–1963*; Old Harbor Marina; Peg Lupone; Peter Neff for his aerial photograph of the Indian River; Sally Maxwell; Sharon Wadsworth Uricchio, town clerk of Clinton; Shore Publishing; Sophia Yalouris and the Maine Historical Society; Sue and Roy Alexander; the Theodore Neely Postcard Collection, Clinton Historical Society; Tom Walsh, Shoreline Aerial Photography; and the United Methodist Church.

INTRODUCTION

Clinton, Connecticut, traces its history to 1663, when a committee appointed by the General Court at Hartford laid out a settlement to be known as the Homonoscitt Plantation. The land was situated between two rivers. One river was at the eastern end of Guilford in the New Haven Colony, and the other was at the western end of Saybrook in the Connecticut Colony. The settlement was to be located on over 50 square miles of land, which had not yet been claimed by white men. The land, in fact, was home to the Homonoscitt people. It was wooded, abounded in game, and had salt meadows, beaches, and a sheltered harbor to the south.

The committee determined that the plantation would be established for 30 families and provisions would be made for a church and support of the minister. Main Street was laid out by a surveyor, and the adjacent land was divided into 30 equal lots. Each of the original 30 families received three parcels: one on which to build a house; a second, a salt marsh, on which to grow salt hay to feed their animals; and a third from which wood could be cut for housing, heating, and cooking.

In 1667, the settlement was designated a town by the Court of Election at Hartford and given the name of Kenilworth. Its name changed to Killingworth by the mid-18th century.

Although the settlers believed that legal title to the property had been granted to them by the General Court at Hartford, in 1669, they purchased the land from the Indians who lived there. The tribal chief sold the new inhabitants all but six acres of land within the town that had been laid out for them. Over the years, the members of the tribe continued to live there until, one by one, they died. The land that they inhabited eventually came to be known as "Indian Acres" and is adjacent to present-day Commerce Street. During their lifetimes, the Indians retained the right to hunt in the woods, fish in the rivers, and use whatever trees they needed to make canoes.

In 1694, Abraham Pierson became pastor at the town's Congregational church. And in 1701, when the Connecticut Colony's General Court granted a charter for a collegiate school, its founders chose Pierson as its rector. For six years, the first classes were held at his parsonage in Clinton. After his death in 1707, the school was moved 25 miles west to New Haven. About 10 years later it was renamed Yale College, after Elihu Yale, an East India Company merchant who had given the Collegiate School a gift of goods that were sold and used to purchase books.

On January 9, 1788, the Connecticut Colony was admitted to the union, becoming the fifth state. In May 1838, the *Resolves and Private Acts of the State of Connecticut* noted, "upon a petition of the sundry inhabitants of the town of Killingworth," the southern portion of the town was incorporated by the General Assembly as the Town of Clinton. Thus, the part of Killingworth that lay south of the line dividing the first and second school societies would "constitute a separate and distinct town, by the name of Clinton." The northern portion of the town would retain the name of Killingworth. And "all paupers of said old town of Killingworth" would be "divided between the two towns of Killingworth and Clinton."

Present-day Clinton has an amazing number of 17th-, 18th-, and 19th-century buildings still standing, which are listed in the National Register of Historic Places. The National Historic Preservation Act of 1966 authorizes the US secretary of the interior to maintain a national register of districts, sites, buildings, structures, and objects significant to American history. The National Register is administered by the National Park Service.

Clinton Village Historic District, established under the National Historic Preservation Act, is comprised of 144 contributing buildings, 2 structures, 2 sites, and 6 objects, which total 154 resources. These resources can be found on Clinton's Cemetery Road, Church Street, East Main Street, Liberty Street, Old Post Road, and Waterside Lane. The authentication process spanned many years of study performed by historic resource consultants and was followed by a review by the Connecticut Historical Commission. In Clinton's case, the photographs of the candidates for the district were taken around 1980 and the consultants' report was dated March 25, 1994.

Two decades before Clinton had a National Register District, a local committee did extensive research to create and establish a local historic district, which was approved on May 23, 1979, by the Connecticut Historical Commission, thereby creating the Liberty Green Historic District.

Clinton's Liberty Green Historic District is comprised of the Town Green and six houses, all but one of which were built before 1800. The district's creation also established the Historic District Commission to oversee and protect the historic district. Although there is no restriction as to what color a house may be painted or what shrubs can be planted within the district, no other changes can be made to the exterior of any building or grounds that can be seen from the street without filing an application for a certificate of appropriateness. After a public hearing is held, the commission deliberates and makes a decision. To date, some of the approvals include a cobblestone apron for a gravel driveway; a cupola on a garage, as well as a flying pig weather vane mounted on that cupola; a storm door with a design appropriate to the era; and the transformation of a house into a bed-and-breakfast.

In 1935, the population of Clinton was a mere 1,930. A little over two decades later, it had only grown by another 536 to 2,466. However, with a bridge over the Quinnipiac River and the Connecticut section of Interstate 95 completed in January 1958, the number of year-round residents soon blossomed to 6,600 by 1965. Today, it stands at 13,047, but between Memorial Day and Labor Day, the population grows by another ten to fifteen thousand with the influx of marina and summer cottage residents.

Clinton is a town populated by numerous people who grew up there. Regardless of whether they left to go to college, for a job, or to seek fame and fortune, many have returned to raise their own families here or to retire from whatever occupation took them away from Clinton in the first place. Some are the town's police officers, schoolteachers, Little League coaches, and volunteer fire department personnel. Others are employed by businesses in Clinton or other nearby towns.

One

HISTORIC PRESERVATION

The Clinton Village Historic District, established under the National Historic Preservation Act, includes 154 resources. Many of them are profiled in this chapter. Clinton also has qualified resources that are not yet listed in the National Register of Historic Places, but soon may be. Additionally, there are the resources that are gone forever, never to be preserved. On the pages that follow, readers will see houses, schools, churches, statues, monuments, cannons, businesses, a cemetery, and miscellaneous artifacts from days of yore that are still present in Clinton today and others that, unfortunately, are not.

East Main Street is a portion of US Route 1 that runs east from Commerce Street and Post Office Square to Old Post Road, which is known as Route 145 today. East Main Street has also been called the Boston Post Road. The street boasts many historic structures, dating back hundreds of years, many of which are listed in the National Register of Historic Places. There, one will find

18th- and 19th-century houses and churches, the town green with a cannon from the War of 1812, and even a milestone that is said to have been put into place at the direction of Benjamin Franklin when he was postmaster general. (Courtesy of Bob Hale.)

Created in 1944 by A.H. Stevens, this replica of a 1663 map shows the 30 parcels of land that comprised the 50-square-mile Homonoscitt Plantation. The names paired with the parcels denote the families that owned them. (Courtesy of the Stevens family.)

Clinton's Indian River is adjacent to the Clinton Volunteer Fire Department and the Indian River Cemetery. It is a tidal river. This means that its flow and level are influenced by the tides; it enters Long Island Sound, and at times will flow upstream. When the town was young, various industries sprang up along the shores of the Indian River. The first shipyard was built there in 1700 near the town bridge. Another followed south of the bridge, as well as one at Waterside. The ships sailed to the West Indies carrying horses and cattle. Their return trip brought back supplies. (Photograph by Peter Neff.)

Sailing on the Indian River, Clinton, Conn.

Mills for grinding grain and wheat were also built along the river. The largest flour mill in the area was on the upper part of the river for more than 100 years. There were also many sawmills, and the timber from them was made into barrel hoops and staves, which were shipped to the West Indies. Today, the river is trafficked by small sailboats, canoes, and kayaks. (Courtesy of Gail Leggett Webster.)

When the first railroad came through the town in 1851, it had three rivers to cross, so heavy-duty bridges were constructed. The bridge that crosses the Indian River is not only still structurally sound, but also a beautiful sight to behold regardless of the season, weather, or time of day. (Photograph by author.)

13

A Connecticut Ox Team, Clinton Conn

Snow's Block was built in 1896 along the Indian River on Clinton's East Main Street. It was constructed on pilings and stone piers as a feed and grain store, with farm implements sold on the upper level. The structure was later converted into a silent movie theater and then became one of the first in the state to offer motion pictures with sound. Unfortunately, because the sound was heard on vinyl records and did not synchronize with the picture, the building did not last long as a movie theater. Subsequently, it served at different times as a roller-skating rink, a luncheonette, blacksmith shop, and a dry cleaning and laundry establishment. It was also a favorite with artists, who would sit on the lawn of Andrews Memorial Town Hall and sketch the barn-like building. (Courtesy of the Theodore Neely Postcard Collection, CHS.)

There was once a secret tunnel that ran from the shore of the Indian River to a home in the center of Clinton. It was part of the Underground Railroad, the network abolitionists used to transport runaway slaves. The passage led down from a camouflaged iron door in a subcellar beneath an old home that sat on a hill on the south side of East Main Street. (Courtesy of CHS.)

The entrance to the tunnel at the edge of the Indian River is said to have been somewhere near Snow's Block, at the west end of the bridge that spans the Indian River. It is probable that the entrance was covered when Snow's Block was built in 1896. Historical accounts indicate that scores of runaway slaves were smuggled and protected by many Connecticut towns on their way north to freedom. (Courtesy of Gail Leggett Webster.)

Legend has it that Clinton residents rowed into Long Island Sound to meet anchored ships that were harboring runaway slaves. They then brought the runaways up the Indian River in the rowboats and smuggled them through the tunnel to the house on the hill. There, they were kept secretly and safely until the following night, when they were sent on to the next station along the Underground Railroad. (Courtesy of Gail Leggett Webster.)

In Colonial days, village stocks were restraining devices used as a form of corporal punishment and public humiliation. These stocks are reminders of Kenilworth's early days. They are along East Main Street, between the entrance to the Indian River Cemetery and Clinton Volunteer Fire Department. (Photograph by author.)

In 1665, the first section of the Indian River Cemetery was established by the Ecclesiastical Society, which became known as the First Church of Christ Congregational two years later. The church's first and second meetinghouses were built approximately where the cemetery's Tomb of the Unknown Soldier is today. Both faced the Indian River. (Photograph by author.)

17

The cemetery's first burial was in 1670. The deceased was Margaret Griswold. Her burial plot is denoted by a pillar engraved "MG 1670." When the railroad came through in 1851, graves of entire families had to be moved. Prior to construction of a railroad underpass, the church had a crossing committee whose job it was to stop a funeral procession from going across the tracks if a train was approaching. The cemetery belonged to the church until 1863, when the Clinton Cemetery Association was founded with a fundraiser—a social that raised $25. Up until that time, people had to maintain the plots of their family members. Over time, the association bought more and more parcels of land as they became available until the Indian River Cemetery reached the size that it is today. (Both photographs by author.)

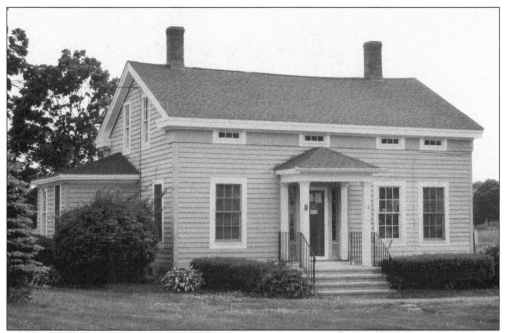

50 East Main Street once stood in the front part of the site where Andrews Memorial Town Hall stands today. Parts of the house date to 1710. This is where Jared Eliot lived when he was the minister of the Congregational church. It was also used as a post office when Benjamin Franklin was the postmaster general. (Photograph by author.)

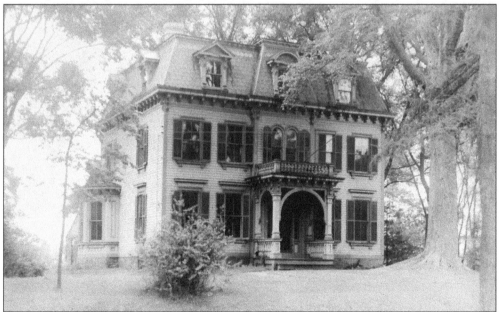

William Stanton Andrews stated in his last will and testament that, if no new town hall had been erected in the Town of Clinton during his lifetime and subsequent to the execution of his will, his executor was to purchase land, suitable in size and proper location, for a town hall. The property his executor selected was the site of one of the Eliot family homes. (Courtesy of the Clinton town clerk's office.)

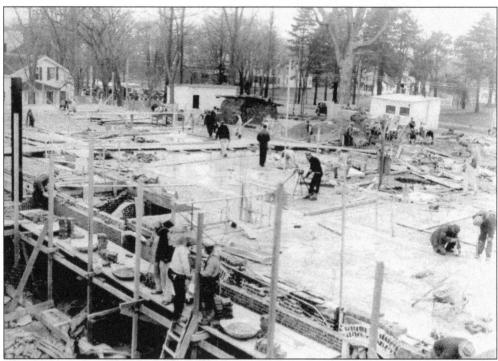

The Eliot house Andrews's executor chose was torn down to make way for the construction of Clinton's new town hall. (Courtesy of the Clinton town clerk's office.)

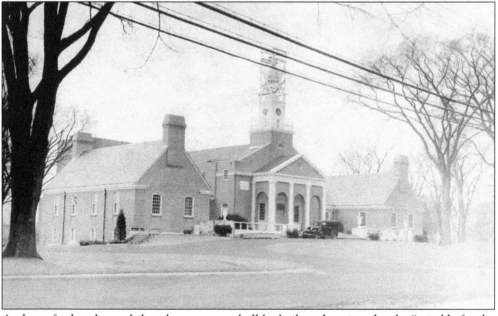

Andrews further directed that the new town hall be built and equipped to be "suitable for the purposes for which a town hall is ordinarily used" and also provide for the town's "social, recreative, and educational activities." The new town hall not only came equipped with the necessary municipal office space, but also had a proscenium theater, a museum room, a courtroom, and a Masonic meeting hall. (Courtesy of the Clinton town clerk's office.)

Andrews asked that his executor consult with five of his friends "as to all architectural and practical questions." Roy Bassette was to be engaged as the architect. The Colonial-style building was constructed of redbrick with white trim, and a cupola or tower with a clock. When completed and accepted, the land and the building belonged to the Town of Clinton. As the building neared completion, Masons laid the cornerstone. (Courtesy of the Clinton town clerk's office.)

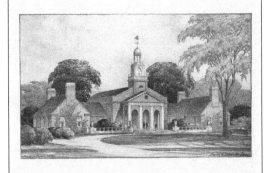

DEDICATION

OF THE

William Stanton Andrews Memorial

Clinton, Connecticut

19 MARCH 1938

With construction completed, the building was dedicated on March 19, 1938. According to Andrews's direction, it was known as the William Stanton Andrews Memorial and had an inscription commemorating the fact that it was given to the Town of Clinton by him. (Courtesy of the Clinton town clerk's office.)

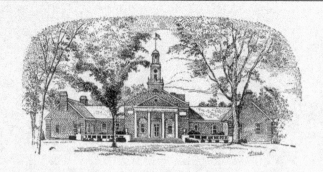

Charlotte and Lewis Harmon's

CLINTON PLAYHOUSE

John Barrymore, Jr.

in

"THE MAN"

WEEK OF JULY TWENTY-SIX TO JULY THIRTY-FIRST
1954

The Andrews Memorial Town Hall's theater has been the site of first-class theatrical and operatic productions as well as first-rate musical concerts. For a time, summer stock came to Clinton, and with each production came stars. Some of the actors included Olivia de Havilland in *Candida*, Farley Granger in *John Loves Mary*, John Barrymore Jr. in *The Man*, Van Heflin in *The Shrike*, and Joe E. Brown in *The Show-Off*, just to name a few. Even then-unknown Jerry Stiller was in *Annie Get Your Gun* as Chief Sitting Bull. (Courtesy of CHS.)

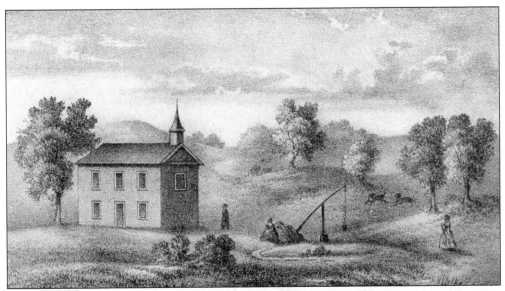

The First Church of Christ Congregational has had four meetinghouses since coming into existence in 1667 in what was at the time the Town of Kenilworth. Its second meetinghouse was built at the beginning of the 18th century, when Abraham Pierson was the rector. It was at his parsonage that the first classes of Yale, then called the Collegiate School, were taught. The sills from his parsonage now support the chimney of the Adam Stanton House. (Courtesy of the First Church of Christ Congregational.)

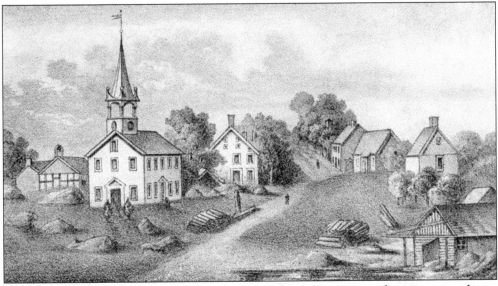

As the years passed, the church's congregation continued to grow, and once again, a larger meetinghouse was needed. In 1731, with Jared Eliot as pastor, the town, now named Killingworth, voted to build yet another house of worship. It was their third since the church had come into existence 64 years earlier. Eliot had replaced Abraham Pierson, who died in 1707. (Courtesy of the First Church of Christ Congregational.)

The third meetinghouse was built on the same hillside where the current First Church of Christ Congregational, erected in 1836–1837, stands today. (Courtesy of the First Church of Christ Congregational.)

Abraham Pierson Memorial, Clinton, Conn.

In 1867, the First Ecclesiastical Society accepted the recommendation of the president and fellows of Yale College to erect a monument celebrating Abraham Pierson. It stands on the same hillside as the church. Chiseled into its base, on two sides, is an inscription. One is in Latin, and the other is in English. It reads: "The earliest senior classes of / Yale College / were taught near this spot by / Rector Abraham Pierson / 1701–1707." (Courtesy of Gail Leggett Webster.)

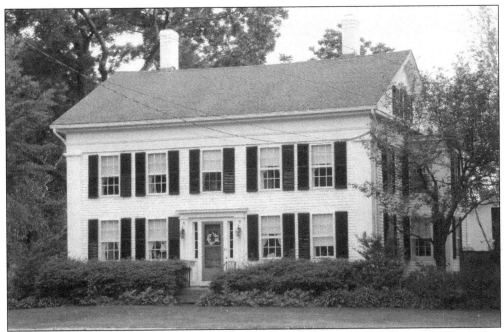

The house at 62 East Main Street was erected in 1783 by a farmer named George Eliot. Many years after it was built, the house was moved back in order to straighten the road. Although a huge central chimney has been torn out and a porch added, this Colonial farmhouse, which is still in the Eliot/Elliot family, remains relatively unchanged today. Until December 2013, the house, next door to Andrews Memorial Town Hall, sat on almost 19 acres of land that ran all the way down to the Indian River. At that time, 17 acres were deeded to the Clinton Land Conservation Trust; the parcel is now called the Elliot Preserve. A second house that was once on another portion of the property was torn down to make way for the construction of Andrews Memorial Town Hall. (Both photographs by author.)

The Clinton Land Conservation Trust was founded in 1967. Chartered by the State of Connecticut, it is a private, nonprofit organization whose purpose is to promote the preservation of the Town of Clinton's natural resources, including water resources, marshland, swamps, woodlands, and open spaces, as well as unique scenic and historic sites; to promote the study of local natural resources and to inform and educate the general public about them; and to acquire property by gift, purchase, or otherwise and to hold and use it to carry out the purposes previously cited. The trust has developed hiking trails at multiple locations throughout Clinton, like at Peters Memorial Woods. (Courtesy of the Clinton Land Conservation Trust.)

26

The Adam Stanton House and General Store was built in 1791. In 1916, the house was left in trust by Adam Stanton's heirs to become a museum. It has been open to the public ever since. It is a unique house-museum that is filled with 19th-century clothing, furnishings, documents, and store inventory, all of which belonged to the original Stanton family. Today, the house looks much the same as when it was built over 225 years ago. (Above, courtesy of Gail Leggett Webster; below, photograph by author.)

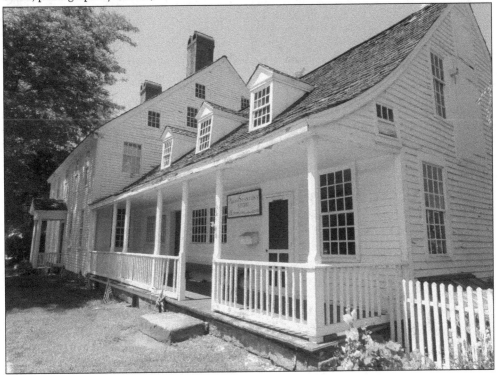

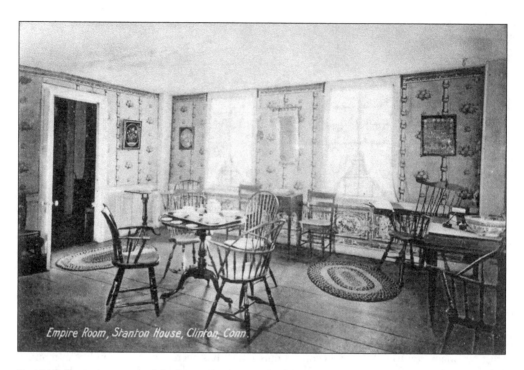

Empire Room, Stanton House, Clinton, Conn.

By 2015, the Stanton House had fallen into a serious state of disrepair, and it had been determined that the trust was insufficient to continue to carry out its intended purpose. Clinton's Historic District Commission applied for and received a $30,000 grant from the Connecticut State Historic Preservation Office to determine what would be needed to preserve the Stanton House and how best to manage the museum going forward. The study recommended that the bank that managed the trust consult with the Connecticut Trust for Historic Preservation and/or Historic New England for guidance in how to transfer a former house-museum to private ownership. The result was a new nonprofit corporation, which in 2018 became the successor to the trust originally created by Adam Stanton's heirs in 1919. (Above, courtesy of Gail Leggett Webster; below, photograph by author.)

ADAM STANTON'S STORE;
of EUROPEAN, & weft India GOODS

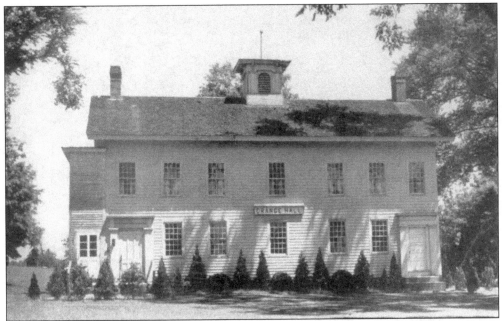

In 1863, after staying at the Stanton House, Henry Wadsworth Longfellow wrote *Tales of a Wayside Inn*, a book of poems divided into three parts. Part one includes "The Poet's Tale: The Birds of Killingworth," which mentions the Academy Building next door. The Academy, built in 1801 as a school, has since had many uses through the centuries, including as Clinton's town hall, a Grange, and home for the Clinton Parks and Recreation Department. Today, it houses the Kidz Konnection Shoreline Theater Academy and looks the same as it did when it was built. (Above, courtesy of the Theodore Neely Postcard Collection, CHS; below, photograph by author.)

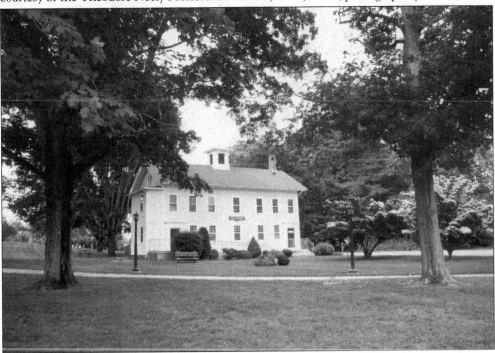

Henry Wadsworth Longfellow's familiarity with what was then Killingworth is evident in his *Tales of a Wayside Inn*. The poem "The Theologian's Tale: Interlude" includes these lines: "The story I shall tell / Has meaning in it, if not mirth; / Listen, and hear what once befell / The merry birds of Killingworth!" Longfellow also references the Academy in "The Poet's Tale: The Birds of Killingworth," writing "From the Academy, whose belfry crowned / The hill of Science with its vane of brass, / Came the Preceptor, gazing idly round." (Courtesy of the Library of Congress.)

Built by a member of the Eliot family, 68 East Main Street was occupied at one time by George Eliot's grandson Ely Augustus Eliot. He was a brigadier general in the artillery, served as a state senator, and was president of the New Haven and New London Railroad. 68 East Main is known locally as "the Milestone House" because of the marker at the corner of the lot. (Courtesy of Henry Carter Hull Library.)

According to Clinton lore, Postmaster General Benjamin Franklin traveled to Boston in a cushioned chaise that had a cyclometer attached to its wheels. Following in carts, men dropped stone markers as each mile was registered on the cyclometer. One of those stones, marked "25 NH," was set on the south side of the Boston Post Road in Colonial Kenilworth. It can be seen there today at 68 East Main Street. (Photograph by author.)

BAPTIST CHURCH CLINTON CONN

The Baptist Society of Killingworth was founded in 1797. It had 36 members. In the early 1800s, it met at the Academy, and by 1835, began construction on a church of its own. It was completed three years later. The new church was erected next door to the Milestone House. The original parsonage was across the street from the church, but a new one was built in the rear in the early 1960s. In 1980, the church constructed a new building on the same site, farther back on the lot at 70 East Main Street. (Left, courtesy of Gail Leggett Webster; below, photograph by author.)

The Morgan School opened for classes in April 1872 with 205 students, a principal, 5 teachers, a janitor, and a budget of $6,500. The building was a gift to the town from Clinton native Charles Morgan, a railroad and shipping magnate who played a leading role in the development of transportation and commerce in the South. In addition to the $110,000 Morgan donated to build and fully equip the school and purchase the cottage next door as a preceptor's residence, he established an endowment fund of $50,000, which increased over time and was valued at $200,000 by 1879. The endowment paid for the school's maintenance, teacher salaries, and all other expenses except textbooks, pens, pencils, and paper. Morgan proclaimed that the building would be solely for the use and benefit of the town and be free of any political, partisan, or sectarian purpose. (Courtesy of the Theodore Neely Postcard Collection, CHS.)

As time went by, the Morgan School needed major repairs, and by 1947, state inspectors had condemned the building as unsafe. In May 1950, the people of Clinton voted 425 to 154 to build Morgan a new home. It was erected on 24 acres, which had been purchased by the town in 1948. With construction complete, the new Morgan opened for classes in the fall of 1950. (Courtesy of CHS.)

By 1953, the first of several additions had taken place, followed by more in 1963, 1967, 1986, and 1988. Shortly after the start of the next century, it became apparent that the new Morgan was facing the same fate as its predecessor. In 2012, by a margin of 40 votes, the people of Clinton approved the construction of yet another new Morgan. Its ground breaking took place in the fall of 2014, and the school opened for classes two years later. (Courtesy of Clinton Public Schools.)

Statues of Abraham Pierson, the first president of Yale, and Charles Morgan were erected in front of the original school in 1874 and have remained in the same location ever since. One side of the Pierson statue's base reads, "Erected by Charles Morgan / of New York / a native of this place." (Photograph by author.)

The Morgan School provided a tax-free education for all of Clinton's children until 1933. By then, the student population had grown to such an extent that the Clinton Grammar School was built next door, where the Morgan preceptor's home once stood. For the first time, the townspeople had to pay taxes for the education of their children. (Courtesy of the Theodore Neely Postcard Collection, CHS.)

The Dew Drop Inn was known far and wide for its dances, special dinners, and entertainment. It was a favorite stop for hunters and fishermen. In the winter, it was the destination of many a sleigh-ride party. The inn's proprietor, who was very well-liked by not only townsfolk but also tourists, was a one-man band and claimed he could play 32 musical instruments at one time. One tragic Wednesday afternoon, his musical instruments and the inn were wiped out in a fire. In its place, a more modest home for the restaurant was constructed. Eventually, as popularity of the horseless carriage grew, the building changed hands and was transformed into a garage. To this day, remnants of the burned out Dew Drop Inn can be found in the current building's underpinnings. (Above, courtesy of the Theodore Neely Postcard Collection, CHS; below, courtesy of Gail Leggett Webster.)

The Clinton Antique Center at 78 East Main Street (below) opened for business in 1992 where the Clinton Garage (above) used to be. Under various owners, the Clinton Garage was in operation from the time the building was constructed in 1925 until 1992. Prior to the garage, the site was the home of the Dew Drop Inn. Other than the signs across the front, the exterior of the building remains unchanged. (Above, courtesy of Gail Leggett Webster; below, photograph by author.)

Episcopalians had a difficult time getting started in Colonial Connecticut. They tried for 172 years, beginning in 1701, and finally, in 1873, the Episcopal Society of Clinton came into existence. One year later, work was started on its church, which was built next door to the original Morgan School. (Courtesy of Gail Leggett Webster.)

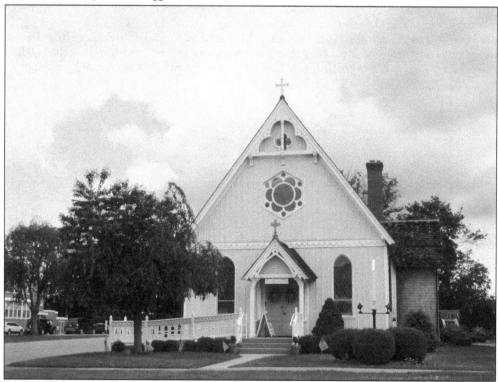

Looking very much the same as it did when it first opened its doors in 1875, the Church of the Holy Advent still exists today on two acres of land at 81 East Main Street. (Photograph by author.)

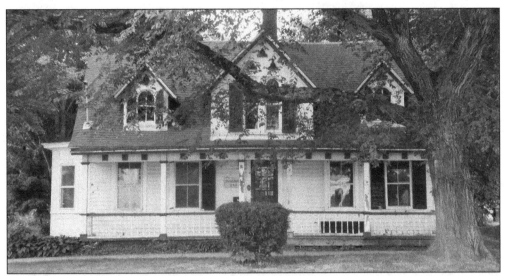

The house at 92 East Main Street was built in 1760 by Josiah Kelsey on land that had been granted to his ancestor William Kelsey in 1665. It is the second house to have been erected on the site and was in the Kelsey family for six generations. Tree trunks still bearing bark are in the cellar and support the house, whose front porch, dormers, and bay windows were added many years later. One of the first-floor rooms has a cupboard that can swivel to reveal a small hidden room. Perhaps it was a place for the family to hide during the First Indian War. In later years, what a wonderful space it must have been for a child to disappear into during a game of hide-and-seek. (Photograph by author.)

This house at 95 East Main Street was built in 1807; 13 years later, Horatio Wright was born there. He went on to become a Civil War icon, serving in the First Battle of Bull Run, the Battle of Gettysburg, the Siege of Petersburg, and the Appomattox Campaign. (Courtesy of Henry Carter Hull Library.)

Said to be the oldest brick house between New Haven and New London, 103 East Main Street was built in 1750 by Elisha White, a ship's captain. The bricks were baked in England and brought to the colonies as ballast on a sailing ship. Today, it is a house-museum and contains portraits, period furniture, and domestic tools appropriate to an 18th-century home. The property, nicknamed "Old Brick," was donated to the Clinton Historical Society in 1987 by Sally MacMillan, who, along with her husband, Douglas, restored the building in the early 1950s. (Both photographs by author.)

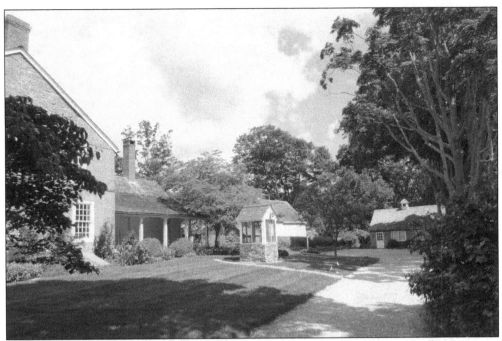

Old Brick's expansive grounds house the Clinton Historical Society's library, which was built following a substantial gift from the estate of George Flynn. Also on the property are a stone smokehouse, which was moved to the grounds from 110 East Main Street in 2017; a spacious garden, where Shakespeare is performed in the summer by the Kidz Konnection Shoreline Theater Academy; and the Buell Tool Museum, whose massive granite step, which originally belonged to the Academy, was removed for the construction of a ramp following the 1990 passage of the Americans with Disabilities Act. The step was donated to the historical society in 2006. (Both photographs by author.)

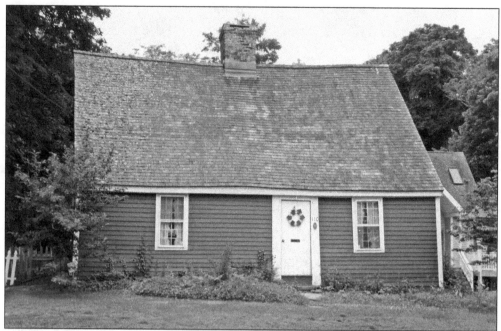

110 East Main Street may well be the oldest house in the town of Clinton that sits on its original foundation. And although it is cited as having been built in 1710, the first mention of a "house and buildings" on the property is recorded on a deed in the Killingworth Land Records dated 11 years earlier, in 1699. (Photograph by author.)

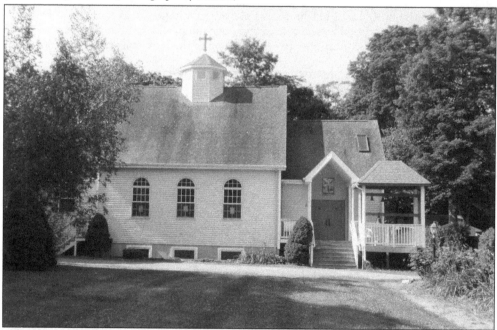

110 East Main Street was built by a relative of one of the signers of the Declaration of Independence. It is opposite the Lower Green on one of the original 1663 grants of land. The house now belongs to a church, which was built in 1998 at 108 East Main Street, just behind and to the right of the house. (Photograph by author.)

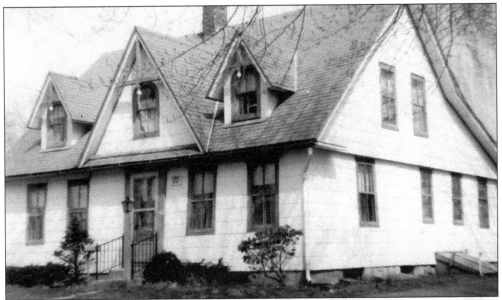

According to a Works Progress Administration (WPA) writers' project, 125 East Main Street was built in Chester, Connecticut, by the Griswold family. The house was moved to Clinton by rolling it on logs while pulling it with oxen. The fireplaces are probably not original, as it would have been almost impossible to move them along with the house. The owners at the time of the WPA project stated that an 1819 penny fell out of the chimney while cleaning it one day. (Courtesy of Henry Carter Hull Library.)

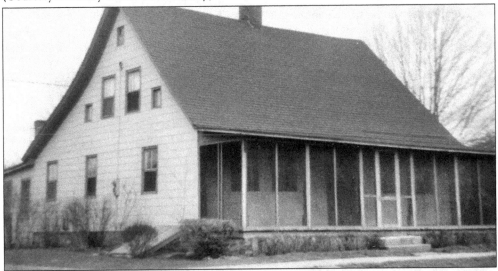

159 East Main Street was built in 1720. It is said to have been a fisherman's house down by the water at Hammock, which was later called Colburn Point, at Beach Park. It was moved to its current location sometime before the next century. At one point, the house was owned by two brothers who did not get along, so they divided it into two equal parts. Thus, there were two of everything, including two kitchens and two wells. In the 21st century, it became part of a condominium complex, but other than removal of the porch, which had been added years after it was originally built, and an extension at the back, the house looks much the same as it did hundreds of years ago. (Courtesy of Henry Carter Hull Library.)

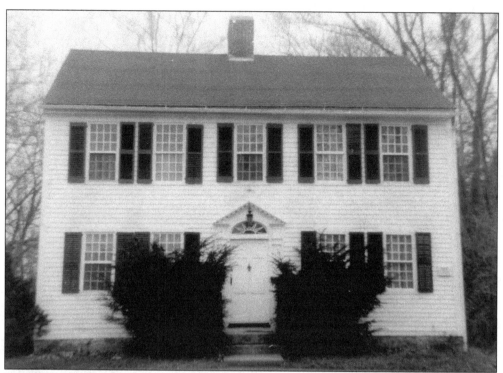

In 1785, Richard Buell constructed 17 Waterside Lane. The underpinnings of the house were built of chestnut logs that were floated down the Connecticut River from Essex and then brought into Clinton Harbor and hauled up the waterside by a team of oxen. The lumber for this house was made from part of the raft that had been used to carry the lumber to construct 23 Waterside Lane downriver. The house looks much the same today as when it was built over 200 years ago. (Courtesy of Henry Carter Hull Library.)

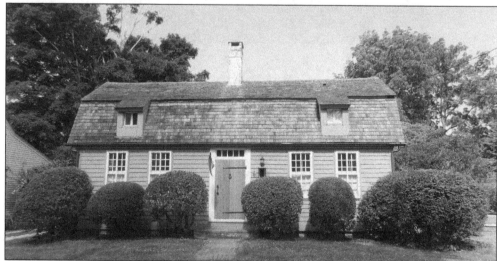

21 Waterside Lane was built in 1800 and has a gambrel, or Dutch, roof in the front, with two slopes instead of one. The slope at the rear of the house is classic Saltbox. Behind it are two barns, an expansive double lot, and an enormous Japanese hydrangea, which displays solid white blossoms about mid-June every year and is considered to be between 125 to 150 years old. (Photograph by author.)

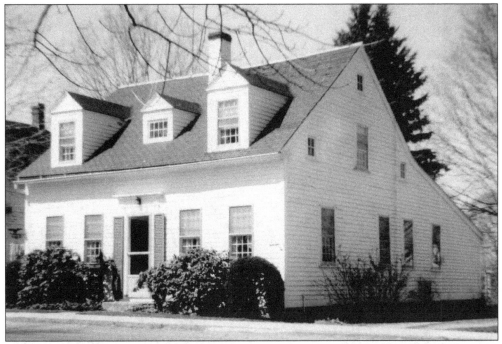

23 Waterside Lane was built in 1785. The lumber used to build the house was floated down the Connecticut River on a raft from Essex. It eventually landed at the foot of South Street, now Waterside Lane. The raft's lumber was then used to build 17 Waterside Lane. The house at 23 Waterside looks much the same today as it did when it was constructed over 200 years ago. (Above, courtesy of Henry Carter Hull Library; below, photograph by author.)

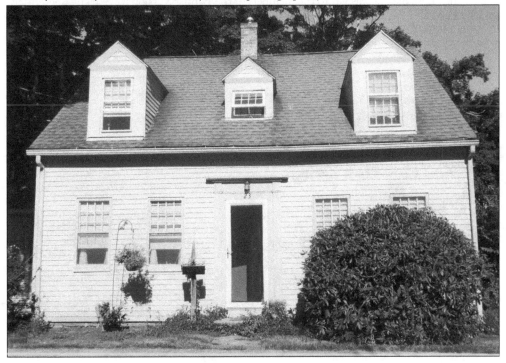

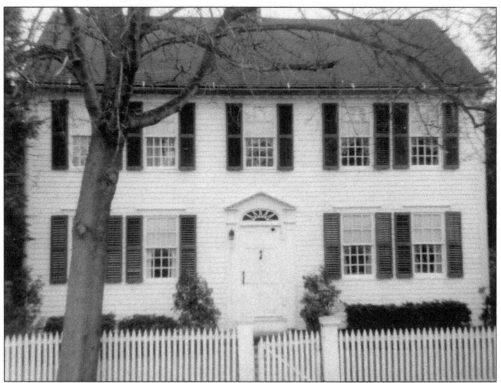

John Wellman built the house at 39 Waterside Lane in 1800. The original carriage house was moved from the yard and attached to the house to make a kitchen. When the last of the Wellman family to own the house died, it was left to the members of the Baptist Missionary Society. Regrettably, they had no use for it, so they sold the house to John Bliss, the proprietor of a meat market in Clinton, for $1,000. (Above, courtesy of Henry Carter Hull Library; below, courtesy of CHS.)

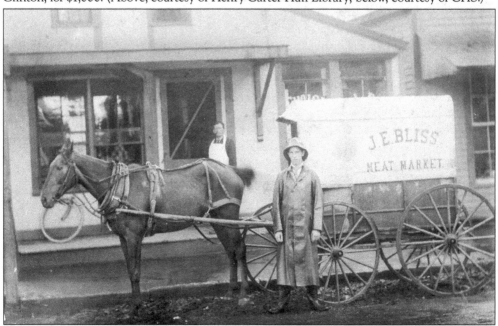

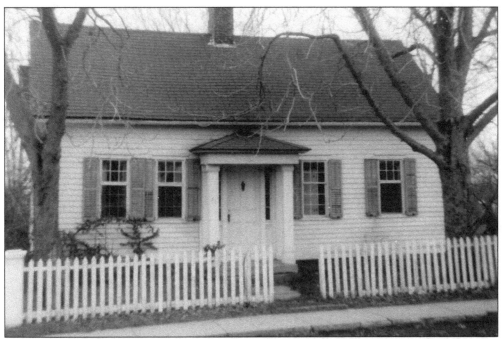

43 Waterside Lane was originally believed to have been built in 1790, but records indicate that it was actually constructed about 15 years later on land purchased in April 1804 by a young man from Oyster Pond Point, Long Island, New York. The following year, he sold the property to his father. The son was a sailing master from the age of 17 who married a local woman and moved away from Clinton. The father was a ship's captain as well. The father continued to live on Waterside Lane until he drowned in Clinton Harbor in 1813. The house looks much the same today as when it was built. (Above, courtesy of Henry Carter Hull Library; below, photograph by author.)

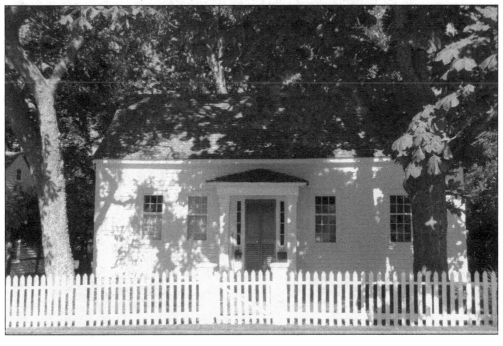

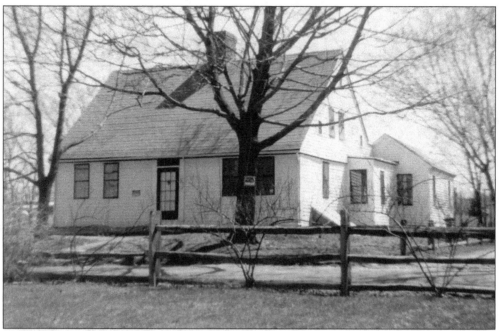

At one time, 62 Waterside Lane was a self-sufficient farm. Built in 1797 by Silas Wellman, it had its own smokehouse, blacksmith shop, pigsty, corncrib, cobbler shop, carriage house, and two full-size barns. As of 1967, the original land grant of 1700 was still in existence. A second land grant followed in 1713 and a third in 1732–1733. "In the reign of the King of England" was included in both land grants. Wellman was not only the deacon of First Church of Christ Congregational for 60 consecutive years, but also a member of the state legislature, where he was influential in the founding of the "old age pension." Today, the house looks much the same as it did when it was built. (Above, courtesy of Henry Carter Hull Library; below, photograph by author.)

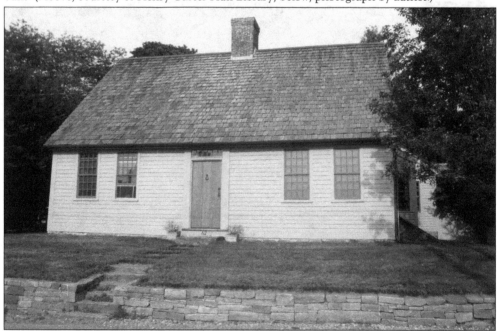

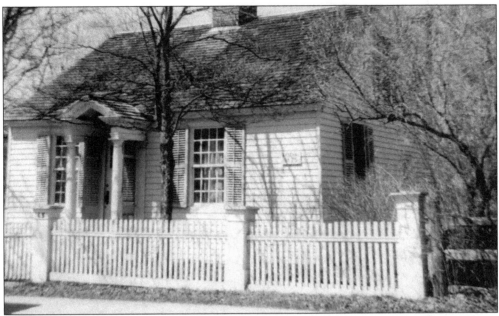

The house at 65 Waterside Lane is known as "the Arsenal" and is the street's oldest-surviving structure. It was originally built in 1675 as a fortification at the foot of Waterside Lane, then known as South Street. Built as an arsenal on the east side of the Indian River, it was a refuge for the colonists against the Native Americans during the First Indian War. Another such fortification was built on Wharf Road, Commerce Street today. During the American Revolution, the Arsenal housed a small group of soldiers, their cannon, and some stores. In 1793, after the Revolution, a team of oxen moved the 506-square-foot building to its present location. Other than a 21st-century addition at the rear, it looks very much the same as when it was moved to its current site. (Above, courtesy of Henry Carter Hull Library; below, photograph by author.)

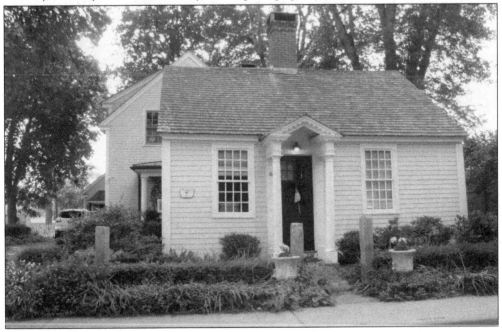

A carronade is a short, smoothbore, cast iron cannon, originally manufactured by the Carron Company, an ironworks in Scotland, which was used by the Royal Navy from the 1770s to the 1850s. Its primary function was to serve as a powerful, short-range weapon. In the park at the end of Waterside Lane is a carronade, which the residents of Killingworth (now Clinton) used during the War of 1812 to rid the harbor of a British frigate. (Photograph by author.)

At the southern end of Waterside Lane, which was known as South Street in Colonial days, is the area known locally as "Waterside." Many of the houses built there hundreds of years ago remain today. It is also the home of the park with the carronade and is adjacent to one of Clinton's many privately owned marinas, as well as the bridge to the town beach. (Courtesy of the Theodore Neely Postcard Collection, CHS.)

Waterside and the Clinton Town Beach are connected by a bridge. Until 1976, the First Church of Christ Congregational owned Parsonage Meadow, which was on the other side of the bridge from Waterside. That year, the church deeded the property to the Town of Clinton. This is now the site of the Clinton Town Beach. (Courtesy of CHS.)

The Old Green, Clinton, Conn.

In 1663, when the original 30 land parcels were allotted to 30 families, there was a town green laid out called "the Common." Years later, it was renamed the Lower Green. Today, it is known as Liberty Green and is an integral part of the Liberty Green Historic District. The green was a muster field during the American Revolution, and at the end of that war, a schoolhouse was erected there. That schoolhouse was replaced twice, the second time by the brick East District School. (Courtesy of Gail Leggett Webster.)

Lower Green, Clinton, Conn.

A redbrick schoolhouse, which was built at the same time as the Academy, once stood on the Lower Green. It was known as the East District School and closed soon after the original Morgan opened. The building then served the town for several years as a store and also a lockup. It was torn down in 1900. (Courtesy of CHS.)

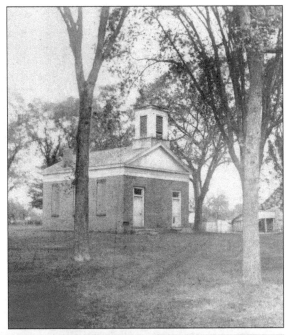

There is a small cannon on Liberty Green that saw service during the War of 1812. It sits on a red carriage mounted on a rectangular stone platform. It was placed on the green by the Woman's Relief Corps on September 10, 1925. On the west side of the cannon's platform, there is a bronze plaque dedicated "to the patriots of the town who defended our coast from British invasion." (Photograph by author.)

According to the plaque on the statue of the Civil War soldier on the Lower Green, it was "erected by the Woman's Relief Corps and the citizens of Clinton in memory of the soldiers and sailors who fought to preserve the Union, 1861–1865. For the dead a tribute, for the living a memory, for posterity an emblem of loyalty to the flag of their country." (Courtesy of CHS.)

The Liberty Green Historic District was created in 1979 following an extensive study and approval by the State of Connecticut. The district is currently comprised of six houses on Liberty Street and Liberty Green. It is overseen and protected by the Historic District Commission, which was created along with the district. (Map by author.)

Liberty Green
Historic District
Established 1979
Based upon Assessor's Map #67

LIBERTY ST.

1

2

3

4

5

6

23

26

EAST MAIN ST.

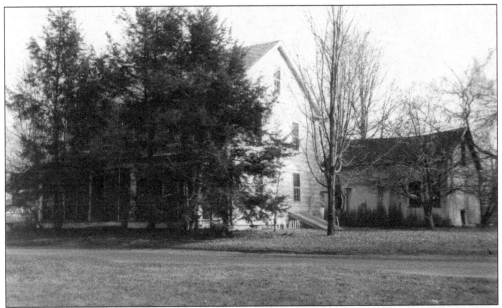

Built in 1734 by John Rossetter, 3 Liberty Street is a two-story Colonial-style house in the Liberty Green Historic District. The Rossetters owned this property until approximately 1800, when it was bought by the Buell family. The legendary "Leatherman," a vagabond who traveled between the Hudson River and the Connecticut River for years, was friendly with Buell, and whenever he was in Clinton, he slept in an upper room of Buell's shop at the rear of the property. The site, at one time used for the blacksmith trade, today is a bed-and-breakfast with historically appropriate decor. (Above, courtesy of Henry Carter Hull Library; below, photograph by author.)

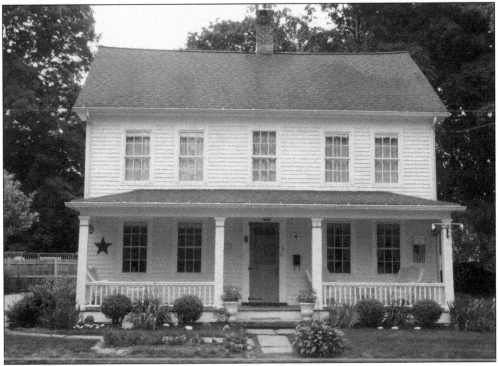

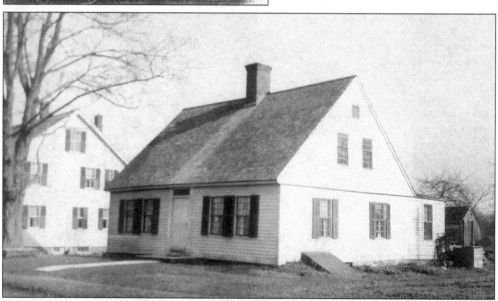

The oldest house in Clinton's Liberty Green Historic District is the Elderkin Homestead at 5 Liberty Street. On March 17, 1725, John Elderkin of Norwich, County of New London, sold land in Killingworth, which at the time was in the County of New London, to his son James for £20. The sale was recorded on July 1, 1726, in the Killingworth Land Records. Part of the deed is pictured here. (Courtesy of the Clinton town clerk's office.)

On March 9, 1791, Elisha Elderkin, a Revolutionary War veteran, and his brother John bought the land and the house upon it from their father, James Elderkin, who still lived there at the time of the transaction. By now, Killingworth's county was Middlesex, and Connecticut was no longer a colony, but a state. The deed for this sale is on file in the Killingworth Land Records. (Courtesy of CHS.)

On August 9, 1817, Elisha Elderkin of Killingworth sold the house and land to Buckminster Brintnil Elderkin, a War of 1812 veteran. His estate sold the house on October 20, 1879, and it passed out of the Elderkin family. (Photograph by author.)

WAR OF 1812
DOWD, RUSSELL B.
ELDERKIN, BUCK
ELIOT, ELY A.
GRISWOLD, ASHBIEL
GRISWOLD, SAMUEL
HALE, WILLIAM

In 1993, a fire destroyed the interior of 5 Liberty Street, and the owners would not repair or sell it. The house sat with a tattered blue tarp on it for almost 10 years and was overrun by termites and powder post beetles. (Courtesy of Linnea Taylor Grande.)

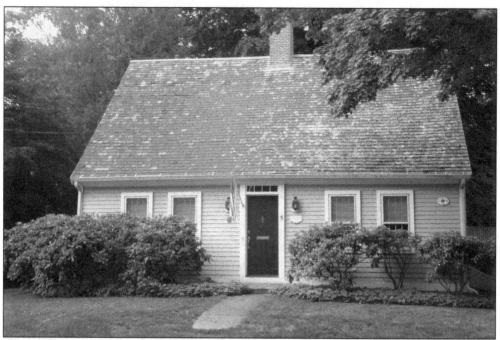

In the summer of 2000, the Town of Clinton went to court and got the house condemned, and the owners were notified by certified mail that its demolition had been ordered. Then, the owners were finally willing to sell the house, which was fully restored by the new owner at the end of April 2002. (Photograph by author.)

In 1724, one year before James Elderkin bought the property from his father, he built a gristmill on the Indian River. It was the first mill ever to be built on that river and was located in the section of town appropriately named the Mill District. (Photograph by author.)

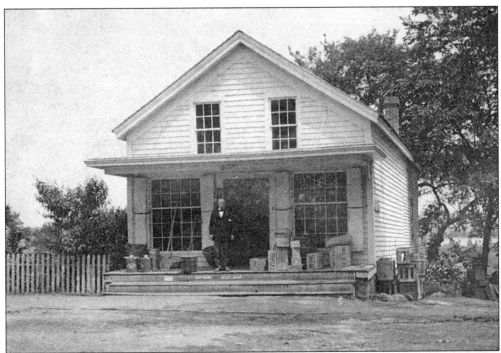

In Colonial times, the area behind 109 East Main Street and 6 Liberty Street was considered to be Clinton's inner harbor. Thus, the entire marsh and wetlands behind the Indian River Cemetery up through Liberty Street was navigable by small boats. When the railroad came through in 1851, the railroad bridge and the railroad bed cut off most of the inner harbor, which silted and filled in with marsh grasses. Looking closely, the remains of old docks behind the houses on both sides of the railroad tracks can still be seen today. (Above, courtesy of Joe and Ginny Kabe and David Perrelli; below, photograph by author.)

6 Liberty Street was built in 1840 and is on the western side of Liberty Green. Due to the height of the forsythia hedge in front, one might not even know it is there. The hedge and the grass behind it, down to the driveway, actually belong to the Town of Clinton. Regardless, the homeowner trims the hedge multiple times each year and mows the town's portion of the lawn. Additionally, due to the house's proximity to the marsh grasses that filled in centuries ago, the owners of 6 Liberty Street have multiple sump pumps in their basement running 24 hours a day, seven days a week. 109 East Main Street and 6 Liberty Street are in the process of being added to the Liberty Green Historic District. (Above, photograph by author; below, map by author.)

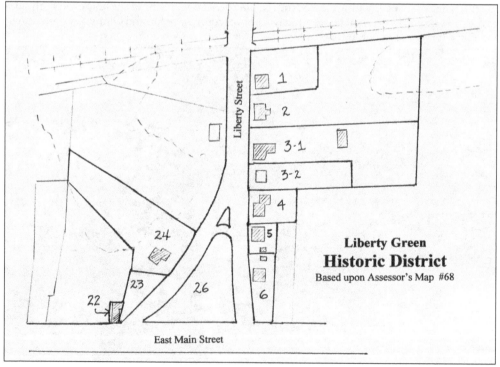

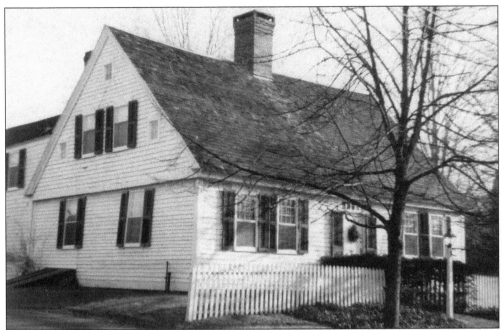

11 Liberty Street, another of the six original houses that comprise the Liberty Green Historic District, was built in 1750. Until November 2007, the house had a generous side lot, with a magnificent stone wall that ran the length of the property along Liberty Street. Unfortunately, a misguided employee in the town's Land Use Office told the owners that they were entitled to one free land split. While that may well be true in other parts of town, it cannot be done in a local historic district. But by the time what she had advised them was discovered, the split had been made, and the land was sold to a local developer who bulldozed the wall without even acquiring any of the necessary permits. (Above, courtesy of Henry Carter Hull Library; below, photograph by author.)

Luckily, the town's Historic District Commission required that the contractor build a house whose appearance was period appropriate, rather than the Texas-style ranch house he had planned. Regardless, the remaining property at 11 Liberty Street looks much the same from the street as it did centuries ago. (Photograph by author.)

The front of 15 Liberty Street, as seen from the road, was built by John Rossetter III and his wife, Elizabeth, in 1799. This facade and an addition were part of remodeling done by them of John Rossetter Sr.'s 1663 home, one of the 30 original land grant parcels. Members of the Rossetter family were successful privateers and captains who amassed a fortune during the American Revolution and War of 1812 by capturing British ships. (Courtesy of Henry Carter Hull Library.)

In peacetime, their vessels transported agricultural goods to the West Indies and returned to Clinton with sugar and molasses. John Rossetter III operated a grocery and liquor store at 15 Liberty Street from 1818 until his death in 1841. He and his ancestors are buried at the Indian River Cemetery. The property remained in the Rossetter family into the 1900s. (Photograph by author.)

15 Liberty Street is yet another member of the Liberty Green Historic District. It sits on almost two acres of land, an extensive piece of property in modern times for a home so close to the town center. There is a pond where the owners' geese and ducks can swim, a barn, and an expansive lawn. Today, the facade looks much the same as when it was remodeled by Elizabeth and John Rossetter III in 1799. (Courtesy of Rich Manley and Eric Ambler.)

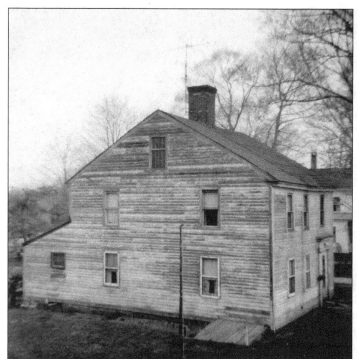

Heading north, 22 Liberty Street is on the left, just over the hill and next to the railroad tracks. Of course, no railroad was there when this house, constructed of 21-inch planks, was built in 1750. The kitchen was once a chicken coop, the beams in the attic are held together by wooden pegs, and the chimney base is the brace that supports the whole house. (Courtesy of Henry Carter Hull Library.)

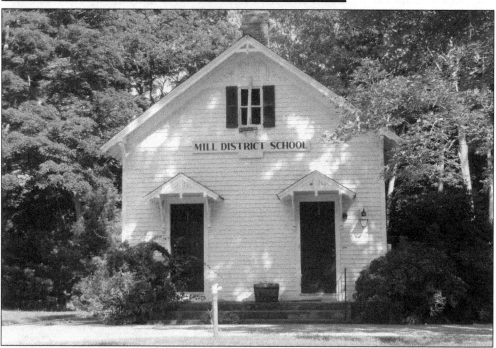

As settlements grew, new schools were built in different parts of the town called districts. Each district erected and cared for its own school and had a district committee that hired the teacher and took full responsibility for the building and its operation. One was the Mill District School, a one-room schoolhouse with two front doors, one for the boys and one for the girls. Its student population in 1814–1815 numbered 14. (Photograph by author.)

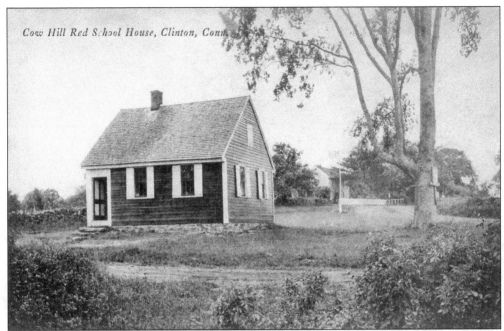

Cow Hill Red School House, Clinton, Conn.

Another district school was Cow Hill, built in 1800, which had 40 pupils 14 years later. As with other early schoolhouses, it had one room and was constructed of wood. Additionally, there was a woodshed; an outhouse, known as a privy; and a potbellied stove to heat the building. The blackboard was on one wall and made of boards that were painted black. The students sat at double desks, which were arranged in rows, and had seats with backs. Two students sat at each desk. Books, slates, and slate pencils were paid for by the parents, and penmanship was practiced in paper-copy books. The teacher's desk was on a raised platform, which made it easier to see any mischief-makers. (Both, courtesy of Gail Leggett Webster.)

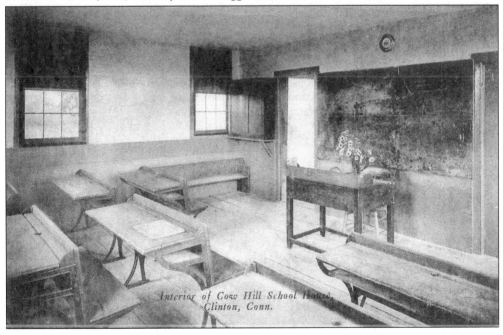

Interior of Cow Hill School House, Clinton, Conn.

Clinton has a number of residential beach communities adjacent to Long Island Sound. One is Grove Beach, which shares its name and part of the beachfront with the neighboring town of Westbrook. Grove Beach was originally developed as a summer resort by William Lewis, who acquired the land in 1871. Since railroad service along the Connecticut coast ran a mere half mile north of Grove Beach, Lewis decided to share the beauty of his woods and beaches with farm families and city workers as well as school and church groups. For a modest fee, they could visit his grove for rest and recreation. In the woods near his house, he built picnic tables and a dance pavilion, all overlooking Long Island Sound. Nearby were refreshment stands, swings, a shooting gallery, bowling alley, and croquet lawn. And there were bathhouses on the beach in which bathers could change their clothes. By the late 1880s, there were doctors, lawyers, educators, and engineers who owned their own cottages at Grove Beach rather than renting them. (Courtesy of the Theodore Neely Postcard Collection, CHS.)

Another is Clinton Beach, which was devastated by the hurricane of 1938. In 1819, when the trolley was introduced to the shoreline, Clinton became a vacation destination for landlocked folks. Thus, two innovative developers began to build cottages along Shore Road. The community was originally called Seaside Homes. The Clinton Beach Association, which includes several homes on Grove Way and the Causeway, along with those that were built on Shore Road, was formally established as a taxing district by Special Act No. 271 of the Connecticut legislature in 1967. (Above, courtesy of the Theodore Neely Postcard Collection, CHS; below, courtesy of Gail Leggett Webster.)

Four Corners, also known as "the Corners," is the place where east meets west in Clinton. It is the intersection where East Main Street, West Main Street, Commerce Street, and Post Office Square converge. On the northwest corner, at the intersection of West Main Street and Post Office Square, is 1 West Main Street, a large brick building that was the final home of Henry Carter Hull's Clinton National Bank. Across the way, on the southwest corner of West Main and Commerce Streets is Clinton's post office. The town's current brick post office was constructed in 1936, replacing the gabled building that once served the town. (Both, courtesy of CHS.)

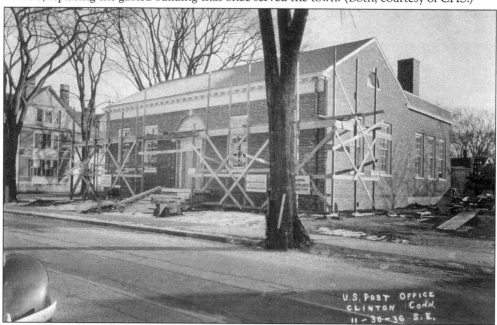

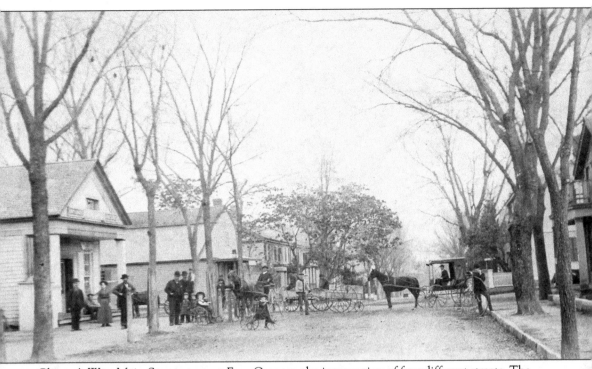

Clinton's West Main Street starts at Four Corners, the intersection of four different streets. The road is also known as the Boston Post Road, as well as US Route 1, and runs west to neighboring Madison's town line, located at the bridge over the Hammonasset River. (Courtesy of CHS.)

Clinton's Commerce Street was originally named Wharf Lane. It was first laid out in 1814 to facilitate access to the shipyards. The Methodist church and Lobster Landing can both be found on Commerce Street. A number of marinas are situated there as well. In the days of the Homonoscitt Plantation, its southern end was the general location where the Native Americans lived in proximity to the settlers. (Courtesy of the Theodore Neely Postcard Collection, CHS.)

Clinton's Methodist church came into existence in May 1830, following a conference in New York City where a pastor was appointed. The cornerstone of its first meetinghouse, a rough, unfinished barn on the outskirts of town, was put into place a few months later. It was the congregation's home for the next 20 years. But the parishioners wanted their place of worship to be in the center of Clinton, so in 1854, a parcel of land was purchased from J.D. Leffingwell for $300. Within a year, the structure that still stands at 12 Commerce Street opened its doors for worship. Although the church was built with a steeple, the congregation so feared for its safety that they voted to have it removed. In 1888, it was. (Both, courtesy of the United Methodist Church.)

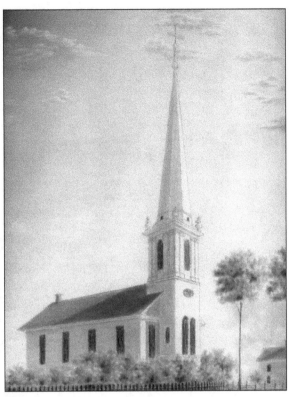

Methodist Church, Clinton, Conn.

During its first two decades, the church had no parsonage, which made it difficult to attract a pastor. But with the 1853 purchase of a house on John Street, the church could now easily attract a qualified preacher. The parsonage remained at John Street for the next decade, at which time a new one was built on Commerce Street, next door to the church. In the meantime, for more than 120 years, the church went without a steeple and remained that way until 2009, when a new one was installed. (Left, courtesy of Gail Leggett Webster; below, courtesy of the United Methodist Church.)

Commerce Street starts at the Boston Post Road and runs south, ending at Clinton Harbor. Grove Street does the same. When both streets reach the docks, they converge since they are not parallel. Where they meet is known as Lobster Landing. The current building at 142 Commerce Street was constructed in 1940 and has been known by various names. (Courtesy of the Theodore Neely Postcard Collection, CHS.)

For some time prior to 1995, it was known as J&J Lobster. From 1995 to 2002, it was named BB&G Lobster and was owned by two brothers from Italy. After one brother went back across the pond, the one who remained renamed the business Lobster Landing—a name that has been synonymous with the site for over a century. (Courtesy of the Theodore Neely Postcard Collection, CHS.)

St. Mary's Roman Catholic Church, Clinton, Conn.

During the 1600s and 1700s, Clinton's settlers were predominantly Protestant. In the 1800s, there was an increase in immigration from Southern European countries, which brought religious diversity. The town's Catholics were served by mission priests who initially held Mass in private homes and later at the Academy Building. Clinton's first Roman Catholic church, St. Mary's, was constructed on Pearl Street in 1914 and enlarged three years later. The current building, at 54 Grove Street, was built in 1956. (Courtesy of Gail Leggett Webster.)

Bacon House, Clinton, Conn.

In the 1800s, people who loved the shore flocked to Clinton's Bacon House. The hotel was situated on a hill on the west side of Grove Street and overlooked the harbor. Its guests were transported to Clinton by train, boat, or horse-drawn vehicle from other parts of Connecticut, as well as other states. Many made the hotel home for the summer, bringing their children, household help, and even their dogs. (Courtesy of Gail Leggett Webster.)

CLINTON MANOR INN, CLINTON CONN.

During the summers when the Clinton Playhouse was in town, the actors stayed at the Clinton Manor Inn at 90 West Main Street. It has been said that when John Barrymore Jr. was in a production, he regaled everyone with post-curtain parties there. The Clinton Manor Inn closed in 1976 and was torn down to make way for a small shopping mall that was built on the site the following year. (Courtesy of Gail Leggett Webster.)

The house at 129 West Main Street was built in 1837 by a couple with the surname of King; it stayed in their family for four generations. Although no early pictures of the house could be found, it is believed to look much the same today as when it was built (Photograph by author.)

The Kings, who built 129 West Main Street, had daughters. Legend has it that none of them ever married, so in 1890, their parents built a house next door in which these spinster offspring could reside. Today, it is 121 West Main Street, and other than the addition of a front porch, the house looks much the same as when it was built. (Courtesy of George and Tisha Marshall.)

Cedar Island is in Long Island Sound and belongs to the town of Clinton. Today, it is no longer an island but rather a peninsula. It is attached to Hammonasset State Park in neighboring Madison, Connecticut, due to the strait that separated them being filled in to improve the flow of the Hammonasset River through Clinton Harbor. The island has 54 homes and a summer population of approximately 125. There is no electricity or telephone service, although a solar-powered telephone on the town dock runs directly to the police department for use in emergencies. The public water supply to the homes is seasonal, and today, many of them use propane gas for heat and hot water, while others use solar power. The only transportation to and from Cedar Island is by boat. (Above, courtesy of Tom Walsh; below, photograph by author.)

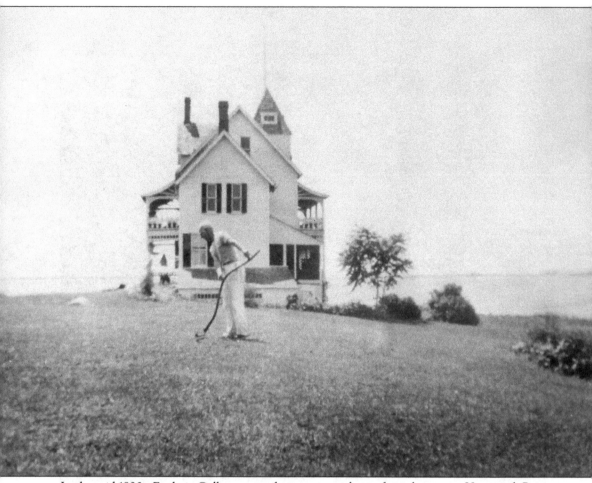

In the mid-1800s, Frederic Colburn rented property at what today is known as Hammock Point. There, he established an oil works, which processed porgy, whitefish, and menhaden, also known as bunker. The fish were cooked with steam to break down the cells and then pressed to separate the oil. The oil, in turn, was used in paint and for tanning hides. The pieces of fish that remained were dried in kilns and then crushed into meal, which was used as fertilizer and to feed farm animals. In 1880, Colburn bought the property, where he built a summer house using no nails, only dowels. The house, which withstood the hurricane of 1938, was destroyed by fire on March 11, 1974. (Both, courtesy of Marcy Fuller)

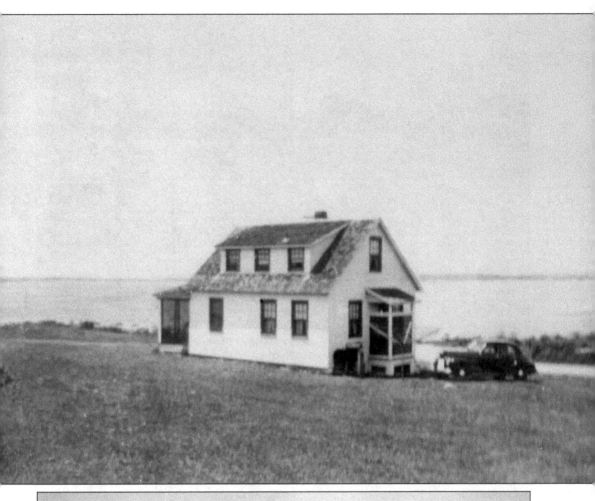

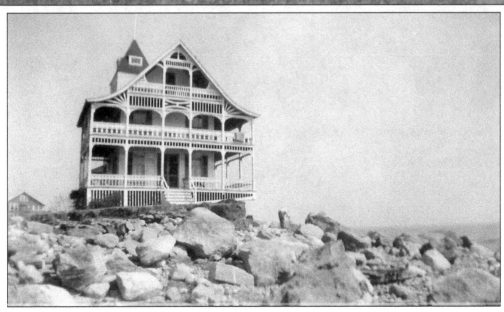

Clinton's history embraces seafaring folks, and thus, the town has always had many marinas. Some are small and front on the Indian River, and today, along with renting out seasonal slips to boat owners, at least one rents kayaks and canoes on a daily basis. Another one is at Waterside. Larger marinas, including the town's, are in Clinton Harbor opposite Cedar Island. Some are even on the Hammonasset River, across from the neighboring town of Madison. The town's marina has both seasonal and transient slips and posts and is where the police and fire departments tie up their boats. Plenty of seagulls are there as well. Anyone who wants to know from which direction the breeze is coming just has to watch the gulls. They will always be facing directly into the wind. (Photographs by author.)

Two

LEADERS AND LEGENDS

Through the centuries, the town, regardless of name, has had numerous leaders and legends. They have varied from the well-to-do to some of the financially poorest members of society. Some were innovative. Some were philanthropic. And still others were absolutely unique. Nevertheless, they have all left their mark on the town—forever.

Across the street from the milestone marker at 68 East Main Street is the birthplace of one of the country's greatest universities. According to *Tercentenary Clinton, Connecticut: 1663–1963*, in 1700, Connecticut Colony's 10 leading ministers were appointed "to found, erect and govern a college," which came to be known as the Collegiate School, later Yale University. Each of these trustees is said to have brought or pledged books to the enterprise. The colony's General Assembly ratified their petition for approval and assistance the following year. Three weeks after ratification, the trustees met in Saybrook, a town along the Connecticut shore, which had been chosen for the Collegiate School's location, and named Rev. Abraham Pierson as its first rector. At the time, he was the pastor of a Congregational church in the Town of Kenilworth, and it was there in his parsonage that he taught the Collegiate School's first undergraduates. (Courtesy of CHS.)

In 1704, the Town of Kenilworth contracted to "have a scoll houes bult" adjacent to the church. Reverend Pierson taught there until his death in 1707. He was buried at the Indian River Cemetery, and the Collegiate School moved 25 miles west of Kenilworth to New Haven. This move was due in part to a substantial contribution from Elihu Yale, a Boston-born London merchant and former governor of the East India Company. Yale had made a gift of goods, which were sold to fund the purchase of books. It was the largest private donation to the college for more than the next hundred years. As a result, the Collegiate School was renamed Yale College at its 1718 commencement. (Photograph by author.)

Today, the Stanton House, built in 1791 where Rector Pierson's house was torn down, rises at one end of the lot on which the Collegiate School once stood. Parts of the old Pierson homestead were built into its successor, and the sills of Yale's first home can be found in the cellar, laid across great stone piers, supporting the two immense stone chimneys. In the Stanton garden is the well from which the first Yale students drew their water supply. (Photograph by author.)

Located nearby on the lawn adjacent to Clinton's Abraham Pierson Elementary School is a statue of Pierson himself, an 1874 gift from Charles Morgan. On the front of its base is inscribed "In honor of / the good and learned / Abraham Pierson / first president / of / Yale College 1701–1707 / pastor of Killingworth Church / now Clinton 1694–1707 / the time his death / beloved and regretted / by all." (Photograph by author.)

Jared Eliot was born in 1685 in the town of Guilford, just a few miles west of Kenilworth. In 1699, he matriculated at Harvard and graduated third in his class. After graduation, he returned to Connecticut to help his family with their farms. In 1701, Eliot traveled to Long Island to study medicine under Rev. Joshua Hobart but returned to Kenilworth the following year to continue his studies under Rev. Abraham Pierson, who by now was the rector of the Collegiate School. In 1706, Eliot graduated at the top of his class and took the job as schoolmaster for the town of Guilford. When Pierson died in 1707, it was discovered that he had stated in his will his desire for Jared Eliot to be his successor as pastor of Kenilworth's Congregational church. Eliot was ordained and held that position for 56 years. (Courtesy of the Elliot family.)

The town of Kenilworth gave Reverend Eliot, now married with a family, more than a dozen acres along the Indian River. While a pastor, he continued to practice medicine, and in 1713 was appointed chief physician of the Colony of Connecticut. In 1730, he became a trustee of Yale, which by then was in New Haven, and introduced science lectures there in 1740. Meanwhile, in 1734, Eliot had begun agricultural and scientific experiments, the latter leading to his discovery of how to produce iron from sea sand. In 1762, he was awarded a gold medal by the Royal Society of London and was the first American inducted into the Royal Society of Science. Jared Eliot, minister, physician, and scientist, died in 1763 at the age of 78 and is buried at the Indian River Cemetery. (Left, courtesy of the Elliot family; below, courtesy of Gail Leggett Webster.)

Horatio Gouverneur Wright was born in Clinton in 1820 and lived at 95 East Main Street. At the age of 14, he entered Alden Partridge's military academy in Vermont, which today is Norwich University. Upon graduation, he received an appointment to West Point and matriculated there in 1837. In 1841, Wright graduated second in his class of 52 with a commission in engineering and taught both French and engineering at West Point for several years. The Army then sent him to Florida, where he spent a decade working on the harbor at St. Augustine and the defenses at Key West. (Both, courtesy of CHS.)

In 1856, having already been promoted to the rank of captain, Wright was named assistant to Col. Joseph G. Totten. During the Civil War, Wright served the Union Army at various command posts, receiving multiple promotions along the way. Reconstruction followed, and he continued to rise through the ranks as he helped to rebuild the nation. This included a number of major engineering projects, including construction of the Brooklyn Bridge and the completion of the Washington Monument. In March 1879, Wright was named chief of the Army Corps of Engineers, and three months later attained the rank of brigadier general. He retired in 1884 and divided his time between Clinton and Washington, DC, where he died in 1899 at the age of 79. Horatio Wright is buried at Arlington National Cemetery. (Courtesy of CHS.)

Born in Cologne, Germany, in 1888, Emil Pallenberg is considered to have been one of the greatest bear trainers of all time. He was the first person to teach a bear to ride a bicycle and a motorcycle. Pallenberg also taught his bears to roller-skate, dance, play musical instruments, and walk the tightrope. In fact, he originated many of the bear acts that are performed today. (Courtesy of the Pallenberg/Burnham family.)

Pallenberg and his wife, Catherine, and their bears were with Ringling Bros. and Barnum & Bailey from 1915 to 1929. After they left the circus, they performed in Boston and New York City and appeared in two feature films, *The Eagle*, starring Rudolph Valentino, and *Buck Benny Rides Again*, starring Jack Benny as himself. They also appeared in plays on Broadway. (Courtesy of the Pallenberg/Burnham family.)

When the Ringling Bros. and Barnum & Bailey's winter quarters was in Bridgeport in 1914, the Pallenbergs and their bears moved to 15 North High Street in Clinton. They had two children, a son, Emil, and a daughter, Dibirma, while they were still with the circus. Emil Sr. retired in the winter of 1953–1954, and his son continued the family tradition. (Photograph by author.)

In 1969, Emil and Catherine Pallenberg were inducted into the Circus Hall of Fame in Sarasota, Florida. Though Emil Sr. had died six years earlier, his widow, Catherine, attended the ceremony. Their daughter, Dibirma Pallenberg, married Clinton resident Ernest C. Burnham Jr., and they continued living at the North High Street address. Dibirma was the town's historian and died in 2018. Her daughter Dibby Jean still lives at 15 North High Street. Both Emil and Catherine are buried at Clinton's Indian River Cemetery. (Photograph by author.)

Clinton Little League – 1980

Harry Swaun moved to Clinton with his family in 1965. Nine years later, he became a Little League coach and remained one for almost 30 years. During his time as Clinton Little League president, he introduced programs for girls. On opening day in April 2001, Coach Harry, as he has been affectionately called for decades, was surprised to learn that Clinton Little League had been renamed Harry Swaun Little League, in honor of "his commitment and dedication to the youth and community of Clinton," as stated on the plaque presented to him. Additionally, he coached boys' basketball and baseball at the Jared Eliot Middle School throughout the 1990s, was an assistant varsity basketball coach at Morgan, and coached first- through third-grade girls' softball from 2005 to 2014. Now well into his 80s, Coach Harry does the clock and scoreboard for almost all the boys' and girls' indoor and outdoor sports at Morgan and coaches eighth-grade boys' basketball. He is also in his 36th year as a Clinton parks and recreation commissioner and served as its chairman for 15 of those years. Pictured are members of his 1980 Little League team; Harry Swaun is on the right. (Courtesy of Harry Swaun.)

Mark Carlson grew up in Clinton, and as a little kid, he played football, basketball, and baseball. In high school at Morgan, he was on the varsity football, basketball, baseball, and track teams and graduated in 1981. After high school, he matriculated at Southern Connecticut State University where he played varsity football. (Courtesy of Mark Carlson.)

During his college football career, Carlson was named to the NCAA Division 2 All-American team (honorable mention) and twice earned postseason spots on All-Eastern College Athletic Conference teams. After graduation, Carlson was signed as a free agent by the NFL Washington Redskins but was released after training camp. However, he was invited back to play for them as offensive tackle during the NFL strike of 1987. (Courtesy of Mark Carlson.)

Carlson's first game as a replacement player was against the St. Louis Cardinals. Despite the Cardinals having 14 regulars on their roster, the Redskins won the game 28-21. For his play in that game, Carlson received Washington, DC, radio station WMAL's player-of-the-game award for the job he did shutting down Pro Bowler Curtis Greer. In the second game during the four-week span in which the Redskins replacements played, Washington took down the New York Giants 38-12. When the strike ended, the Redskins replacement players had one final game against the Dallas Cowboys. Even though the Cowboys had their complete team back, Washington won 13-7. (Courtesy of Mark Carlson.)

After the Dallas game, Carlson and seven others were kept on the Redskins team for the rest of the season, including a trip to Super Bowl XXII against the Denver Broncos, which Washington won 42-10. After summer camp in 1988, Carlson was released by the Redskins and subsequently signed by the Atlanta Falcons. A back injury ended his career. After his professional football career was over, Mark Carlson did not forget his roots. He moved back to Clinton with his wife and daughters, where he coached football at Morgan, his high school alma mater, from 2000 to 2004, helping to propel them to their first state playoff game since 1986. (Courtesy of Mark Carlson.)

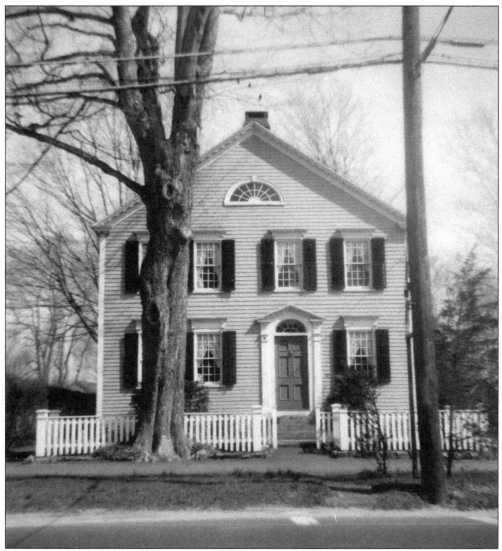

Lewis Jefferson Mays grew up in Clinton at 101 East Main Street. His father, Victor, was a naval intelligence officer, artist, and historian. His mother, Lynnabeth, was the children's librarian at Clinton's Henry Carter Hull Library. Mays graduated from the Morgan School in 1983 and matriculated at Yale College, where he received a bachelor of arts degree before going on to graduate work at the University of California, San Diego. He starred on Broadway, portraying 40 characters in the one-man production *I Am My Own Wife*, the Pulitzer Prize–winning play by Doug Wright. Mays was in the play on Broadway for almost a year, from the fall of 2003 to the spring of 2004, and in May of that year, he won the Tony Award for Best Performance by a Leading Actor in a Play, the 2004 Drama Desk Award for Outstanding One-Person Show, and a 2004 Theatre World Award for his solo performance. Before coming to Broadway in that role, Mays appeared in the same play off-Broadway at Playwrights Horizons in May 2003 and the La Jolla Playhouse in 2001. (Courtesy of Henry Carter Hull Library.)

Erica Hill grew up in a modest condominium complex in Clinton and today is a television journalist who works for CNN as its lead fill-in anchor and national correspondent. After graduating from Morgan, she matriculated at Boston University and received her bachelor of arts degree in 1998. Listed in *People* magazine's 2006 "100 Most Beautiful People" issue, Hill began her journalism career as a production assistant for *PC Week Radio*, the online news program for *PC Week* magazine. Three years later, while working for TechTV, she was noted for her live reporting of the September 11, 2001, terrorist attacks at New York City's World Trade Center. In 2003, she joined CNN's *Headline News*, working as a general news anchor for different programs. Since then and prior to her current CNN assignment, Hill has served CNN *Newsource* as a national correspondent, coanchored *Prime News Tonight*, and teamed with Anderson Cooper. (Photograph by author.)

Joe Grippo came to Morgan in 1982 to teach mathematics and coach girls' basketball. In 1983, he was asked to coach girls' volleyball, a game he knew almost nothing about. Through the years, Coach Grippo not only learned the game, but also coached his girls to the Connecticut Shoreline Championship 22 years in a row, garnered 12 state championships in the sport, became a Connecticut Coach of the Year, and was elected to the Connecticut Volleyball Hall of Fame. Additionally, he is the only coach in state history with 600 career wins in each of two girls' sports, for his basketball team also did phenomenally well. Coach Grippo retired from teaching in 2013 and coaching in 2016. (Both photographs by Adam Coppola, courtesy of *Harbor News*.)

Geraldine and Suzanne Artis of Clinton were two of the plaintiffs in a lawsuit that eventually led to the US Supreme Court's striking down Section 3 of the Defense of Marriage Act, which defined marriage for federal purposes as the union of one man and one woman and allowed states to refuse to recognize same-sex marriages granted under the laws of other states. Until Section 3 was struck down in 2013, same-sex couples, such as Geraldine and Suzanne, were not recognized as spouses and were not eligible for Social Security survivor benefits. Additionally, they could not file a joint federal tax return, thus having to decide which one would declare their three sons as dependents. Section 3, in short, imposed restrictions on the benefits that could be received by legally married same-sex couples. Now, they have parity. From left to right, sons Geras, Gezani, and Zanagee hug their moms Geraldine and Suzanne Artis. (Courtesy of the Artis family.)

The Leatherman was a vagabond who wore a hat, shoes, scarf, and handmade suit of leather. He traveled a circuit between the Connecticut River and the Hudson River from approximately 1857 to 1889. Fluent in the French language, it was thought he might be French Canadian. Most of the time, he communicated with grunts and gestures, rarely using his broken English. The Leatherman walked a 365-mile route, year after year, which took him to certain towns in western Connecticut and eastern New York. He returned to each of those towns for food and supplies every 34 to 36 days. Though he usually lived in rock shelters and caves while roaming, he stayed in a building at the back of the Buell property at 3 Liberty Street when in Clinton. The Leatherman died on March 24, 1889. (Courtesy of CHS.)

Over the years, Clinton has memorialized townspeople who have selflessly donated their time and services to the people of Clinton. Some examples of this include the Dan Vece Sr. Gazebo, situated where the original Morgan School used to be, which is now the site of weekly summer concerts; Harry Swaun Little League; and McCusker Landing, located behind Andrews Memorial Town Hall, where kayaks and canoes can be launched. Even some of the streets are named for Clinton families, mostly of yore, such as Stanton Road, Buell Court, Morgan Park, Dan Vece Jr. Way; and Pallenberg Drive, as are the Morgan, Pierson, and Eliot Schools. (Photographs by author.)

Three

BUSINESSES, BENEFACTORS, AND TOWN AGENCIES

Clinton has a town meeting form of government. The town also has its own constitution called a charter. With a town meeting government, most ongoing financial matters and capital expenditures, as well as new ordinances and charter revisions, are voted on at a town meeting or by referendum. Although there are salaried positions, such as town clerk, assessor, police officers, and schoolteachers, much of the town's operation is overseen by boards and commissions comprised of volunteers. These boards and commissions include but are not limited to the Board of Education, Harbor Management Commission, Board of Police Commissioners, and the Planning and Zoning Commission. Without these unpaid board and commission members, the town could not function. Many of the people who serve on these boards and commissions work for or own businesses in the town. And some of these individuals and businesses have been philanthropic as well.

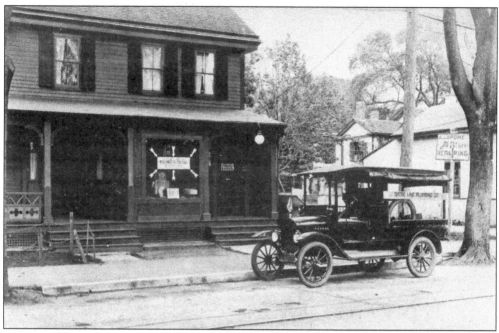

Lupone's Clinton Department Store was a fixture in Clinton for 100 years. Angelo Lupone and his bride, Battista, moved to Clinton in 1906, and he established his shoemaking and shoe repair business. The shop was in a small barn-like building that stood at the rear of an empty lot that, years later, became the site of the department store. A sign on a tree directs customers to the cobbler shop. (Courtesy of Marcy Fuller.)

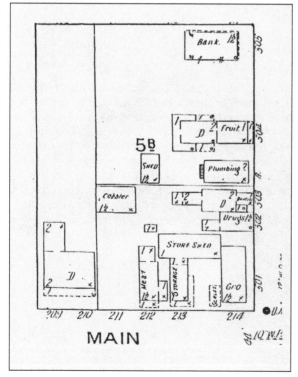

As time went by, Lupone expanded his business by selling work shoes and clothing to his customers. Because Angelo had a sight problem, Battista helped out by operating the cash register. In 1922, a brick building, which was to house the store, affectionately known as "Lupone's," was constructed on the lot in front of the barn. It still stands today. Pictured is a 1917 site map. (Courtesy of the Lupone family.)

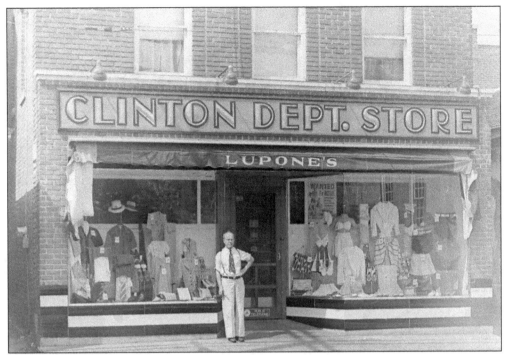

Angelo Lupone named it the Clinton Shoe and Boot Store. The second floor of the building is where the family lived. Patrons often felt like they were visiting their home while shopping there. If lucky, customers sometimes even got a whiff of what was being cooked for dinner that night. (Courtesy of the Lupone family.)

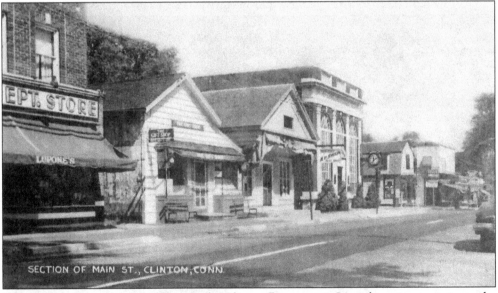

One of the earliest postcards depicting the Clinton Department Store shows its proximity to the Clinton National Bank and Post Office Square. This part of West Main Street looks much the same today as it did when the photograph was taken. Only the names of the businesses have changed, one being Lupone's, which closed its door forever in 2007 after 100 years of service to the people and the town of Clinton. (Courtesy of the Lupone family.)

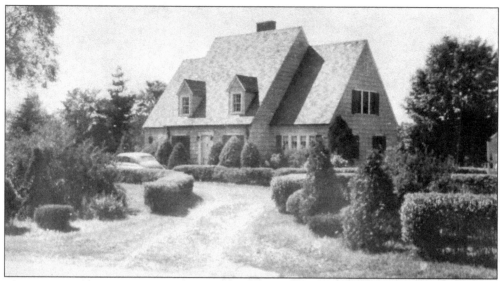

The Connecticut Water Company has been in Clinton since about 1890. It started as several small distinct water companies, one of which was the Clinton Water Company. Three years later, it was formally chartered by Connecticut's General Assembly. That same year, the water companies of Guilford and Madison were chartered as well, and shortly thereafter, the three consolidated. In the early 1900s, Chester's and Deep River's water companies merged with them, and they all came together as the Guilford-Chester Water Company. Again, the name changed when the Guilford-Chester Water Company merged with the Naugatuck Water Company to form the Connecticut Water Company in 1956. Its business office has been at 93 West Main Street since 1954, when it acquired a 1928 building from Clinton Lumber and Coal, which originally served as a lumberyard and model home. (Both, courtesy of the Connecticut Water Company.)

Chamard Vineyards was founded in 1983 by William R. Chaney and his family. Chaney, a Clinton resident for many years, was chief executive officer of Tiffany & Co. from 1983 to 1999 and chairman of its board from 1984 to 2003. Chamard's first vines were planted in the spring of 1984 on 5.5 acres and consisted primarily of chardonnay. By 1988, the vineyard had grown by 14.5 acres and that summer became a licensed farm winery. Its first wine, a 1988 chardonnay, was released for sale in November 1989. (Photographs by author.)

Throughout the town's history, there have been many pioneers, leaders, and benefactors. One such person was Charles Morgan. Born April 21, 1795, Morgan lived at 86 East Main Street in Clinton until he was 14 years old, when he went to New York City to work as a grocer's clerk. Morgan had what was then known as a "common education," for in those days, an academic or collegiate education was only meant for people who planned to pursue "learned professions." At 21, Morgan went into business for himself, owning a ship chandlery and import business. He invested in sailing vessels as early as 1819, yet sold the last of those investments 27 years later. During the 1830s, he owned stakes in steamship companies that shipped to Kingston, Jamaica, and Charleston, South Carolina. He also owned a stake in a company that shipped between Galveston, Texas, and New Orleans, Louisiana. In 1855, Morgan incorporated his assets, cofounding the Southern Steamship Company. (Courtesy of CHS.)

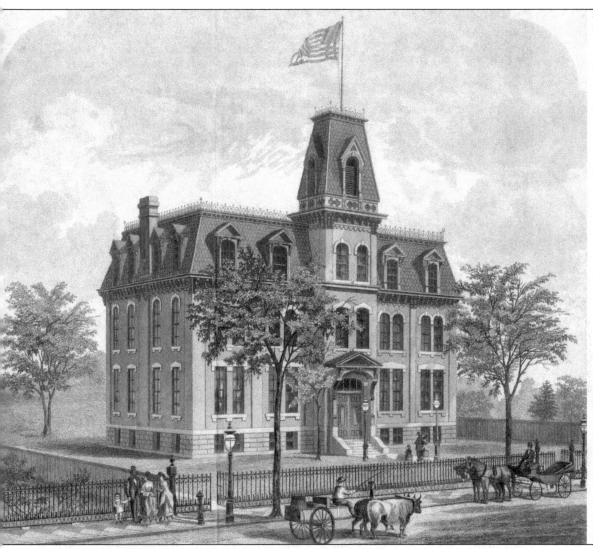

During the Civil War, some of Morgan's steamships were seized by both the North and the South. Since most of the seized ships were owned by the Southern Steamship Company, it was liquidated in 1863. Despite his losses, Morgan prospered during the war. Though he ran blockade runners for the Confederacy, his most profitable venture during this period was the Morgan Iron Works, which built 13 ships for the Union Navy. When the war was over, Morgan repurchased some of the steamships that had been seized at very low prices. After the war, he sold his interest in the Morgan Iron Works, expanded his steamship fleet, and in 1869, bought his first of three railroads. That same year, he donated the money to pay for land and construction of the Morgan School. Morgan died in 1878 at the age of 83 at his home in New York City. (Courtesy of CHS.)

Since 1949, the Clinton Art Society has had a summerlong exhibition in Andrews Memorial Town Hall. Yale's Whiffenpoofs and renowned violinist Joshua Bell have performed there as well. In 2015, it was the site of a four-day convention honoring the life and literary work of Edgar Rice Burroughs. Members of the Burroughs family attended the convention and judged the "Tarzan yell" competition. (Photograph by author.)

As irony would have it, the 2018 Edgar Rice Burroughs convention was in Morgan City, Louisiana, where the first *Tarzan* motion picture, a silent film starring Elmo Lincoln, was filmed in 1918. Ironic, because Morgan City was named for Clinton's Charles Morgan. (Courtesy of Edgar Rice Burroughs Inc.)

George Flynn lived at 148 Old Post Road. A frugal man, his house, built in 1838, had no electricity, no running water, and no indoor plumbing. Yet when he died in 1997 at age 93, it was discovered that he had left a trust fund of nearly $2 million to provide for "classical music concerts for the benefit, education and pleasure of the inhabitants of the town of Clinton" in perpetuity. The first George Flynn Classical Concert was in 1998. Admission was free and continues to be so. There are at least four concerts a year at either Andrews Memorial Town Hall or the Morgan School's auditorium, and they have included the Vienna Boys Choir, Joshua Bell, Orchestra New England, the Emerson String Quartet, the Empire Brass Quintet, and the Preservation Hall Jazz Band. The logo pictured below was created by Vic Mays. (Above, courtesy of Henry Carter Hull Library; below, courtesy of George Flynn Classical Concerts.)

One of Clinton's most generous benefactors was a research and manufacturing company that arrived in 1888 under one name and left in 2012 under another, with a third name in between. It came as Pond's Extract and left as Unilever. But for 57 years in between, the company was known as Chesebrough-Pond's. The company came to Clinton following the purchase of a parcel of land housing the Whittemore Soap Factory, whose trademarks and products were transferred to Pond's Extract with the buyout. As the company grew and the product line expanded, new buildings replaced old ones. (Both, courtesy of CHS.)

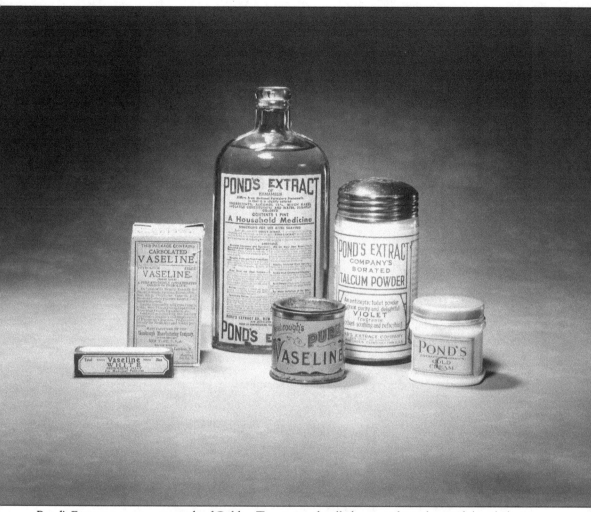

Pond's Extract was an outgrowth of Golden Treasure, a distilled extract from the witch hazel plant. It was the 1864 creation of Theron Pond and a medicine man from an Oneida Indian tribe. Pond's Cold Cream and Pond's Vanishing Cream followed in 1907, with Angel Face arriving in 1946. Chesebrough was the surname of a New York chemist who manufactured a salve compounded from a mineral instead of a vegetable, which could be used as a base for medicinal purposes. This pure emollient, semisolid, non-rancid, stable, odorless, and colorless product is known as Vaseline Petroleum Jelly. Production of Pond's Extract was discontinued just five years before the 1955 merger of the two companies. (Courtesy of CHS.)

Pond's Extract's first donation to the Town of Clinton was a compressed air horn in 1914. It was to be used as an alarm by the volunteer fire department and replaced the bell that had been in service until that time. This was followed five years later with the donation of the town's first fire engine. In 1982, the company, by then Chesebrough-Pond's, matched a flood relief grant and presented Clinton with a check for $25,000 to assist victims whose property had been destroyed or damaged in the flash flood of that year. (Both, courtesy of CHS.)

In 1988, in celebration of its centennial, the company, now Unilever, funded the repair of the clock atop Andrews Memorial Town Hall. Some other Clinton recipients of its altruism were Clinton Education Foundation, Families Helping Families, and the Clinton Police Department's Citizens Academy. In 1937, the Clinton plant's employees numbered 260. By 1988, it employed over 550 people, of which over 210 were residents of the town. Together, employer and employees made donations to those in need, including the troops—from World War II in the 1940s to those sent to Iraq in 2008. Though the company has been gone since 2012, its building, still bearing its original logo, is a reminder of the friend the town has lost. (Photographs by author.)

Clinton's first fire protection was in 1820 in the form of bucket brigades comprised of town residents. Despite the fact that the town lay between the Hammonasset and Menunketesuck Rivers and is divided down the middle by the Indian River, it was difficult to get the necessary water and transport it to a fire. Thus, in 1911, the Clinton Fire Brigade was formed and a hand-drawn hose reel was purchased. It required several men to pull it through the streets to the scene of a fire. Next came a four-wheel hose wagon, which was also drawn by hand, and required an additional man to ride on top to apply the brakes and ring the bell. The equipment was first housed on John Street Extension, but shortly after, it moved to a garage on High Street, just north of the pedestrian underpass. A large bell was placed on another property in town and was used to spread the alarm. Today, that bell is mounted at the entrance to the Clinton Volunteer Fire Department's home at 35 East Main Street. (Photograph by author.)

In 1914, the Clinton Fire Brigade was disbanded and replaced by a 25-man Clinton Volunteer Fire Department. Alarms were sounded by the bell until February of that year, when Pond's Extract Company donated a compressed air horn. In 1919, Pond's Extract once again showed its generosity by donating a Ford truck chassis, which, with work, became the department's first fire engine. The department's next truck was purchased in 1929 and is pictured here at a 1936 brush fire on Waterside Lane. (Courtesy of CHS.)

In the 1930s, construction began on a new firehouse at 48 East Main Street, on the east bank of the Indian River. It opened for operation in 1931 and served as its home for 40 years. In 1971, the volunteer fire department turned that building over to the Clinton Police Department and moved into its current home just across the street. The new building, pictured here, was a gift from Sturges G. Redfield Jr. Today, the department, including emergency medical service, numbers 100 volunteers. (Courtesy of CHS.)

Because some of the Town of Clinton's residents reside on Cedar Island, the Clinton Volunteer Fire Department maintains a boat at the town's marina. In 1954, the department expanded its service to the people of Clinton by providing emergency medical service. The department's EMS has evolved over the years. Hundreds of first responders and emergency medical technicians have gone through hundreds of hours of lifesaving training. Today, the interactions between emergency personnel, emergency room doctors, paramedics, and the use of the LIFESTAR helicopter all help to save lives. (Both, courtesy of the Clinton Volunteer Fire Department.)

Officer Doane Says, "More Haste, Less Speed," Clinton, Conn.

The Clinton Police Department came into existence in 1939 as a result of legislation that was introduced by a Clinton resident who was a member of Connecticut's General Assembly. Until that time, law enforcement in Clinton was conducted by constables who combined their police work with regular jobs. Most of the police work done by the constables was directing traffic. Once the number of automobiles on the road increased, it was time for the town to have a full-time police department. (Courtesy of CHS.)

The legislation also provided for a Board of Police Commissioners who would oversee the police department. The commission chose Horace Andrews, one of the town's three constables, to be Clinton's first police chief. Since that time, the town has had eight chiefs. Today, the department has bicycle and marine patrols, a dive team, and a canine unit in a department that numbers 27 officers. (Courtesy of the Clinton Police Department.)

The police department's first home was one room in the basement of Andrews Memorial Town Hall. Its second was 50 East Main Street, where it stayed until the early 1970s. Then the department relocated to 48 East Main Street next door, which had been vacated by the volunteer fire department's move to its new headquarters across the street. Eventually, the Clinton Police Department outgrew that building, and the town built the officers a new home at 170 East Main Street. It was dedicated in 2004. Their first three homes are clearly visible in this aerial photograph. (Courtesy of the Clinton Police Department.)

Around 1968, the Town of Clinton appointed a Parks and Recreation Commission, which in turn created the Department of Parks and Recreation. The department has many programs for both children and adults, as well as extraordinary facilities, one of which is the Ethel Peters Recreation Complex. When Clinton resident Ethel Peters died, she left $250,000 to the town, of which $125,000 was earmarked by her for parks and recreation for the youth of Clinton. The other $125,000 went to the Clinton Land Conservation Trust. The Department of Parks and Recreation then applied for and received a matching grant from the state's Land Water Conservation Fund. Additionally, it received a Federal Land Conservation Fund grant for $250,000 to upgrade Glenwood, a park already owned by the town, to create the Ethel Peters Recreation Complex. It was completed in 1982, and $10,000 of the money derived from both grants was placed in an escrow account. The interest is still being used decades later for recreational purposes for Clinton's youth. (Courtesy of the Clinton Parks and Recreation Department.)

Less than a decade after completion of the Peters Complex, 201 Killingworth Turnpike in Clinton was raided by local and state police because illicit drugs were being sold there. The land was then confiscated under the federal government's asset forfeiture law. Eventually, the town bought the property, through a process known as eminent domain, in order to build a new elementary school. But the project was overturned, and Jim McCusker, the first selectman at the time, called a meeting, to which he invited the heads of all the Town of Clinton's boards and commissions. The objective was to see which one, if any, was interested in the land. Only three people showed up. McCusker, the first selectman; Bob Bischoff, the town treasurer; and Harry Swaun, chairman of the Parks and Recreation Commission, who convinced the first selectman that the property should become a park. And so it did. The 47-acre project was completed in 1998 and is known as the Indian River Recreational Complex, affectionately called IRRC (pronounced "Irock"). (Courtesy of the Clinton Parks and Recreation Department.)

The Indian River Recreational Complex consists of a 90-foot baseball diamond; three soccer fields, including one of artificial turf, which is also used by the high school for varsity lacrosse and field hockey; a nature trail; basketball courts; a picnic pavilion; fishing in the Indian River; and an equatorial sundial. Also there, after years of being administered downtown in the Academy Building, is the Clinton Parks and Recreation Department's permanent home. (Photograph by author.)

Clinton Town Beach is accessed by crossing the bridge at Waterside. There, one will not only find a beautiful sandy beach that overlooks Cedar Island, Clinton Harbor, and many marinas, but also a dog walk trail, a playground, a splash pad, picnic pavilions, a bathhouse, food concession stand, volleyball nets, and a boccie court. (Courtesy of the Clinton Parks and Recreation Department.)

PUBLIC LIBRARY.
CLINTON CONN

B100-8

In 1910, twelve young women organized and incorporated the Clinton Public Library Association. The association's library was first housed in a room upstairs in the Eliot Building on Post Office Square. They began with 925 books, but within two years, the shelves had become so crowded that the association moved the library to rented space on the second floor of a Main Street building. (Courtesy of CHS.)

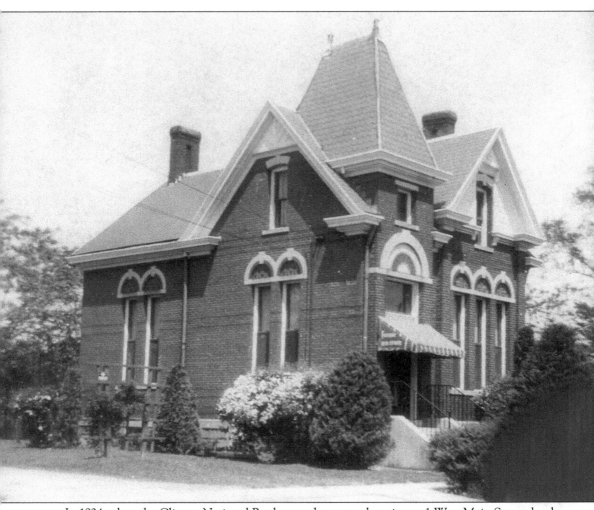

In 1924, when the Clinton National Bank moved to a new location at 1 West Main Street, bank president Henry Carter Hull deeded the redbrick building at the head of Post Office Square that had been vacated by the bank to the Clinton Public Library Association. With that move, the association was dissolved, and articles of association were adopted for the Henry Carter Hull Library. (Courtesy of CHS.)

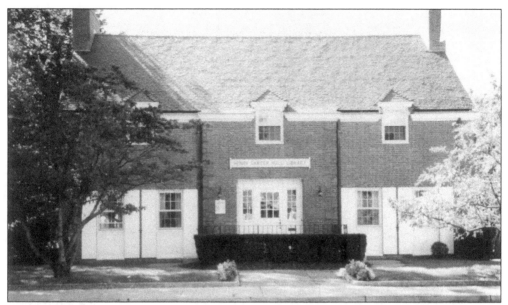

On August 5, 1951, the Henry Carter Hull Library once again had a new home, thanks to a bequest in the will of Hull's wife, Arabelle (Meigs) Hull. It was built at 10 West Main Street on the site of the former Hull residence. Its architect was Roy Bassette of Hartford, the same architect who had designed Andrews Memorial Town Hall. (Courtesy of CHS.)

In 1998, the library moved again, this time to an empty building at 10 Killingworth Turnpike, which once housed a bank's corporate headquarters. The Town of Clinton bought the building for $1.3 million. The $750,000 renovation was paid for by a $500,000 library construction grant and fundraising, which included $50,000 from Chesebrough-Pond's, by then a subsidiary of Unilever. Ever since the completion of the renovation, the Henry Carter Hull Library has leased the building for $1 a year from the Town of Clinton. (Photograph by author.)

Selectmen's Report.

POOR EXPENSES.

Paid for support of Kate McGarvin,	-	-	$161	00
" " Elizabeth Wilson,	-	-	104	29
" " Edson Taylor,	-	-	104	29
" " Elizabeth Dee,	-	-	96	00
" " Carlo Delfanto,	-	-	233	00
" " John M. Milliken,	-	-	21	43
" " Wm. James,	-	-	5	75
" " Jennie Birch,	-	-	87	66
" " Jane Buell,	-	-	62	78
" " Eunice Hutchin,	-	-	9	70
" " Mrs. Chas. Jones,	-	-	4	28
" " Tramps,	-	-	27	00
Assistance to Chas. Hurd,	-	-	80	00
Medical attendance to poor,	-	-	6	30
Supplies,	-	-	16	85
			$1,020	33

ROADS AND BRIDGES.

Paid Burton E. Kelsey,	-	-	$14	50
H. H. Kelsey,	-	-	71	80
Wm. W. Crocker,	-	-	2	10
Wilson M. Crawford,	-	-	2	25
Chas. E. Carter,	-	-	16	75

Helping those in need is nothing new to the Town of Clinton. It has been doing that for centuries. In its 1897 "Statement of the Financial Affairs of the Town of Clinton," the first item listed is "poor expenses." The list not only provides individual names and how much support each received, it also has an entry for vagabonds, designated "tramps." Today, altruism still prevails in Clinton. There, one will find Youth and Family Services; the Department of Social Services; Families Helping Families; the late Jim Beardley's Cancer Relief Fund Walk-a-thon; the Department of Parks and Recreation's scholarships, which allow children from low-income families to participate in its programs; a Fair Rent Commission; and property tax relief for senior citizens. (Courtesy of the Clinton town clerk's office.)

BIBLIOGRAPHY

Abraham Pierson file. Clinton, CT: Clinton Historical Society.

Adler, Peggy. *Liberty Green Historic District Expansion Report*. Clinton, CT: Historic District Commission, 2018.

Andrews, William Stanton. Will. Hartford, CT.

Charles Morgan's Gift to Clinton: The Morgan School. Clinton, CT: Morgan Alumni Association.

Clinton Historic District Commission 5 Liberty Street file. Clinton, CT: Andrews Memorial Town Hall.

Clinton's History Trails. historytrail.clintonctedc.com/history-trails/waterside-lane/.

The Early Historic Homes of Clinton. Clinton, CT: 1967.

First Church of Christ Congregational. *Two Hundred and Fiftieth Anniversary, 1667–1917: First Church of Christ, Clinton, CT*. New Haven, CT: Yale University Press, 1917.

Johnston, Dolores. "The Henry Carter Hull Library: A Short History." hchlibrary.org/files/HCH-Library-history-by-Dolores-Johnston.pdf.

Killingworth Land Records. Killingworth, CT: Killingworth Town Hall.

Ladies Society of the First Church of Christ Congregational. *Clinton: Its Old Houses and Legends*. Clinton, CT: First Church of Christ Congregational, 1951.

Matteis, Jen. "Five Clinton Facts That (Maybe) You Didn't Know." *Clinton Chamber of Commerce Community Guidebook* (2018–2019): 13–18.

McQueeney, Gloria Schoen. *Glory Days: A Tribute to Those Who Made it Possible!* Clinton, CT: Unilever Manufacturing US, 2012.

National Register of Historic Places. www.nps.gov/subjects/nationalregister/.

Oviatt, Edwin. *The Beginnings of Yale: 1701–1726*. New Haven, CT: Yale University Press, 1916.

Pierce, Henry. *Colonial Killingworth: A History of Clinton and Killingworth*. Clinton, CT: Clinton Historical Society, 1976.

Report: Historic District Study Committee. Clinton, CT: Historic District Commission, 1979.

Resolves and Private Acts of the State of Connecticut. Hartford, CT: John B. Eldredge, 1838.

Tercentenary Clinton, Connecticut: 1663–1963. Tercentenary Commission, 1963.

DISCOVER THOUSANDS OF LOCAL HISTORY BOOKS FEATURING MILLIONS OF VINTAGE IMAGES

Arcadia Publishing, the leading local history publisher in the United States, is committed to making history accessible and meaningful through publishing books that celebrate and preserve the heritage of America's people and places.

Find more books like this at
www.arcadiapublishing.com

Search for your hometown history, your old stomping grounds, and even your favorite sports team.